The Jewish Heritage in American Folk Art

The Jewish Heritage in American Folk Art

Norman L. Kleeblatt
Gerard C. Wertkin

With an essay by
Mary Black

The Jewish Museum/New York
Museum of American Folk Art/New York

The exhibition and catalogue
were made possible by major grants
from the National Endowment for the Arts,
the New York State Council on the Arts,
and the Joe and Emily Lowe Foundation, Inc.,
as well as by generous support from
Mr. and Mrs. Samuel Schwartz.

UNIVERSE BOOKS
New York

Cover illustration:
Decoration for the Eastern Wall (Mizrah)
Attributed to the Mount Pleasant Artist
Probably Lancaster County, Pennsylvania, c. 1830
Watercolor and ink on paper
Cat. 30

Design by Kay Douglas

Published in the United States of America in 1984
by Universe Books
381 Park Avenue South, New York, N.Y. 10016

84 85 86 87 88 / 10 9 8 7 6 5 4 3 2 1

Printed in the United States of America

Library of Congress Cataloging in Publication Data
Main entry under title:

The Jewish heritage in American folk art.

 Bibliography: p.
 1. Folk art – United States – Catalogs. 2. Jewish art
and symbolism – Influence – Catalogs. 3. Jews – United
States – History. I. Jewish Museum (New York, N.Y.)
II. Museum of American Folk Art.
NK805.J48 1984 745'.089924073'07401471 84-40352
ISBN 0-87663-449-8
ISBN 0-87663-858-2 (pbk.)

Contents

In transliterating, the museums have used standard, contemporary Hebrew rather than Yiddish.

Names in inscriptions are given in their common English forms if such equivalents exist, but are left in Hebrew where a common equivalent is not available.

Preface

Collaboration between museums on the planning of an exhibition and the preparation of an accompanying catalogue presents both a challenge and an opportunity. Differing vantage points must be considered in the creation of a new unity and coherence. Working together means that areas of curatorial expertise and the individual strengths of the cooperating organizations' staffs may be called upon in ways that allow for greater breadth of coverage and deeper insights.

The Jewish Heritage in American Folk Art is the result of just such a collaboration. For almost two years, the curatorial and administrative staffs of the Museum of American Folk Art and The Jewish Museum have worked closely together, and we are pleased that the resulting collaboration has been not only pleasant but fruitful.

Because this exhibition presents an introduction to a subject that has received only the most limited treatment, specialists in the fields of Jewish religious and ceremonial art and American folk art were initially apprehensive that sufficient material related to the chosen topic simply did not exist. Each museum, however, was able to call upon its own resources, as well as on a large number of scholars, institutions, and collectors, in an effort to identify works of art for inclusion in the exhibition. This sharing of responsibilities resulted in the location of a large number of significant pieces, many of which were unknown even to scholars in the field.

The Jewish Heritage in American Folk Art also provided an intensive learning experience for those involved in the exhibition. Jewish ceremonial materials have provided insights into the nature and some of the sources of American folk art. Likewise, the approach of American folk art historians to other folk traditions and interrelationships has been helpful in understanding the influences on Jewish folk art and material culture in America.

This cooperative endeavor has represented teamwork at its best. Heading the effort were Norman L. Kleeblatt, curator of collections of The Jewish Museum, and Gerard C. Wertkin, assistant director of the Museum of American Folk Art, whose work was in every way a joint endeavor. Working closely with the co-curators were Anita Friedman and Irene Z. Schenck of The Jewish Museum and Jeanne Bornstein of the Museum of American Folk Art.

This exhibition could not have been presented without major grants from the National Endowment for the Arts, the New York State Council on the Arts, and the Joe and Emily Lowe Foundation, and the generous support of Mr. and Mrs. Samuel Schwartz. This generosity permitted the extensive research necessary to organize the exhibition, the production of a handsome and informative catalogue which permanently documents the newly discovered materials, and the installation of the exhibition at The Jewish Museum.

The cooperation and enthusiasm of the institutional and individual lenders are deeply appreciated. They are listed in Lenders to the Exhibition on page 11.

Prior to *The Jewish Heritage in American Folk Art*, almost no reference material was available on the subject. We are delighted at the prospect that the exhibition and catalogue will serve as an impetus for the continuing discovery and presentation of this type of new material and further research in the field.

ROBERT BISHOP
Director
Museum of American Folk Art

JOAN H. ROSENBAUM
Director
The Jewish Museum

Acknowledgments

The Jewish Heritage in American Folk Art had its origin in a series of conversations that took place in 1979 and 1980 between Robert Bishop, director of the Museum of American Folk Art, and Susan Goodman, chief curator of The Jewish Museum. Bob Bishop was eager for Jewish folk art in America to be documented so that it might take its place among the other religious and ethnic traditions American folk art comprises. Susan Goodman's office had become a clearinghouse for information on the work of self-taught artists who were introducing Jewish themes into painting and sculpture in a search for personal roots. These informal conversations led directly to plans for collaborating on an exhibition. While the research undertaken since then resulted in a shift of emphasis as objects were located and the scope of the subject matter was more fully identified, we continued to benefit throughout the course of our work from the knowledge and encouragement of Bob Bishop and Susan Goodman. Without their foresight and inspiration, *The Jewish Heritage in American Folk Art* could not have been presented.

It would have been impossible to undertake work on an exhibition of this nature without the understanding and support of the administration of our respective museums. Joan Rosenbaum, director of The Jewish Museum, and Bob Bishop made available to us sufficient time and resources, provided guidance, and contributed needed insights and constructive criticism.

We are pleased to acknowledge with gratitude the cooperation of our colleague, Mary Black, who prepared an informative essay for this catalogue and provided helpful counsel and advice.

The research undertaken in preparation for *The Jewish Heritage in American Folk Art* and the writing of entries for this catalogue have been a collaborative effort based on a constant exchange of information and insights. The dedicated, creative, and scholarly support of Jeanne Bornstein, Anita Friedman, and Irene Z. Schenck in researching, writing, and attending to an endless variety of details did much to guarantee the success of our efforts; their participation in almost every aspect of the exhibition has been invaluable and warrants special thanks. Lesley Schab deserves credit for unstinting organizational work on both the catalogue and installation, which was always undertaken with enthusiasm, efficiency, and good humor. Karen Wilson has served in the last six months of this project as coordinator at The Jewish Museum. Our thanks to her for undertaking a myriad of supervisory tasks and making certain that no detail was overlooked, and all this with great spirit and moral support.

Early in the conceptual and developmental stages of this exhibition, Valerie Redler and Lois Avigad did significant work in gathering materials, establishing contacts with private collectors and institutions, and providing information—all done with energy, insight, and cooperation.

The thoughtful collaboration of the Judaica Department of The Jewish Museum enhanced our understanding of the objects in the exhibition in the context of Jewish art and religious practice. For their assistance at every level and their careful review of catalogue entries, we are grateful to Dr. Vivian Mann, curator of Judaica; Emily Bilski, assistant curator; and Sharon Makover, curatorial assistant. Thanks also to Sharon Liberman for her thorough translation of the extensive Hebrew inscriptions.

The need to transport objects from all parts of the country and from the homes of many individuals as well as from institutional locations has placed burdens on the registrarial staff of The Jewish Museum. Special thanks are due to Rita Feigenbaum, registrar, who encouraged us with her frequent expressions of

9

enthusiasm, and to her assistant, Dana Cibulski, and former assistant, Ann Driesse. The kind cooperation of the registrar of the Museum of American Folk Art, Claire Hartman Schadler, is also acknowledged.

The professional and administrative staffs of The Jewish Museum and the Museum of American Folk Art offered encouragement and assistance. We especially want to express our warm appreciation to:

Andrew Ackerman	Naomi Karp
Ann Applebaum	Joan Lowenthal
Etti Baussidan	Anne Minich
Ruth Dolkart	Beth Mitchneck
Susan Flamm	Jan Bloch Rosensaft
Sheila Friedland	Anne Scher
Vicki Garfinkel	Judy Siegel
Rosemarie Garipoli	Harley Spiller
Allison Greene	Virginia Strull
Phyllis Greenspan	Barbara Treitel
Kay Gutfreund	Carole Weisz
Belle Saunders Kayne	

We are grateful to the late Naomi Strumpf for her assistance in undertaking an initial survey of The Jewish Museum's collection and her continual enthusiasm as additional objects from other collections became known.

Many items in this exhibition required conservation treatment in order to prepare them for exhibition and preserve them for the future. Sincere gratitude to Konstanze Bachmann, Judith Eisenberg, Elayne Grossbard, Hermes Knauer, Annie Luce, Edith MacKennan, the Textile Conservation Workshop, and Charles von Nostitz, who carefully restored these works. Also thanks to Nancy Stein for her attention to the large task of reframing.

Many experts, colleagues, and collectors contributed advice and information, provided helpful leads, and were generous in sharing their knowledge and insights. Especially helpful were Professor Abraham J. Karp, who not only brought to our attention the wonderful objects in his own collection and made them available for the exhibition, but also offered a wealth of informative comments throughout its preparation; Dr. Nathan M. Kaganoff of the American Jewish Historical Society, who took time to provide information about the important resources of that institution and offered invaluable suggestions and guidance; and Deenah Loeb of the National Museum of American Jewish History, who gave expert assistance on objects from Philadelphia sources. Others whose scholarship and knowledge of the field were helpful are:

Ita Aber	Bernard Kusnitz
Gloria Abrams	A. Alan Levin
Harry Aronson	Seymour Levine
Leah Bar Zeev	Karl V. Mendel
F. Frederick Bernaski	Miriam Miller
Charlotte B. Brown	Leah Mishkin
Ed Connolly	Alfred Moldovan
Allen Daniels	Patsy Orlofsky
David Davies	Irving Pushkin
Davida Deutsch	Joan C. Sall
Leslie Eisenberg	Alexander Schermer
Robert P. Emlen	Daniel Schermer
Eugene Epstein	Richard Schermer
Howard Feldman	Sandi Schermer
Phyllis Freedman	Esther Schwartz
Frederick Fried	Francisco F. Sierra
John Gordon	Linda Crocker Simmons
Leah Shanks Gordon	Sanford Smith
June Griffiths	Amy Snider
Cissy Grossman	Lita Solis-Cohen
Herbert W. Hemphill, Jr.	Jody Steren
Faye K. Hersch	Rabbi Malcolm Stern
Barbara Johnson	Joseph A. D. Sutton
Jay Johnson	Lucien Therrien
Susan H. Kelly	Jay Weinstein
Barbara Kirshenblatt-Gimblett	Pastor Frederick Weiser
	Anne C. Williams

All the lenders and staffs of the lending institutions have been extremely helpful in sharing with us their objects and information about these works, much of which had not been published previously. Their names are included in Lenders to the Exhibition. We owe them all a debt of gratitude.

The enthusiasm and organizational expertise of Adele Ursone of Universe Books, who served as both editor and project coordinator, assured us a finely produced publication. Her marvelous disposition and sensitivity to the works in the exhibition were an added bonus for us. Also, thanks to Dorothy Chanock of Universe Books for her assistance.

Special thanks to Michael Sonino, who carefully edited all aspects of this catalogue, and to the designer Kay Douglas for her creativity. For the installation of the exhibition at The Jewish Museum, we wish to thank Clifford La Fontaine and his staff.

Last, but hardly least, we must thank the numerous people who have brought many fine works of art to our attention, some of which unfortunately have not been used in this exhibition. Their interest, cooperation, and patience during the long selection process have been invaluable in permitting us the opportunity to crystallize our thoughts and have given us ideas for future research and exhibitions.

N.K.
G.W.

Lenders to the Exhibition

MR. AND MRS. SIDNEY G. ADLER

MR. AND MRS. STANLEY ALBERT

AMERICAN JEWISH HISTORICAL SOCIETY, WALTHAM, MASSACHUSETTS

MANFRED ANSON

T'MAHRY AXELROD

THE BALTIMORE MUSEUM OF ART, MARYLAND

EVELYN GLICK BLOOM

BUCCLEUCH MANSION, NEW BRUNSWICK, NEW JERSEY

THE CONGREGATION BETH ISRAEL JUDAICA MUSEUM, WEST HARTFORD, CONNECTICUT

CONGREGATION MIKVEH ISRAEL, PHILADELPHIA, PENNSYLVANIA

CONGREGATION SHAAREI ELI, PHILADELPHIA, PENNSYLVANIA

PAUL AND TOBY DRUCKER

THE GERSHON AND REBECCA FENSTER GALLERY OF JEWISH ART, TULSA, OKLAHOMA

NORMAN FLAYDERMAN

MR. AND MRS. STEPHEN TEN EYCK GEMBERLING

MR. AND MRS. DAVID A. GERBER

PHILIP AND HANNA GOODMAN

MARY BERT AND ALVIN P. GUTMAN

HEBREW UNION COLLEGE, SKIRBALL MUSEUM, LOS ANGELES, CALIFORNIA

THE HUDSON RIVER MUSEUM, YONKERS, NEW YORK

PHILIP AND DEBORAH ISAACSON

THE ISRAEL MUSEUM, JERUSALEM, ISRAEL

SIDNEY JANIS GALLERY, NEW YORK CITY

JAY JOHNSON AMERICA'S FOLK HERITAGE GALLERY, NEW YORK CITY

JEWISH HISTORICAL SOCIETY OF CENTRAL JERSEY, NEW BRUNSWICK, NEW JERSEY

THE JEWISH MUSEUM, NEW YORK CITY

THE LIBRARY OF THE JEWISH THEOLOGICAL SEMINARY OF AMERICA, NEW YORK CITY

THE FAMILY OF MINNIE KANOFSKY

KARP FAMILY COLLECTION

DR. BARBARA KIRSHENBLATT-GIMBLETT

BERNICE AND ABRAHAM KREMER

ELEANOR SOSNOW LEVITT

MR. AND MRS. RICHARD LEVY

THE LIBRARY COMPANY OF PHILADELPHIA, PENNSYLVANIA

JUDAH L. MAGNES MUSEUM, BERKELEY, CALIFORNIA

THE MARYLAND HISTORICAL SOCIETY, BALTIMORE

KARL MENDEL

MORIAH ANTIQUE JUDAICA, NEW YORK CITY

MUSEUM OF AMERICAN FOLK ART, NEW YORK CITY

MUSEUM OF THE CITY OF NEW YORK

NATIONAL MUSEUM OF AMERICAN JEWISH HISTORY, PHILADELPHIA, PENNSYLVANIA

PHILADELPHIA JEWISH ARCHIVES CENTER, PENNSYLVANIA

MAE SHAFTER ROCKLAND

JOANNA S. ROSE

LEONARD L. ROSENTHAL

IDA ROTHBORT

ESTHER AND SAMUEL SCHWARTZ

MR. AND MRS. ARTHUR SHEINER

EDYTHE P. SIEGEL GALLERY OF JEWISH-AMERICAN FOLK ART, STAMFORD, CONNECTICUT

FRANCISCO F. SIERRA

SAUL SILBER MEMORIAL LIBRARY, HEBREW THEOLOGICAL COLLEGE, SKOKIE, ILLINOIS

SMITHSONIAN INSTITUTION, NATIONAL MUSEUM OF AMERICAN HISTORY, WASHINGTON, D.C.

SPERTUS MUSEUM, CHICAGO, ILLINOIS

MRS. LEON STERNBERGER

ABRAHAM STOLLERMAN

MR. AND MRS. A. HARVEY STOLNITZ

TEMPLE BETH ISRAEL, PLATTSBURGH, NEW YORK

JUDITH TULLER

DAVID M. WAGNER

SYLVIA ZENIA WIENER

ANNE C. WILLIAMS AND SUSAN H. KELLY

HERBERT I. WINER

JANE VOORHEES ZIMMERLI ART MUSEUM, RUTGERS THE STATE UNIVERSITY, NEW BRUNSWICK, NEW JERSEY

PRIVATE COLLECTION

Snuff Shop, 113 Division Street, Manhattan. January 26, 1938.
The sign and one of the crocks are inscribed in Yiddish.
Photograph by Berenice Abbott, Federal Art Project
"Changing New York." (Courtesy of Museum of the City of
New York)

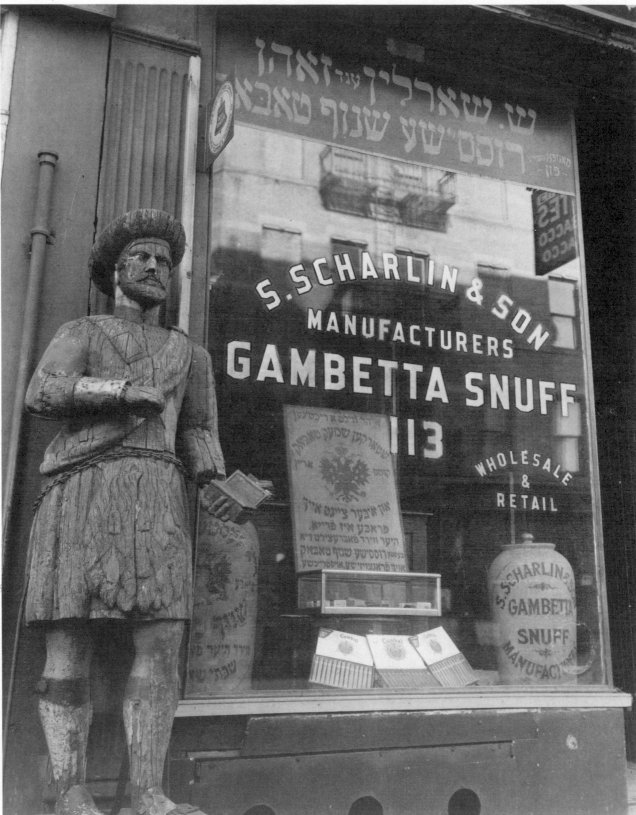

Introduction

The Jewish Heritage in American Folk Art is an exhibition offering the first systematic examination of an important element in the diverse panorama of folk creativity in the United States. It not only presents a view of American Jewish life as preserved in the work of folk artists, but considers the traditional arts of the Jewish people as they have been given fresh expression in this country. In keeping with the theme of the exhibition, *The Jewish Heritage in American Folk Art* has been jointly organized by The Jewish Museum and the Museum of American Folk Art.

Although there has been a lively interest in Jewish ethnography and folklore, and the beginnings of a reliable body of literature in that field, remarkably little of scholarly significance has been published on Jewish folk art in America. From the early decades of the 20th century up to World War II, a number of distinguished European art historians and ethnographers undertook to study, record, and preserve the folk art of Old World Jewry. Unfortunately, this research is neither readily accessible nor well represented in published studies of Jewish art in the English language. In the field of American folk art, little, if any, attention has been given to Jewish materials. Indeed, none of the standard sources on American folk art includes a single reference to the existence of such a tradition, even though it is a commonplace that the religious folk cultures of the Pennsylvania Germans and the Spanish of the Southwest, to give the most obvious examples, must be considered in any survey of the field.[1]

The rise in appreciation of folk art in America in the second decade of this century was concurrent with a similar awareness of Jewish folk art in Eastern Europe. The awakening interest in these two different aesthetic traditions is closely linked to the artistic, social, and cultural events of the era. Given the prior discovery of West European folk art and the realization of the aesthetic merits of African and Oceanic objects—formerly the domain of the ethnographer—it was only logical that attention would ultimately be turned toward similar phenomena in America and in the large Jewish settlements of Eastern Europe.

Spurred by the rapid social changes brought about by the Industrial Revolution, 19th-century artists began to seek expressions that were (seemingly) simpler and more direct. One of the first such instances was the renewed interest in 13th- and 14th-century Italian artists by the Nazarenes, a group of German artists who lived in Rome during the early 19th century, and later by the Pre-Raphaelite Brotherhood, a group of painters who worked in England in the 1850s and 60s. Inspired by William Morris in England in the 1870s, and reaching America at the turn of the century, the Arts and Crafts Movement—in its desire for simpler, hand-crafted designs—was another outgrowth of this sensibility.

Early in the second decade of the present century, the artist and collector Hamilton Easter Field founded an artists' colony and school in Ogunquit, Maine. Field's collection of American folk art informed the tastes and influenced the work of some of the artists of that colony, such as Robert Laurent, Max Weber, and William Zorach. Attracted to the simple forms and linearity of the objects, and their abstract qualities and lack of pretension, these artists began collecting examples of American folk art themselves. Alice Winchester has observed that the "cult of American folk art did not exist until the artists of the 1920s

1. See, for example, Jean Lipman and Alice Winchester, *The Flowering of American Folk Art, 1776–1876* (New York: Viking Press, in cooperation with The Whitney Museum of American Art, 1974).

began seeking the roots of American art in early non-academic work."[2] Indeed, many of our current ideas about American folk art began to be shaped in the exhibition presented at the Whitney Studio Club in 1924, organized by the painter Henry Schnackenberg, who borrowed many of the objects on display from artist friends. Charles Sheeler, Elie Nadelman, Charles Demuth, Peggy Brown, and Yasuo Kuniyoshi were among the painters and sculptors of that day who collected and were influenced by these examples of the cultural heritage of early America. As they experimented with new concepts, these artists "realized that the products of previous generations of American artisan-craftsmen provided a precedent and thus a means of legitimizing their own use of simplified shapes, arbitrary perspective and unmixed colors."[3]

The story of the "discovery" of American folk art by American artists of the 20th century has been told frequently. It is perhaps less well known that at about the same time, Jewish artists in Eastern Europe were undertaking a search for a "Jewish style" with similar inquiries into their own folk art heritage. The Russian-Jewish playwright and thinker, S. An-Ski, set out in 1912 from St. Petersburg on an expedition to search out Jewish ethnographic and folk material. The material collected included thousands of folktales and legends, songs, some 500 manuscripts and 700 "antique articles."[4] This influenced the important 1916 journey made by the artists Issachar Ryback and El Lissitzky to view the wooden synagogues along the Dnieper River. "Ryback and Lissitzky, in search of personal and collective roots, drew plans, made colored drawings and gathered inscriptions from about two hundred wooden synagogues, among them the famous synagogue of Mohilev."[5] Lissitzky left a fascinating account of this journey and he was deeply moved by what he observed: "It was quite a different feeling from the one I had when I first entered a Roman basilica, a Gothic chapel, a baroque mosque in Germany, France or Italy. It is like a child enveloped by a screen, opening his eyes upon awakening and being startled by the sunflies and butterflies glittering in the rays of the sun."[6] Ryback and Lissitzky, along with Nathan Altman and Marc Chagall, soon incorporated into their work, elements from the folk painting of those Russian synagogues, as well as those from the

Jewish and Russian folk prints or *lubok,* and the Russian icon.

The influence of secular life on Jewish culture in 19th-century Europe began to dilute traditional religious artistic expressions. In fact, as academic training became available to Jews through the relaxation of legal restrictions that had formerly prohibited their entry into a number of fields, Jews who might have practiced crafts associated with religious ritual now became free to pursue the study of painting and sculpture.

The tradition of European academic training for many American artists in the 19th century fostered a stylistic dependence on European models. Directed away from academic sources, the new artistic movements, coupled with political and nationalist movements both here and abroad, made both American and Russian-Jewish artists look to new sources of expression through indigenous local traditions.

The word "heritage," which has been associated with this exhibition since its inception, curiously seems to express the core reason for the interest in these folk traditions; and with the recent enthusiasm for both Judaica and folk art, the moment seemed appropriate to examine those aspects of folk art related to the Jewish experience in the United States. The exhibition has taken a broad eclectic viewpoint, and therefore ranges from early 18th-century portraits of Jewish settlers by non-Jewish artists to contemporary folk paintings on Jewish themes by Jewish artists. An encyclopedic approach seemed appropriate for the first exhibition devoted to this subject.

This exhibition opens a new area of study, and the corpus of material that has been uncovered for the first time reveals the richness of the tradition of Jewish folk art in America.

Special mention must be made of the American Jewish papercuts. While many pay homage to their East European origins, others reveal distinctive American elements, either stylistically or iconographically. Because of the perishable nature of the medium and the vagaries of Jewish life in Europe, few examples of this folk art form from Europe have survived. The fact that so many American examples were uncovered in the preparation of this exhibition demonstrates both the strength of that tradition in Europe and its cultural adaptation in America. It is certain that many more American Jewish papercuts will surface as a result of this exhibition.

Micrography, the only art form known to be specifically Jewish in origin, involves the use of minute Hebrew script to create patterns or images. It is striking that this wholly Jewish form has often become influenced by American stylistic conventions at the hands of Jewish folk artists in this country. Although the tradition of micrography in this country may have been recognized, this exhibition should

2. *Ibid.,* 10.

3. Beatrix T. Rumford, ed., *American Folk Portraits: Paintings and Drawings from the Abby Aldrich Rockefeller Folk Art Center* (Boston: New York Graphic Society in association with the Colonial Williamsburg Foundation, 1981): 11.

4. Avram Kampf, "In Quest of the Jewish Style in the Era of the Russian Revolution," *Journal of Jewish Art* 5 (1978): 50.

5. *Ibid.,* 52.

6. El Lissitzky, as quoted in Avram Kampf, *op. cit.:* 52.

focus more attention on the form which, with its origins in Jewish artistic and religious conventions, has become part of the repertoire of American folk art.

Woodcarving is another important medium that took shape in America as Jews organized congregations as stable structures for communal expression. Principally in connection with the decoration of synagogues, Jewish carvers merit a special place in American folk sculpture. Catering to the needs of these new congregations, Jewish sculptors created in wood an impressive body of work which heretofore has largely been overlooked. The body of American folk carvings is greatly enhanced by the incorporation of these Jewish forms, which add to the scope and range of American folk sculpture.

The Western Ashkenazic Torah binder is by its very nature a specifically Jewish folk art form. American examples incorporate iconographic symbols associated with this nation and contain rare examples of the vernacular in addition to the standard Hebrew inscriptions. American artists have also included representations of new technological advances which have become identified with American pragmatic sensibility.

As these Jewish folk art forms are observed and studied, it becomes clear that they frequently reveal that the artists who created them were individuals of great learning and scholarship. Not only is knowledge of the Hebrew language implied by their work but knowledge also of the Bible and other Hebrew ethical, legal, and liturgical works. The papercuts, micrographs, and Torah binders exemplify Franz Landsberger's early observation that "the combination of pictorial and [associated] verbal decoration is frequently found in [Jewish] folk art."[7]

At first it was hoped that there would be examples of American engraved pewter holiday plates similar to the numerous extant European examples. Yet, none has been discovered. The ostensible reason for this was the necessity in Colonial America to recycle certain materials—and pewter was commonly melted down and reused for other fabrications. The absence of American Torah Crowns made of paper flowers such as those known in Western Europe, and which would have fit so readily into American 19th-century sensibility, is probably attributable to their perishable nature.

7. Franz Landsberger, *The History of Jewish Art* (Port Washington, N.Y.: Kennikat Press, 1946): 17.

American examples of amulets, arising from various folkloric traditions which are frequently found in the Jewish folk art of Europe and the Middle East, also have not been found, a fact which may be related to the nature of Jewish life in America.

The broad approach taken by this exhibition led to the inclusion not only of Jewish objects but those documenting Jewish life, such as portraits, silhouettes, and prints where such objects relate to the American folk art experience.

Silhouettes, even those by trained artists such as Edouart, have been included for several reasons. The personages they record played an important role in the history of Jews in early America and are related to other objects in the exhibition. Their two-dimensionality and straightforward technique relate well to other folk-art forms, in particular the paper-cuts that form an important segment in this exhibition.

In the late 19th and early 20th centuries, commercial printing was a trade practiced by many Jews in the United States. Several prints shown here were included for a variety of reasons. They are generally naïve in conception; even those assembled with readily available and seemingly sophisticated components were designed by persons who clearly lacked academic training and sensibility. Some tell a story by incorporating several narrative sequences into one scene, each with its own perspective. Other prints relate to those of the Pennsylvania Germans, generally considered folk art.

The activity of Jews in the manufacture of carved carousel animals would produce similar results as exemplified by the Lions and Decalogue fragment of a Torah ark by Marcus Charles Illions. Just as Jewish printers would create works to serve religious functions as the need arose, the activity of Jewish carvers in such fields as the production of carved carousel animals would also produce architectural decorations for the synagogue.

Ordered chronologically, the objects range in date from 1720 to the present with almost every decade represented in this span of more than two and a half centuries. The objects are geographically widespread, coming from large urban areas as well as small rural villages. The variety of objects and media give testament to the strong role folk art plays in the history of Jews in America.

This exhibition provides groundwork that is certain to lead to further discovery and preservation of similar examples as well as other forms of Jewish folk art.

N.K.
G.W.

Illions & Sons workshop, 1910 or 1912, showing the
production of carousel animals. The Pair of Lions and
Decalogue from a Torah ark (cat. 84) hangs over the
doorway. (Photograph courtesy of Smithsonian Institution,
Washington, D.C.)

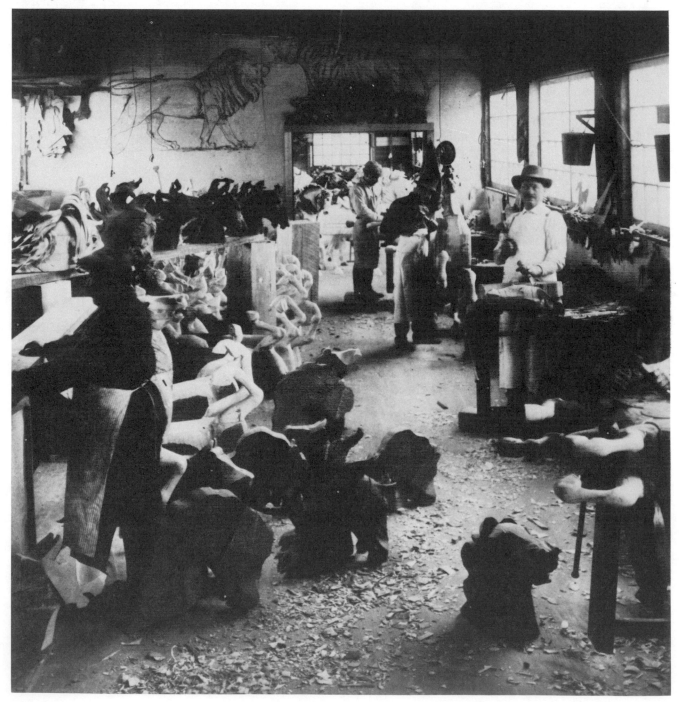

Aspects of American Jewish History:
A Folk Art Perspective

Mary Black

lthough there is recorded evidence of two
earlier arrivals, the first Jews on Manhattan
Island were the twenty-three refugees who
landed on the shores of the East River early in
September 1654, a date that marked the founding of
the first Jewish community in the colonies. This little
band had been expelled from Portuguese Brazil, and
their Netherlands-bound voyage was diverted by
pirates. A French privateer bound for the New
Netherlands rescued them, and brought them to
Manhattan. At first the penniless newcomers were
forced to camp out near their point of debarkation
while they sought ways to pay the cost of their
passage. The Dutch burghers of New Amsterdam
came to their aid, and bought what few possessions
they owned, subsequently returning these clothes and
furnishings, thereby enabling the refugees to take
their place in the early history of what was to become
New York.

The group formed the little Congregation Shearith
Israel, "Remnant of Israel," which, despite its
inauspicious beginnings, survived and modestly pros-
pered. By the end of the century it comprised about
one hundred members, who held regular services in
rented quarters in Lower Manhattan. The congrega-
tion saw to the religious education of its children
and to the care and support of elderly and infirm
members. Aside from the heavy manuscript books of
records (which were written in Portuguese and
English), there is no other documentation of this early
Jewish community that would illustrate its faith or
show the appearance of its members. Not until the
first quarter of the 18th century, when many

descendants of the first colonists had become
prosperous members of the New York merchant
community, were they portrayed by resident painters.
But even before that time, their lives had been
memorialized by the stonecutters who carved the
markers in the group's second, ancient cemetery,
vestiges of which still survive near New York's
Chatham Square.

The first painters to portray members of the Jewish
community were not themselves Jews, but colonial
artists whose most frequently treated subjects
belonged to their own prospering families and those
of their associates. Portraits of members of the related
Franks and Levy families (early Ashkenazic members
of the Sephardic Congregation Shearith Israel) are
attributed to third-generation members of the
Duyckinck family, glaziers and limners who lived
near New York's first synagogue on Mill Street (now
Stone Street) in Lower Manhattan. The carvers of the
gravestones in the burial ground near Chatham
Square, of which the tomb of Walter P. Judah is the
most ambitious example, have not been identified,
but since stones of a similar style and period may be
found in abundance in Christian cemeteries in
Manhattan, it is more than likely that these stone-
cutters, like the portrait painters, were also non-Jews.

The likenesses of Moses and Grace Levy, their
daughter Bilhah, her husband, Jacob Franks, and
several of the Franks children, are by Gerardus
Duyckinck and his first cousin, Evert Duyckinck III
(cats. 1–3). At the start of the 18th century, the
Duyckincks belonged to a fraternity of portraitists
that had transferred their center of artistic productiv-

ity from New England to New York. The two cousins and Gerardus's father, Gerrit, were, with John Watson, New York and New Jersey members of this group. From the late 17th to the mid-18th century, other artists who flourished along the Hudson – in Kingston, Albany, and Schenectady – performed the valuable service of preserving the likenesses of their contemporaries.

By the time this casual association of painters – each looking over the other's shoulder – had disbanded, a Jewish community was forming in Newport, Rhode Island. With the establishment of the new congregation there, a few members of the New York congregation were attracted to coastal New England, where an unidentified painter captured the likeness of Aaron Lopez, one of the most influential Jews in Rhode Island's early history.

The Stevens family, Newport stonecarvers, produced tombstones for the Christian community, as well as some for the growing Jewish one. Their skill as stone engravers is confirmed in the Hebrew words incised on the tomb of Rebecca Polock (cat. 5). The stone of the infant Isaac Lopez is cut with English words (cat. 4) and also records the Hebrew year of his death beneath the winged seraph decorating the slab.

By the eve of the Revolution there were perhaps as many as a thousand Jews in all the colonies. (In 1790, the first national census recorded approximately four million inhabitants in the United States.) The greatest number lived in Charleston, New York and Newport, where religious tolerance gave rise to sizable Jewish communities, and thus made synagogues possible. The urban populations of these three seaports patronized skilled Jewish craftsmen and ensured the interests of Jewish merchants. Smaller groups, however, were established in Philadelphia and Lancaster, and there were also a few Jewish settlers in Virginia and Georgia, with fewer still in the other colonies.

Some of New York's leading Jewish families continued the custom begun by the Frankses and Levys by commissioning portraits from little-taught painters while others patronized academic artists such as Gilbert Stuart and Thomas Sully. A miniature of Gershom Mendes Seixas (cat. 9), the first American-born leader of Shearith Israel, represents one example of the ongoing interest shown by New York families in preserving their likenesses.

One of the few pieces of folk art that has survived as the work of a member of the early Jewish community is a rare sampler worked by Elizabeth Judah in 1771. Elizabeth was eight when she stitched her sampler which incorporates the Decalogue into its design. At eighteen she married the American fur-trader Chapman Andrew. She was widowed two years later, and in 1787 married Moses Myers of New York. The couple eventually settled in Norfolk, Virginia, where their twelve children were born.

When the British captured New York during the Revolution, patriot members of the New York Jewish community followed Gershom Mendes Seixas to exile in Philadelphia, where Haym Salomon gained prominence in helping to finance the American cause. Most of the community returned to New York after the departure of the British in 1783.

By 1787 there were six Jewish congregations in the newly formed United States. A generation later, the American Jewish population had swelled to almost six times the size it had been at the start of the Revolution. The increase was chiefly due to an influx of immigrants who fled European oppression following in the wake of Napoleon's defeat at Waterloo. The new arrivals, unlike the earlier Spanish – Portuguese refugees, were mostly Jews from Western and Central Europe.

Two portraits by Charles Peale Polk, the nephew of Charles Willson Peale, demonstrate the continuing patronage of local portraitists by Jews. The first portrait depicts Barnard Gratz (cat. 13), a merchant and investor, who became the first president of Philadelphia's Congregation Mikveh Israel. Later he participated in the opening of the Western Frontier. His portrait, and the one depicting Shinah Solomon Etting (cat. 12), wife of Elijah Etting of Pennsylvania, were painted by the artist in the first half of the 1790s.

Two works, both by Isaac Nunez Cardozo, represent early American examples of decorated pen-and-ink work by a Jewish calligrapher. Executed more than twenty years apart, the earlier (cat. 14) is a genealogy of the Beals-Wilkerson family penned in Boston in 1795. The record of the marriage and children of Samuel Beals and Rebeckah Wilkerson is decorated with sketches of Noah's Ark and a tent at Sinai, as well as other symbols from Masonic iconography. Samuel Beals was listed as a member of the Rising States Masonic Lodge of Boston in 1794.

The later Cardozo work (cat. 24), an illuminated text of the Ten Commandments (a theme already familiar from Elizabeth Judah's sampler), in both Hebrew and English, was created in Easton, Pennsylvania. A slightly earlier work of this kind is a marriage contract (ketubbah) in Aramaic and Hebrew, which was executed by an unknown scribe in Charleston, South Carolina, in 1814 (cat. 23).

Samplers – and, later, watercolors, pinprick pictures, theorems, and paintings on velvet – were worked by young women in every part of the new republic. They were taught needlework at home and at the girls' schools that many of them attended. A representative example in this genre is the silk-embroidered sampler by Rachel Seixas (cat. 29). A grandniece of Gershom Mendes Seixas (and the daughter of another hazzan of Shearith Israel, Isaac B. Seixas, and his wife, Rebecca Judah), Rachel was a member of the old New York Jewish community. Embroidered in about 1830, and

embellished with bouquets and sprays of flowers, her sampler bears a verse extolling the moral value of "Religion, Modesty and Truth."

Three quilts, from Pennsylvania, Maryland, and New York are in the tradition of contemporary examples made by Christian quiltmakers of the Central states. The one from Pennsylvania, an "album" quilt, is the work of Katie Friedman Reiter and her mother, Liebe Gross Friedman, and memorializes the deaths of their respective sons in 1891 (cat. 58). The Maryland example (cat. 37), also an "album" quilt, is by an unknown maker, and includes motifs traditionally thought to represent objects associated with the Jewish wedding ceremony incorporated into its design. The other, a late-19th-century New York quilt, is of pieced satin and velvet (cat. 54 and plate 1). It is unusual in that it was made by a man, Adolph Schermer; its construction is similar to pieced table-covers made from printed-silk cigar-band advertisements. One of the squares features a crude American flag worked in chainstitch, overlaying a larger pieced Star of David.

Several early-19th-century portraits of members of the New York Jewish community represent a style typical of the heyday of the untutored or little-taught painters who prospered in the first years of the Republic. One of the most charming examples is a double portrait of Mary Jane Solomons and her brother, Adolphus Simeon Solomons (cat. 28), children of John and Julia Levy Solomons. It was painted in 1828 by an unidentified artist. The boy grew up to be a philanthropist, a member of Shearith Israel, and the founder of a number of Jewish organizations; he was also instrumental in the establishment of the American Red Cross.

A delightful full-length portrait of a girl with a basket of cherries (cat. 30) is attributed to Micah Williams, an artist who worked in pastel and, less frequently, in oil (as in this case), in New Jersey, New York, and Connecticut. The subject is thought to depict a Jewish child who perished in the New York cholera epidemic of 1832. The Jewish merchant Simon Content of New York and his Christian wife, Angelina Pike Content (cats. 31 and 32), were painted by John Bradley, an artist believed to have been of British origin. Bradley appeared in New York and painted a number of portraits of Staten Island and Manhattan residents in the early 1830s. He disappeared from view after 1847. Content, in his top hat, recalls the fashion among 19th-century Jewish men of wearing this type of headgear in the synagogue; he is the only known Jewish subject by this artist.

Many silhouette portraits of illustrious Jews by known and unknown makers demonstrate the popularity of these images. Among the earliest examples in this medium are the profiles of Solomon Etting (cat. 19), a leader in the small Jewish community of

Baltimore in the first half of the 19th century, and his wife, Rachel Gratz Etting (cat. 20). The portraits were cut at Peale's Museum in Philadelphia around 1810. The double portrait of Rabbi Isaac Mayer Wise of Albany, New York – identified as "The Moses of America" – and his wife (cat. 39), and one depicting Samuel Myer Isaacs (cat. 33) of New York, appear to be by the same artist. Isaacs was the hazzan of B'nai Jeshurun in 1839 (the date inscribed on the work). Other inscriptions further identify him as a "Father of the 'Old Jewish School,'" founder of The Jewish Messenger, and one of the founders of Mt. Sinai Hospital, as well as the "Esteemed friend of Sir Moses Montefiore." Silhouettes of the Kursheedt family (cat. 34) were cut by Augustin A. C. F. Edouart in New York in 1840. Unlike many of the popular silhouettist's conversation pieces, this one lacks a drawn background. Although the figures are set against plain paper, the ages and names of family members are indicated.

Ritual objects associated with Judaic observance provided an opportunity for virtuoso needlework by both Jewish men and women. In 1851–52, an unidentified maker embroidered a hallah cover (cat. 40 and plate 6) in gold metallic thread on silk brocade, incorporating into its design an American eagle and the national motto, E Pluribus Unum, as well as a Star of David and a Sabbath blessing in Hebrew. A silk satin bag for a prayer shawl from 1874 (cat. 50), embroidered with vines, a rose wreath, and the Hebrew inscription "Isaac" was made by Charity Solis-Cohen of Philadelphia.

Great changes were taking place in the mid-19th century as the influence of the Ashkenazim in Jewish communities increased. These years witnessed the swelling of Jewish migration from Germany, a flood unleashed by the suppression of the German and Hungarian revolutions of the late 1840s. By 1850, the Jewish population of the United States soared to about 50,000. Most of these newer immigrants flocked to cities with large Jewish communities; and the number of congregations in the United States increased to seventy-seven.

The philanthropic and educational roles of the synagogue were supplemented by independent mutual-aid and fraternal societies, even as some individuals were changing religious observance both in the synagogue and at home. Several Jews were prominent in the Abolitionist movement, and thousands from old established families, as well as new arrivals, joined either the Union or Confederate cause during the Civil War, serving in the army or volunteering for hospital and charitable work behind the lines.

Among other newcomers from Central Europe were German immigrants belonging to Christian pietist sects, who thronged to Pennsylvania (well over a century before the German Jews) seeking new oppor-

tunities and freedom from religious oppression. There, professional scribes created illuminated family records for these farmers. A work by one of the illuminators, identified only as the Mount Pleasant Artist, is a decorative marker for the eastern wall of a house, or *mizrah* (cat. 26), inscribed in Hebrew above a stylized drawing of a menorah. Several other examples showing the use of Jewish symbols within the Christian framework of Pennsylvania-German folk art suggest acceptance of German Jews in the state founded by the Quaker William Penn, and ties between immigrants of differing religious beliefs. A printed Berks County birth and baptismal certificate (cat. 43) for Adam Alfred Georg was inscribed by one Martin Wetzler in 1860. The maker possibly identifies himself as a Jewish scrivener in the Star of David that divides the Hebrew lettering of his first and last names written both in German Gothic and Hebrew lettering. A cutwork *mizrah* (cat. 49), complete with lions of Judah and menorah, combined with the familiar hearts and drawn ornaments typical of Pennsylvania-German folk art, is the work of Joseph A. Michael.

By the last decades of the 19th century, some who formed part of the mid-century German–Jewish migration had established themselves as manufacturers and processors in the garment trade. It was that industry that gave employment to many of the workers who came with the great East European immigration from the 1880s to the early 1920s. The chief impetus that inspired the first mass exodus which uprooted families and entire villages in Russia and Russian-dominated Poland was the bloody pogroms that took place after 1881. The arrival of these millions altered the Jewish census count from about 300,000 in 1878 to three million by 1914.

Many of the East European newcomers were poor, and networks of relatives and organizations like the Hebrew Immigrant Aid Society helped relieve the situation of these people, most of whom were absorbed into the sweatshops and overcrowded tenements of New York's Lower East Side and other major American cities.

The furnishing of small synagogues with decorative pieces and ritual objects reflecting East European designs became a transplanted tradition in urban centers, where the new immigrants lived, worked, and worshiped. Six tin Hanukkah lamps demonstrate how a simple, cheap, and easily worked material might be used in ritual objects made for the home (cats. 67–72). A carved and gilded eagle and crown from a Torah Ark from upstate New York (cat. 105), and a similarly finished pair of wooden lions from Kansas City, Missouri (cat. 73), were made as synagogue decorations. The latter piece dates from the turn of the century, when a number of Jewish artisans were employed in New York woodworking establish-

ments, where crafting figures for shop signs, circus wagons, and carousels were the most frequently commissioned items. Lithuanian-born Marcus Charles Illions of Brooklyn is one of those Jewish woodcarvers who produced these figures (cat. 83) as well as synagogue decorations (cat. 84). It was in the cigarmaking industry that the first trade unions organized by Jewish labor leaders developed, and it was thus singularly appropriate that some of the figures made by Jewish artisans stood in front of shops where cigars were sold.

Register books, the *pinkasim* of Eastern Europe, were decorated in colorful and traditional designs. American examples include one from the Chicago congregation, Ohavei Shalom Mariampol (cat. 93A), another from the Russell Street Synagogue in Boston (cat. 86), and a pair from a Philadelphia congregation, Atereth Israel (cats. 82, 89). The latter, illuminated by Benjamin J. Wexlar, features extraordinary side columns of Northwest Indian totem poles. Even more exotic is the walrus tusk engraved with the portraits of a Jewish couple, possibly by an Eskimo. A Hebrew New Year's greeting is inscribed on it, as well as its city of origin, *Nome, Alaska,* in English (cat. 87).

Four *mizrahim,* or decorations for the eastern wall of a home or synagogue, continued the tradition brought to America by East European Jews, much in the same way as Germanic folk designs had been treated in Pennsylvania by Christian immigrants a century or so earlier. One (cat. 55) is a very crude cutwork and watercolor design on paper made by Joseph Hochfelder in the late 1880s, featuring double lions and strange winged creatures. An 1888 example (cat. 56) is actually a family record made by Joseph Selig Glick; it is decorated in richly colored designs and was–by family tradition–apparently used as a *mizrah,* although the inscription includes memorials and records of births and marriage. Two by Selig A. Goldsmith (cats. 61, 62) were executed more than a decade apart, in 1896 and before 1909. The earlier version, made in Denison, Texas, includes imaginary profile portraits of the progenitors of the twelve tribes of Israel along with numerous watercolor vignettes. The later version is incomplete; unfinished, according to the maker's note on the reverse, because he was at first too discouraged, and then too involved in community affairs to complete the piece.

As Pennsylvania-German illuminated records occasionally reflect the influence and attributes of the new country, so the Jewish newcomers—perhaps more frequently—included specifically American symbols in their creations. Examples of this blend of cultures are seen in the 1869 Torah binder (cat. 48), in which a Hebrew letter is decorated with the stars and stripes, and—even more amusingly—in a book made by Morris Weinberg of Chicago, where the title page of his "Psalms of King David Written by Hand" is

illuminated with an American flag (cat. 90). One of the psalms is illustrated with depictions of musical instruments: a lyre, shepherd's pipe, shofar—and gramophone!

A variety of embroideries reveals the continuance of East European custom in the New World. Here, however, American history intrudes upon and transforms Old World tradition. One example, by an artist who crafted a small-scale scroll and cover, celebrates American history, and was made to honor the one-hundredth anniversary of "The Star-Spangled Banner" (cat. 92). An American flag decorates the covering of the parchment scroll.

A 1927 Torah binder (cat. 104) commemorating the birth of Werner Willie Wolf Frank bears an iconographic reference to Lindbergh's flight on May 20 and 21 of that year. It is one of the more unusual Torah binders made from circumcision swaddling cloths.

Among the most recent examples by Jewish folk artists in America are four works on religious themes by three artists. The two earliest are the work of the celebrated naïve painter, Morris Hirshfield, who began painting late in life. Most of his works reveal an exquisite attention to texture and detail, reminding some critics of his profession in the needle trades. Both *Moses and Aaron* and *Daniel in the Lion's Den* (cat. 117 and plate 12, cat. 118) date from 1944; they

are naïve, colorful interpretations of important biblical figures. Meichel Pressman's *The Seder* (cat. 124) of 1950 is a work strongly reminiscent of 19th-century Pennsylvania-German compositions by fraktur artists, while Desider Lustig's *The Sabbath Table* (cat. 128) is a colorful composition that crowds a myriad of fascinating details into one naïve and charming genre painting.

The pattern, and there appears to be one, in this outpouring of paintings and objects for and by American Jews from the early years of the 18th century to the present, in some ways follows their history in this country. In combining the symbols and ideas of their new nation with the design tradition of their cultural origin, Jews were following a pattern set by non-Jewish artists who immigrated here: most notably, in objects for religious observance and pictorial works.

The Russian and Polish Jews who came here in the last decades of the 19th century—and who continued to arrive until the punitive immigration legislation passed in 1924—brought with them new and different design elements that enriched the existing American tradition. From the mid- to the late-20th century, Jewish artists in America have participated in a fresh burst of folk art creativity, engendered, it appears, by the revival of interest in the creations of self-taught painters and sculptors of our nation's earlier history.

The Synagogue Lions (cat. 97) are part of the Torah ark from
the former Congregation Shaarei Eli in Philadelphia.
Photograph by Stephen Hebden.

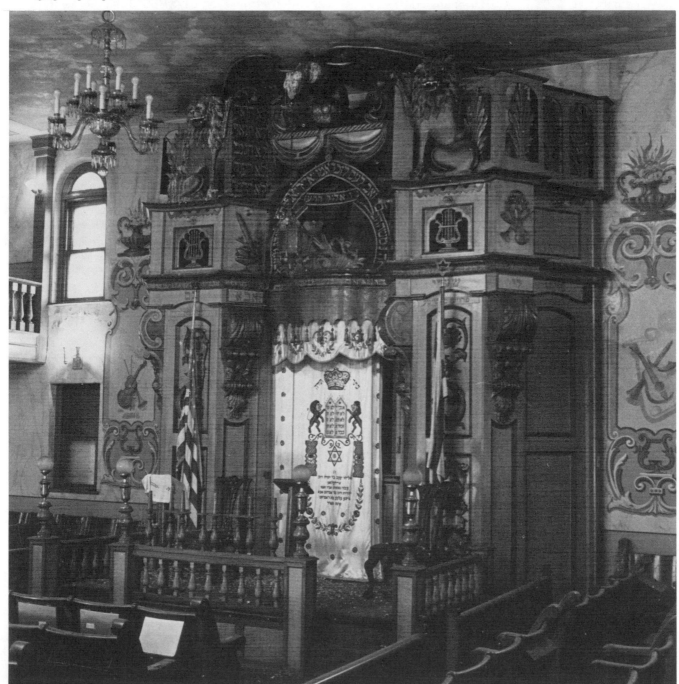

Jewish Folk Art In America: Traditional Forms and Cultural Adaptation

Norman L. Kleeblatt
Gerard C. Wertkin

*T*he *Jewish Heritage in American Folk Art* is an exhibition that breaks new ground; and it should, it is hoped, contribute to the ongoing academic dialogue concerning the essential nature of American folk art. Alan Jabbour, director of the American Folklife Center of the Library of Congress, recently observed that current assumptions about our nation's folk art might well be clarified by a consideration of the traditional materials represented in *The Precious Legacy: Judaic Treasures from the Czechoslovak State Collections,* an exhibition that first brought to the attention of many Americans the rich heritage of Central European Jewish folk art.[1]

One of the major purposes of *The Jewish Heritage in American Folk Art* is to shed further light on the subject by introducing the story of Jewish folk art in North America, and also to correct misconceptions clouding existing literature as the result of omission and erroneous generalization.

In her essay in this catalogue, Mary Black discusses the manner in which the early years of the American Jewish experience may be observed through family portraits by folk artists and silhouettists, as well as by samplers and quilts, all of which represent familiar forms of our arts and crafts. But, as she states, there is little of specifically Jewish content in these early works. Even though they may provide intimate glimpses of the manner in which a small new community acclimatized itself to the American environment, they offer little documentation pertaining to the lives of members of the community as Jews. To be sure, Hebrew may be found on a sampler (cat. 21), a quilt may contain an iconographic element that family tra-

dition associates with the Jewish wedding canopy and *kiddush* cup (cat. 37), and some silhouettes may provide evocative images of early religious and civic leaders (cats. 18, 20, 33, 39), but the surviving body of material is scant; a fact that is perhaps only logical, given the small size and limited scope of the newly formed community.

Lacking the strength of numbers, Jewish settlers and their families in New York and Newport, Philadelphia and Lancaster, Savannah and Charleston, tended to assimilate the cultural patterns of the majority of the local populations. Having been uprooted from ancestral homes on the Iberian Peninsula in the late 15th century, and having moved in succeeding generations to Holland, England, Brazil, or the West Indies before settling in North America, these early Sephardic settlers, and the Ashkenazim who followed almost immediately, brought with them few indigenous artistic traditions. Of necessity, whatever ritual objects they required here had to be commissioned from colonial artisans, or imported from communities overseas. An exception to this can be found in the work of the important New York silversmith, Myer Myers (1723–95), who wrought silver articles for the colonial synagogues, and who also undertook work commissioned by churches and private clients, including the Jewish Franks and Gratz families. "Elegant in their execution," Myers's silverware often followed "the form and decorative scheme of English models," and must properly be considered in the history of the decorative arts in America.[2] He and other Jewish silversmiths of the colonial period were not folk artisans; the very nature of their

1. *Library of Congress Information Bulletin* 43, no. 7 (February 13, 1984): 40. The exhibition was organized by the Smithsonian Institution Traveling Exhibition Service in 1984.

2. Joseph Gutmann, "Jewish Participation in the Visual Arts of Eighteenth and Nineteenth-Century America," *American Jewish Archives* 15 (April 1963): 23.

medium and the design traditions associated with it lie outside the scope of folk art. Insofar as religious architecture is concerned, the design of colonial synagogues was entrusted to such non-Jews as Peter Harrison (1716–75), who designed Newport's Touro Synagogue (dedicated in 1763). While conforming to the requirements of the faith, the outward appearance of such structures was no different than that of other public buildings in colonial America. (Interestingly, in 1828, Benjamin Howland, a Newport city clerk, was commissioned to paint a representation of the Ten Commandments on canvas. This was placed above the synagogue's Ark, where it can be seen today. Howland's Hebrew may have been faulty, but his colorful Decalogue with its columns, arch, and crown is in keeping with traditional Jewish synagogue decoration.)[3]

As Abram Kanof has observed, "the circumstances of Jewish history and the character of folk art coincide. Unselfconscious and primitive in nature, for all its charm, folk art is essentially a village development, largely unaffected by any surrounding sophistication...."[4] Of course, Kanof is referring to the substantial folk-art traditions of European "village" Jewry. Employing Kanof's yardstick, however, it may not be surprising that little folk art from Jewish hands was produced in the early years of Jewish settlement in North America, in view of the urban nature of that settlement. Residing in important ports and commercial centers, the early Jews in this country were upwardly mobile, and while many persevered in the faith—thus ensuring the uninterrupted survival of such institutions as the Shearith Israel congregation in New York—others married into Christian families and became lost to Judaism. In the larger cities, too, a cosmopolitan outlook obtained; by contrast, American folk art developed in the smaller, more isolated cities and in the towns and rural areas, where fewer Jews resided.

Those objects that have survived from the period are more in the area of the domestic arts, such as the working of samplers, that were cultivated among the rising mercantile classes and gentry in the cities in which Jewish communities were located. In the letters of Abigail Franks—the matriarch of an important 18th-century New York Jewish family—for example, there are references to the instruction of her son, Moses, in the art of painting on glass by William Burgis, the

noted American lithographer; and her daughter, Phila, in plainwork, flourishing (a type of floral or figural ornamentation), embroidery, and quilting.[5] As many of America's earliest Jewish settlers resolutely maintained their religious identity in the face of the welcoming, democratic tendencies of a society more open than that of Europe, they also participated fully in the genteel artistic pursuits of their neighbors. Their religion may have been that of Israel, but their cultural expression was that of the American majority.

The lack of distinctive Jewish folk-art forms in the colonial period and in the first years of independence was also the result of a confluence of historical circumstances. The truly authentic Jewish folk-art heritage—rich and multifaceted—did not reach North America until the arrival of large numbers of Jewish immigrants in the mid-19th century. These new immigrants brought with them cultural traditions and artistic conventions that were firmly rooted in the faith of Israel. At first glance, such a statement might seem ironic, because the Jewish faith generally has been considered to be iconoclastic and ambivalent to the visual arts. Although it is incorrect to suggest that Judaism has abjured the use of figurative representation, rabbinic interpretation of the Second Commandment has in various times and places limited the iconographic repertoire available to the Jewish folk artist. However, it also provided a challenge to discover an acceptable iconography in scripture, rabbinical lore, and popular wisdom. This permitted the development of a distinctive body of materials that were available to craftsmen and artisans. While folk art in general tends toward abstraction and two-dimensionality, within Jewish folk art these conventions have a religious base, and thus permit the artist to transfer imagery from the real world and move it into the realm of symbols. It has been noted that the floral motifs and animals of Jewish folk art "do not distinguish themselves by their pronounced physical structure, their naturalistic appearance or physical material characteristics. In the main they are spiritual, symbolic and abstract creatures. They do not draw from the woods or fields but from legends... and folklore."[6] The 20th-century artist El Lissitzky thought he saw in the murals of the wooden synagogue at Mohilev thinly disguised human figures. "Behind the masks of four-legged animals and winged birds," he wrote, "there are the eyes of human beings."[7]

3. Rabbi Dr. Theodore Lewis, "History of Touro Synagogue," *Newport History: Bulletin of the Newport Historical Society* 48, part 3, no. 159 (Summer 1975): 286, 287, 302.

4. Abram Kanof, *Jewish Ceremonial Art and Religious Observance* (New York: Abrams, 1969): 41.

5. Leo Hershkowitz and Isidore S. Meyer (eds.), *The Lee Max Friedman Collection of American Jewish Colonial Correspondence: Letters of the Franks Family (1733–1748)* (Waltham, Mass.: American Jewish Historical Society, 1968): 3, 4, 13, 48.

6. Yekhezkel Dobrushin as quoted in Avram Kampf, "In Quest of the Jewish Style in the Era of the Russian Revolution," *Journal of Jewish Art* 5 (1978): 61.

All discussion of Jewish folk art must ultimately confront the religious basis of Jewish life. Although not all Jewish folk art is associated with ritual or ceremonial practices, almost all of it embodies religious content. "Folk art emerges to a great extent from the functional necessities of life—house, furnishings, tools—and its chief events—birth, marriage, death. . . . [I]t is motivated by the pious determination to provide these with the appurtenances of religious observance."[8] Indeed, there is perhaps no religious system in the Western world in which objects play such an important and distinctive role as in Judaism. The performance of ritual acts may be symbolic of less tangible religious motives, but these motives are objectified and hence brought into the natural world through objects; and without these objects the rendering of symbolic acts is impossible. In the Book of Exodus, Chapter 15, verse 2, Moses and the Children of Israel sing, "The Lord is my strength and song and He is become my salvation. This is my God and I will adorn Him."[9] A summary of the rabbinical exegesis of this verse indicates that "every religious act must be done in the handsomest way."[10] In other words, ritual objects are to be beautiful; thus, God Himself may be adorned metaphorically. In Judaism there must be a tangible and literal modus to render the abstract religious idea real; or, conversely, to bring the real world into contact with the divine, to sanctify daily life.

Beginning in the 1840s, the second major wave of Jewish immigration to America was composed chiefly of Ashkenazic Jews from Germany and Central Europe. As itinerant peddlers and merchants, these people soon dispersed throughout the United States. Unlike their earlier coreligionists, these Jews brought from their homes in Europe a variety of folk-art forms, of which one of the most distinctive is the Torah binder, also known as the *wimpel.* The origin and use of this ritual object has been carefully documented by Barbara Kirshenblatt-Gimblett, who sees it as a nexus between the rite of circumcision—by which a male child is entered into the covenant of Abraham—and the Torah, the central object in Jewish worship.[11] In the Torah binder, "there are multiple images of beginnings and endings within the life of the individual, the community and the universe."[12] (See cats. 48, 57, 104.)

Although the restrictions of European craft guilds imposed limitations on Jewish artisanship, the Ashkenazic Jews of Central Europe also brought to these shores a unique Jewish design vocabulary as well as skills in woodcarving and in the art of embroidery and other needlecrafts. They soon created stable communities, which included synagogues and charitable and fraternal organizations, in which these cultural idioms could be given form. For the first time in the history of the Jewish settlement in North America, the design of houses of worship and the decoration of their interiors, the making of ceremonial objects, and the other needs of congregational and domestic Jewish life could be accomplished here, and far less reliance was placed upon obtaining such objects from the older established communities abroad or from local non-Jewish sources.

In terms of sheer numbers, the most important wave of Jewish immigration to the United States was composed of the hundreds of thousands who fled the tribulations they suffered in Eastern Europe—Poland, Russia, Lithuania, and Romania. With their arrival (beginning in large numbers in the 1880s), a whole variety of imported Jewish folk-art traditions began to appear on the American scene.

Franz Landsberger has noted that the East European Jews lived in sharply segregated settlements and could thus regulate their own lives with a certain amount of independence, which thus permitted craftsmen free rein in the practice of their arts.[13] Among the handicrafts specifically associated with East European Jewry were ceramicware (including commemorative plates and candlesticks), weaving—especially a unique form of ceremonial weaving called *spanier*-work—and lacemaking. Giza Frankel notes that in Europe the products by Jewish artisans also found a market among the local Christian population. "The Jews therefore participated in the creation and/or development of certain branches of Polish folk art."[14] Richly ornamented and decorated synagogues could be found in villages through much of Poland, Lithuania, and White Russia. These intricately carved and

11. Barbara Kirshenblatt-Gimblett, "The Cut That Binds: The Western Ashkenazic Torah Binder as Nexus Between Circumcision and Torah," in Victor Turner (ed.), *Celebration: Studies in Festivity and Ritual* (Washington, D.C.: Smithsonian Institution Press, 1982): 136–46.

12. *Ibid.*

13. Franz Landsberger, "The Jewish Artist before the Time of Emancipation," *Hebrew Union College Annual* 16 (1941): 389.

14. Giza Frankel, "Little Known Handicrafts of Polish Jews in the Nineteenth and Twentieth Centuries," *Journal of Jewish Art* 2 (1975): 42.

7. Avram Kampf, "In Quest of the Jewish Style in the Era of the Russian Revolution," *Journal of Jewish Art* 5 (1978): 53.

8. Kanof, *op. cit.*: 42.

9. The Hebrew is also given as "exalt" or "beautify," but the rabbinical exegesis is the same.

10. Rabbi Solomon Ganzfried, *Code of Jewish Law,* rev. ed., Vol. 1 (New York: Hebrew Publishing Company, 1927): 19.

painted structures must have made lasting impressions; the design motifs of their carvings and murals may be found repeated in many forms of folk art created by East European Jews in America. As Kanof observes, the folk art of East European Jewry comprised a large and important body of work, but the "exigencies of Jewish history" have left but a minimal sampling.[15] Fortunately, there are many extant descriptions of the folk art associated with the wooden synagogues. A maze of pillars, tendrils, animals, carved candelabra, and other Judaic symbols in openwork, "which represent true masterpieces of carving," would greet the visitor.[16] Woodcarving was not the only type of East European folk sculpture; a well-developed tradition in tombstone design also existed.[17] Several wooden synagogues in Eastern Europe were also notable for extensive murals and painted friezes incorporating imagery inspired by biblical and other sources. Rachel Wischnitzer notes that itinerant artists were often involved in the building and decorating of these houses of worship, and that their work was "thematically a mixture of peasant folklore and Biblical and medieval Jewish imagery . . . a provincial version of the Baroque style of the seventeenth and eighteenth centuries." The scrollwork, floral designs, cartouches, and animals of the synagogue murals can all be traced to the modish silk and damask fabrics that were in vogue for clothing, curtains, and furnishings at the court of Louis XIV in France, and which were subsequently copied by the Polish nobility.[18] A consideration of the carvings in such wooden synagogues as those of Izabielin and Suchowola and the murals in those of Mohilev and Odelsk, for example, is sufficient to demonstrate the importance of the source material present in such carvings and murals.[19] As they entered American life, East European Jews took inspiration not only from this traditional corpus of designs and motifs, but also demonstrated their profound love of their new country by incorporating uniquely American images within traditional Jewish forms.

Probably the best-known study on the folk culture of East European Jewry (which, as Mary Black points out in her essay in this catalogue, is the preponderant background of American Jewry) is *Life Is with People: The Culture of the Shtetl*, by Mark Zborowski and Elizabeth Herzog. Built upon research completed at Columbia University under Margaret Mead and Ruth

Benedict, this publication has been continuously in print for over thirty years. Based upon interviews with individuals living in the New York metropolitan area, the book contains a number of glaring errors, but it also provides some fascinating insights. Zborowski and Herzog have confounded the literature with the conclusion that "Jewish folk art is chiefly verbal." They write, "There is a rich lore of stories, songs, sayings, proverbs, but very little Jewish handicraft. . . . There is no equivalent of the peasant embroideries, or the elaborate paper cutouts made by the Poles[!]. The reason obviously does not lie in lack of manual facility, for the *shtetl* has produced many highly skilled craftsmen, goldsmiths, diamond cutters, and watchmakers. The free election of the folk, however, appears to be verbal or at least audial rather than visual or tactile. 'In the beginning was the Word,' [they quote rather inappropriately, from the Gospel According to St. John] and the word still leads all forms."[20]

If Zborowski and Herzog err on some points, their errors are mitigated by the great emphasis Judaism has placed on the word—written, spoken, and sung—in a manner that has a pervasive impact upon the folklore of the people. As many of the objects in this exhibition demonstrate, the word, decorated and adorned, lies at the very heart of Jewish folk arts. *Soferim*, or scribes, have cultivated Hebrew script in "an unbroken tradition through the continuous writing of Torah scrolls. The geometric character of the Hebrew letter is preserved; there is an emphasis on two-dimensionality and a recognition of the importance of words. The letter is distinguished by the great variability of its vertical and horizontal components. They can be expanded or shortened, thinned or thickened, according to the will of the artist. The distinguishing quality of the Hebrew letter is in its simplicity, reserve and completeness."[21] In this respect the Jewish approach may also be seen mirrored in the folk arts of such Protestant groups as the Pennsylvania Germans, for whom the decorated words of biblical and pious verses are an important element of folk expression. Although the traditional thematic materials available to Lutheran and Reformed penmen may be broader than that of Jewish folk imagery, continental Protestantism shares the resistance to literal or figural representation that has marked some periods of Jewish history.

15. Kanof, *op. cit.*: 43.

16. Landsberger, *op. cit.*: 393.

17. *Ibid.*, 396.

18. Rachel Wischnitzer, *The Architecture of the European Synagogue* (Philadelphia: Jewish Publication Society of America, 1964): 144.

19. *Ibid.*, 133, 134, 135, 140, 142.

20. Mark Zborowski and Elizabeth Herzog, *Life Is with People: The Culture of the Shtetl* (New York: Schocken, 1952): 364.

21. Kampf, *op. cit.*: 61–62.

22. Giza Frankel, "Jewish Paper-Cuts," *Polska Sztuka Ludowa* 3 (1965): 135–46, 178 (English summary).

Among the many unique East European traditions revealing a strong emphasis on the decorated word, is the *pinkas,* or register book. The *pinkas* not only is a key to the communal, congregational, and organizational life of East European Jewry, but frequently represents a fine example of folk art itself. *Pinkasim* typically contain the articles of the association, its rules and regulations, lists of its members and officers, and minutes of the proceedings of the *shtetl* organization; but the title page, section or paragraph headings, and page margins are often ornamented with scrollwork, floral motifs, fanciful folk figures of animals or zodiacal signs, and fine Hebrew lettering, which, not infrequently, were the work of a scribe. Early European examples are often bound in leather with parchment pages, but American *pinkasim* are more commonly inscribed in commercially manufactured blank journals or account books purchased from stationers. (See cats. 86, 89.)

Notwithstanding Zborowski's and Herzog's erroneous conclusion, the art of papercutting was widely practiced among the Jews of Eastern Europe, and has been continued by their descendants in the United States. According to the view expressed by Giza Frankel, whose study of this Jewish folk art spanned five decades, the paper-cuts were made by men and by schoolboys,[22] but Weinreich records the childhood memories of one woman who recalled learning the art as a girl.[23] Frankel believed the art to be of ancient origin; possibly derived from Far Eastern shadow plays and puppets.[24] Most surviving Jewish paper-cuts date from the late 19th and early 20th century. The designs can be extremely intricate, and many incorporate the same basic iconography employed in other forms of Jewish folk art, such as flowers, animals, crowns, stars, and Hebrew inscriptions; typical images include the Tree of Life, architectural motifs often based on descriptions of Solomon's Temple, the Decalogue, and the Star of David. (See cats. 95, 98, 99.) Paper-cuts can even be combined with different forms; for instance, a pen-and-ink *mizrah* embellished with watercolor ornamentation might also include paper-cut elements as part of its overall design. Special cutouts were associated with Shavuot, the holiday celebrating the giving of the Torah to Moses on Mount Sinai. Frankel finds a relationship between Jewish paper-cuts and the Polish version of this folk-art form.[25]

In an illuminating discussion of Jewish textiles—which may serve as a model for a consideration of folk art in general—Barbara Kirshenblatt-Gimblett notes the traditional distinction between *folk* and *professional* production, "generally on the basis of subjective evaluation of the quality of the work and the degree of sophistication, naivete or primitiveness." She encourages, instead, a consideration of the varying "repertoires of techniques and forms used by professionals as opposed to folk artisans," as well as the differing methods by which patterns and models have been transmitted, the organization of production, and the standards of interpretation within the community itself.[26] As useful as such methodology is, distinctions between "folk" and "professional" artisanship in the context of Jewish handicrafts are often unclear. The art of the scribe is practiced in a professional setting; yet those family records and memorials produced by scribes that utilize stylized folk imagery and traditional decoration are clearly forms of folk art. Distinctions based solely on the ends served in production—sale, as opposed to home consumption—are untenable in the context of American folk art and seem problematic, as well, when considering Jewish traditional arts.

The fact that much Jewish ceremonial art tends to employ a well-known body of traditional motifs in ways hallowed by custom; that it is transmitted within the community, even where its producers may have been non-Jews; that it is conservative in application, accepting change and influence from outside the group only slowly and with considerable reserve; and that it speaks in a design vocabulary well-understood by both makers and users, would seem to place it in the category of "folk art" (as that term is understood by American folk-art historians), regardless of the professionalism of the maker.

This application may be seen in connection with carved figures used as shop signs or trade symbols, on circus or carnival wagons, and for carousels and amusement parks—an area of American folk art in which Jews have been widely represented (although some academicians may object to the classification of such commercially produced works as "folk art"). Yet even in workshops such as that of Marcus Charles Illions (cat. 83), there was a large degree of individual craftsmanship and hand-finishing lavished on the traditional repertoire of forms. The contribution made by Jewish craftsmen in the creation of carved and

23. Uriel Weinreich, "Paper Cutouts from Eastern Galicia," *Yidishe Folklor,* January 1954: 12.

24. Frankel, "Jewish Paper-Cuts," *op. cit.*

25. *Ibid.*

26. Barbara Kirshenblatt-Gimblett, "Introduction," *Fabric of Jewish Life: Textiles from The Jewish Museum Collection* (New York: The Jewish Museum, under the auspices of The Jewish Theological Seminary of America, 1977): 37, 38.

painted shop and amusement figures, such as cigar-store Indians and carousel animals, provides an interesting subchapter in both the history of American folk art and of Jewish creativity in the New World. While this aspect of folk sculpture is not Jewish in origin, the woodworking traditions in which the Jews of Central and Eastern Europe had been schooled served them well when they practiced this craft in America.

As the years of the 20th century passed, many of the folk-art traditions brought to these shores by first-generation immigrants began to wane. That this first generation was as creative as this exhibition demonstrates may be surprising, in view of the generally accepted idea that the need for a newly arrived immigrant to earn a living to provide for his or her family made the continuation of such traditions difficult at best. What we have found, on the contrary, is a wealth of such material produced by these individuals. It is unfortunate, however, that far more has doubtless been destroyed than has survived. In Europe, it was the havoc of war and a destructive ideology that resulted in the loss of much Jewish folk art; in this country, sadly, the loss frequently has been a result of neglect. Old synagogues standing in areas encroached by urban blight are either closing down or have been abandoned, because the original neighborhood residents have died and the newer generation has moved into the suburbs of an affluent America.

27. See *Project Yerusha-Heritage,* a booklet describing the work of this organization directed by Eric Byron.

Thus, much of the heritage has been lost. To circumvent this, however, conservation projects – such as one involving the former synagogues on New York's Lower East Side, for example – have managed to rescue thousands of objects abandoned by defunct congregations, many of which represent fine examples of folk art.[27] One of the major contributions of this exhibition is to re-create that past for the benefit of a generation perhaps more responsive to its roots.

While many of the traditional art forms suffered a period of neglect, almost concurrently there has been a rebirth of interest in exploring Jewish themes through painting and sculpture. This trend may be seen not only in the work of untrained artists who took brush in hand late in their years, such as Morris Hirshfield (cats. 117, 118) and Meichel Pressman (cat. 124), but in the work of younger painters, such as Malcah Zeldis (cat. 127). There has also been a revival in the crafts tradition, and scores of accomplished craftspersons are again practicing the art of papercutting and of manuscript illumination. Additionally, new inspiration has come from the establishment of a Jewish state in Israel, and the arrival there of Jews with traditions not only from Europe but from the Near East, Asia, and Africa.

The Jewish Heritage in American Folk Art is presented with the hope that Americans will come to know the arts of the Jewish people as they have been practiced in our nation for over two centuries.

Catalogue of
the Exhibition

Entries prepared by
Jeanne Bornstein
Anita Friedman
Norman L. Kleeblatt
Irene Z. Schenck
Gerard C. Wertkin

1 (Plate 3)
Portrait of Moses Levy (1665–1728)
Attributed to Gerardus Duyckinck
New York, c. 1720–28
Oil on canvas
42½ x 33½"; 108 x 85.1 cm.
Museum of the City of New York

Moses Levy, German-born merchant, real-estate investor, and ship owner engaged in domestic and foreign trade, came to New York from England around 1695.[1] His business ventures included purveying food to the expeditionary forces against French Canada and shipping cocoa to London. One of the most prominent Jews in New York, he was elected constable of the South Ward in 1719, though he declined to serve, and held the office of president of Congregation Shearith Israel at the time of his death. In 1711, Levy was one of five Jews who contributed to a fund for building the Trinity Church steeple.

In this pair of life-size portraits, Moses Levy is depicted with his second wife, Grace Mears, whom he married in 1718.[2] Linked compositionally by the simultaneous gestures of their left hands, each pointing to their respective mates, the couple share, too, an aristocratic poise. A large sailing vessel, glimpsed through an open window at the right of the canvas, reflects the subject's vigorous mercantile interests, while the dog below his outstretched hand denotes the traditional symbol of marital fidelity.

This painting has been variously attributed to the artists Pieter Vanderlyn (c. 1687–1778) and Gerardus Duyckinck (1695–1746).[3]

A double portrait of Levy's grandchildren, David and Phila Franks, children of his daughter, Bilhah Abigail (Mrs. Jacob Franks), appears in this exhibition (cat. 3).

Notes: 1. Authorities disagree as to Levy's place of birth. Malcolm H. Stern (*First American Jewish Families*), and David de Sola Pool (*Portraits Etched in Stone*, Biography 6, 197–201) cite Germany. N. Taylor Phillips cites Spain in "The Levy and Seixas Families of Newport and New York," *American Jewish Historical Society Publications* (1894): 189–214. An almost identical portrait of Moses Levy, differing only in the cloud formations and number of ships viewed through the window, is in the collection of the American Jewish Historical Society in Waltham, Mass. 2. These portraits were bequeathed to the Museum by their descendant, Alphonse H. Kursheedt, who was the grandson of Israel Baer and Sarah Seixas Kursheedt (cat. 34). 3. James T. Flexner, "Pieter Vanderlyn, come home," *Antiques* 75, no. 6 (June 1959): 546–49, 580; Fraunces Tavern Museum, *The Jewish Community in Early New York, 1654–1800*, exhibition catalogue (New York, 1979). In her essay in this catalogue, Mary Black attributes the painting to Gerardus Duyckinck. He has also been suggested by Waldron P. Belknap, Jr., as the portraitist of Levy's wife (Grace Mears) and daughter, Bilhah Abigail (Mrs. Jacob Franks). (See cat. 2, note 1.)

References: London, Hannah R. *Portraits of Jews by Gilbert Stuart and Other Early American Artists.* New York: Rudge, 1927: 7–16; ill. p. 91. Pool, David de Sola, and Tamar de Sola Pool, *An Old Faith in the New World; Portrait of Shearith Israel 1654–1954.* New York: Columbia University Press, 1955: 316, 480–81. Myer, John Walden. "Portraits of Mr. and Mrs. Levy." *Museum of the City of New York Bulletin* 3, no. 1 (November 1939): 8–9. Lebeson, Anita Libman. *Pilgrim People.* New York: Minerva Press, 1975: 68–69. Kayser, Stephen S., and Isidore S. Meyer. *Early American Jewish Portraiture.* Exhibition Catalogue. New York: The Jewish Museum, 1952: 7–8, 16.

2 (Plate 4)
Portrait of Grace Mears Levy (Mrs. Moses Levy) (1694–1740)
Attributed to Gerardus Duyckinck
New York, c. 1720–28
Oil on canvas
44 x 35"; 111.8 x 89 cm.
Museum of the City of New York

Possibly commissioned to celebrate her wedding, this portrait depicts Mrs. Levy between the ages of twenty-six and thirty-four. Grace Mears, born in Jamaica, British West Indies, of English parentage, married Moses Levy, who was almost thirty years her senior, in London in 1718. Widowed in 1728 with twelve children (seven of her own and five stepchildren), the indomitable Mrs. Levy subsequently opened a retail shop to help support her family. In 1735 she married David Hays of New York.

American portraitists of the eighteenth century frequently employed English prints as models for their compositions. The prototype for this painting is demonstrably the mezzotint of the *Countess of Ranelagh* of 1699, engraved by John Smith after the painting by Sir Godfrey Kneller.[1] Posed outdoors, Grace Mears is seated in front of a huge brown rock, with a romantic view of supple trees and a patch of sky visible to the left. The vivid contrast of the whiteness of her skin against her long, dark hair, gracefully falling along her right shoulder, heightens the pictorial appeal. Faithful to the print, no ornament has been permitted to detract attention from her fair complexion, the genteel gestures of her hands, and the complex folds of her dress.

The portrait has been problematically attributed to Gerardus Duyckinck by Waldron P. Belknap, Jr., and to Pieter Vanderlyn by James T. Flexner.[2]

A miniature of Mr. and Mrs. Levy's grandson Gershom Mendes Seixas appears in this exhibition (cat. 9).

Notes: 1. Charles Coleman Sellers, "Mezzotint Prototypes of Colonial Portraiture: A Survey Based on the Research of Waldron Phoenix Belknap, Jr.," *The Art Quarterly*, Winter 1957: 407 ff.; ills. 22 and 22A on p. 438. 2. *Ibid.*, 433, 460–62. James Thomas Flexner, "Pieter Vanderlyn, come home," *Antiques* 75, no. 6 (June 1959): 546–49, 580.

References: Rosenbloom, Joseph R. *A Biographical Dictionary of Early American Jews.* Lexington: University of Kentucky Press, 1960: 57, 94, 110. Myer, John Walden. "Portraits of Mr. and Mrs. Moses Levy." *Museum of the City of New York Bulletin* 3, no. 1 (November 1939), 8–9. Pool, David de Sola. *Portraits Etched in Stone.* New York: Columbia University Press, 1952: 225–26. Stern, Malcolm H. *First American Jewish Families: 600 Genealogies, 1654–1978.* Cincinnati: American Jewish Archives and Waltham, Mass.: American Jewish Historical Society, 1978: 190.

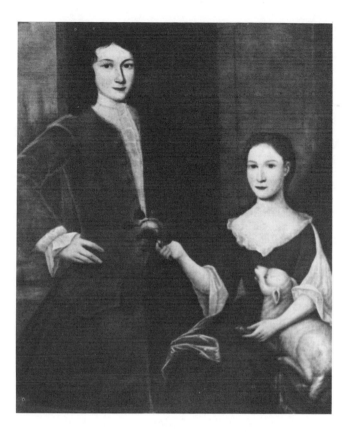

3

Portrait of David Franks (1720–93) **and Phila Franks**
(1722–1811)
Artist unknown
New York, c. 1735
Oil on canvas
44 x 35"; 118.8 x 89 cm.
American Jewish Historical Society, Waltham,
 Massachusetts

David and Phila Franks were children of the prominent
New York merchant Jacob Franks and Bilhah Abigail Levy,
daughter of Moses Levy.[1] Based in Philadelphia, David
enjoyed commercial and social success, engaging in land
speculation, shipping, fur trading, and purveying to the
British Army. In 1748 he was elected a member of the
provincial assembly. A Loyalist during the Revolutionary
War – though he had been a signer of the Non-Importation
Agreement of 1765 – Franks was later arrested and impris-
oned for aiding the enemy. He was exiled in 1780, sailed to
England, but eventually returned to New York, where he
published the first *New York City Directory.* He died in Phila-
delphia, victim of a yellow fever epidemic.

Though Franks had married a Christian, Margaret Evans,
and all his children were baptized, he retained his spiritual
ties with Congregation Shearith Israel (the Spanish and Por-
tuguese Synagogue) in New York and continued sporadically
to attend services there.

In 1742 Phila Franks eloped with Oliver DeLancey, a
member of a prestigious New York family (after whom
Delancey Street was named). They lived for eight years in a

house that became Fraunces Tavern – still standing – the site
of George Washington's famous farewell address to his offi-
cers in 1783. Espousing the British cause during the Revolu-
tion, Phila's husband was appointed brigadier-general of the
DeLancey Battalions, which served the king. Consequently,
DeLancey's property was confiscated, and in 1779 the couple
settled permanently in England. Phila's generosity and civic
spirit became evident in 1762 when she wielded her influ-
ence to raise money for the financially troubled King's Col-
lege, now known as Columbia University. Of her five chil-
dren, her son Stephen became chief justice of the Bahamas
and later royal governor of Tobago, while her younger son,
Oliver, Jr., a lieutenant-general in the British Army, was
elected to Parliament in 1796.

In this portrait, the subjects' elegant attire and studied
repose reflect both their comfortable economic status and
the artist's use of European mezzotints as pictorial models.[2]
Acting as a bond between the brother and sister, and placed
almost directly in the center of the canvas, is a red rose, a
token of love. Though no facial characterization of the sitters
is attempted, Phila's qualities are defined by the significant
presence of a lamb, symbolizing gentleness and innocence.

This double portrait of David and Phila Franks, one of two
such compositions, has been attributed to the artists
Gerardus Duyckinck (1695–1746) and Pieter Vanderlyn
(c. 1687–1778).[3]

Notes: 1. A portrait of their grandfather, Moses Levy, is included in this
exhibition (cat. 1). 2. The source proposed for this painting is the mezzo-
tint of *Lord William and Lady Mary Villiers,* 1700, by John Smith after Sir
Godfrey Kneller. Cf. Charles Coleman Sellers, "Mezzotint Prototypes of
Colonial Portraiture: A Survey Based on the Research of Waldron Phoenix
Belknap, Jr.," *The Art Quarterly,* Winter 1957: 407 ff.; ills. 45 and 45A on
p. 461. 3. The other double portrait of David and Phila Franks is illus-
trated in Sellers, *op. cit.,* no. 46A on p. 461. It is also in the collection of the
American Jewish Historical Society, Waltham, Mass. For Duyckinck
attribution, see Sellers, *op. cit.,* 454, and Mary Black in this publication.
For Vanderlyn attribution, see James Thomas Flexner, "Pieter Vanderlyn,
come home," *Antiques* 75, no. 6 (June 1959): 546–49, 580.

References: London, Hannah. *Portraits of Jews by Gilbert Stuart and Other
Early American Artists.* New York: Rudge, 1927, 7–16; ill., p. 87. Phillips,
N. Taylor. "The Levy and Seixas Families of Newport and New York."
PAJHS, no. 4 (1894), 200. Wolf, Edwin 2nd, and Maxwell Whiteman. *The
History of the Jews of Philadelphia.* Philadelphia: Jewish Publication Society of
America, 1957: 33. Postal, Bernard, and Lionel Koppman. *Jewish Land-
marks in New York.* New York: Hill and Wang, 1964: 174. *The Universal
Jewish Encyclopedia* 4. New York: Universal Jewish Encyclopedia, 1943:
416–17. *The Jewish Encyclopedia* 5. New York and London: Funk and
Wagnalls, 1906: 497–98.

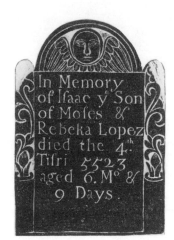

4

Gravestone of Isaac Lopez (rubbing)
Attributed to John Stevens II (1702–78)
Burial ground of Touro Synagogue
Newport, Rhode Island, c. 1763
Rubbing by Anne C. Williams and Susan H. Kelly
17″ x 12″; 43.2 x 30.5 cm.
Collection of Anne C. Williams and Susan H. Kelly

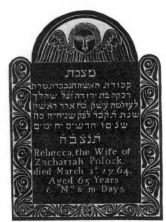

5

Gravestone of Rebecca Polock (rubbing)
Attributed to John Stevens II (1702–78)
Burial ground of Touro Synagogue
Newport, Rhode Island, c. 1764
Rubbing by Anne C. Williams and Susan H. Kelly
37″ x 27″; 94 x 68.5 cm.
Collection of Anne C. Williams and Susan H. Kelly

> How strange it seems! These Hebrews in their graves
> Close by the street of this fair seaport town,
> Silent beside the never-silent waves,
> At rest in all this moving up and down!

This stanza from Henry Wadsworth Longfellow's poem "The Jewish Cemetery at Newport" was inspired by the poet's visit to the burial ground of Congregation Jeshuat Israel, later known as Touro Synagogue. Established by 1678, a year after the first Jews arrived in Newport, the cemetery and the rarely used synagogue building dedicated in 1763 were the only evidence remaining of the city's once-thriving Jewish community, which enjoyed a golden age from 1750 to 1776 before being reestablished in the late 1800s.

The thirty-two gravestones now standing in the cemetery,

including the two illustrated here, are memorials to some of the families who played an active role in the life of the community. The Polock family, of Ashkenazic origin, and the Sephardic Lopez family were both involved in the original plans to build a synagogue in Newport. Moses Lopez and Isaac Polock (the brother of Zachariah Polock) were among the signatories of a letter written on 21 March 1759 requesting financial assistance from Congregation Shearith Israel in New York.[1] The year of the synagogue's dedication also marked the burial of Isaac Lopez, the six-month-old son of Moses and Rebeka. Moses Lopez, a successful merchant, was one of the earliest members of Newport's Masonic Lodge and organized the first Jewish men's club in America in 1761.[2]

Many of the members of the Polock family were prominently identified with the community synagogue, including Zachariah Polock who was among those licensed to examine cattle slaughtered in accordance with Jewish ritual.[3] The gravestone commemorating Zachariah's wife Rebecca, who died in 1764, bears inscriptions both in Hebrew and in English. The Hebrew inscription is translated as follows:

> Monument
> of the burial place of the honored woman
> Rebecca, daughter of Judah,
> who departed to her eternal home on the eve of the
> Holy Sabbath, 28th of First Adar in the year
> [5]524 [1764]. The years of her life
> were 65 years, 6 months and 18 days.
> M[ay her] s[oul] b[e bound up in] t[he bonds of] l[ife.][4]

The final phrase, traditionally inscribed on Jewish gravestones, appears on almost every stone in the cemetery bearing a Hebrew inscription, emphasizing immortality rather than death. A common Hebrew designation for a burial ground—*Bet Hayyim*—is the house, not of the dead but of the living.[5]

The gravestones of Colonial America are considered among the first of the American folk arts. Although there was a well established tradition of stonecarving among the Jews in Europe, in the absence of stonecarvers from their own tradition, members of the American Jewish community sought the services of Christian carvers. This frequently resulted in the interesting juxtaposition of cultural motifs seen here.

Both the gravestone of Isaac Lopez and that of Rebecca Polock may be attributed to John Stevens II (1702–78), of the second generation of a family of three well-known stonecarvers of the same name, whose continuous tradition of stonecutting is the longest known in New England. Characteristic of the style of John Stevens II is his use of cherubim in the tympanum and his well-carved borders of vines and flowers.[6] The stones are of a fine blue-black slate generally utilized by the Stevens family.[7]

Notes:　　1. Rabbi Theodore Lewis, "Touro Synagogue," from *Newport History, Bulletin of the Newport Historical Society* 48, no. 3 (Summer 1975): 316.　　2. Morris A. Gutstein, *The Story of the Jews of Newport: Two and a Half Centuries of Judaism, 1658–1908* (New York: Bloch, 1936): 77.　　3. *Ibid.* 4. Rev. A. P. Mendes, "The Jewish Cemetery at Newport, Rhode Island: A Paper Read Before the Newport Historical Society, June 23, 1885," *The Rhode Island Historical Magazine* 6, no. 2 (October 1885): 86.　　5. *Ibid.*, 105. 6. Susan H. Kelly and Anne C. Williams, *A Grave Business: New England Gravestone Rubbings, A Selection* (New Haven, Conn.: Art Resources of Connecticut, 1979): 30.　　7. Allan I. Ludwig, *Graven Images: New England Stonecarving and its Symbols, 1650–1815* (Middletown, Conn.: Wesleyan University Press, 1966): 330.

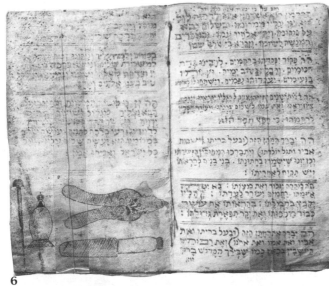

6

Circumcision Record Book
Barnard Itzhak Jacobs
Heidelberg, Pennsylvania, 1765
Ink on vellum
6 x 3¾"; 15.2 x 9.5 cm.
Congregation Mikveh Israel, Philadelphia, Pennsylvania

Barnard Itzhak Jacobs, a shopkeeper from Heidelberg,
Pennsylvania, served as the area's itinerant circumciser
(*mohel*), traveling on horseback to and around Philadelphia,
Lancaster, Reading, and York to perform this rite for the
newborn males of the Jewish community. His record book
includes the names of many who later achieved prominence
in the affairs of the community. It also contains illustrations
of the surgical instruments he used. Although never a resi-
dent of Philadelphia, Jacobs is shown as a subscriber in the
1782 list of Congregation Mikveh Israel.

Reference: Wolf, Edwin 2nd, and Maxwell Whiteman. *The History of the
Jews of Philadelphia from Colonial Times to the Age of Jackson.* Philadelphia:
Jewish Publication Society of America, 1957: *passim.*

7

Pediment from a Torah Ark
Mid-18th century
Wood and polychrome
16½ x 40"; 42 x 100.1 cm.
American Jewish Historical Society, Waltham,
Massachusetts

Although individual Jewish traders may have reached
Lancaster, Pennsylvania, prior to the arrival of Joseph Simon
(1712–1804) in 1740 or 1741, he was the first permanent
Jewish resident of the town, and Jewish life in early
Lancaster centered around him and his home. Soon after his

arrival, Simon and Isaac Nunes Henriquez purchased a plot
of land for use as a Jewish burial ground. Simon also
provided a place of Jewish worship in a room in his home on
Penn Square in downtown Lancaster.[1]

The central focus in synagogue architecture and ritual is
the *aron kodesh*, or Holy Ark, a shrine or receptacle in which
the Torah scrolls are kept. Illustrated here is the upper
portion of the ark from the prayer room in Simon's home,
bearing the inscription in Hebrew, "Know Before Whom
You Stand."

It is believed that the ark was constructed by a local
cabinetmaker, who incorporated typical Pennsylvania-
German motifs into the design.

Note: 1. David Brener, *The Jews of Lancaster, Pennsylvania: A Story with
Two Beginnings* (Lancaster: Congregation Shaarai Shomayim in association
with The Lancaster County Historical Society, 1979): 6–7.

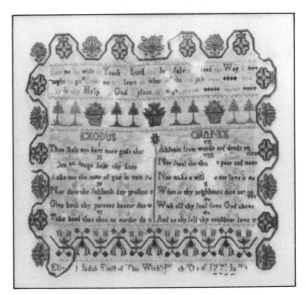

8

Sampler
Elizabeth Judah
Possibly Montreal, Quebec, 1771
Silk embroidery on linen
12 x 12"; 30 x 30 cm.
The Gershon and Rebecca Fenster Gallery of Jewish Art,
Tulsa, Oklahoma

Elizabeth Judah was born (probably in England) into a
prominent Canadian Jewish family in 1763. At the age of
eight, she executed this sampler in green and red on a linen
ground, the central portion of which is embroidered with a
poetic rendering of the Ten Commandments.

Elizabeth's marriage in 1781 to Chapman Abraham, the
first Jewish resident of Detroit, ended with her husband's
death two years later. In 1787, she married Moses Myers,
and they settled in Norfolk, Virginia, where she raised a
large family and lived until her death in 1823.[1] The Myers'
house, built in 1792 and now restored as a historic landmark,
is administered by The Chrysler Museum in Norfolk,
Virginia.

Note: 1. Sotheby's, New York, *Fine Judaica: Printed Books, Manuscripts
and Works of Art,* Sale Catalogue, June 1982: no. 343.

9
Miniature Portrait of Gershom Mendes Seixas
(1746–1816) (not shown)
Artist unknown
Probably New York, 18th century
Oil on ivory
1⅞ x 1⅜"; 4.8 x 3.5 cm.
Museum of the City of New York
Bequest of Annie Nathan Meyer

Gershom Mendes Seixas, often called "The Patriot Rabbi," is shown in his clerical bands, as a relatively young man.[1] He ascended to the pulpit of Congregation Shearith Israel in New York when he was only twenty-three.

Seixas, a third-generation American, was the first native-born American to attain the office of *hazzan* (minister or leader of synagogue services), a more correct term than rabbi, as he had never been formally trained in rabbinical studies or ordained. In the absence of a theological seminary in Colonial America, Seixas relied on his own reading to acquire a knowledge of Jewish law and practice.[2]

Seixas earned his appellation, "The Patriot Rabbi," through his staunch support of the Revolution. Shepherding the congregation out of New York in the face of advancing British troops, he also brought with him all the ceremonial objects and prayer books. He settled first in Stratford, Connecticut, and then in Philadelphia, where he served as the first *hazzan* of the newly established Congregation Mikveh Israel. He returned to New York in 1784.

One of his concerns during his Philadelphia sojourn was the effort to amend the 1776 Pennsylvania Constitution, eliminating a religious test oath that barred Jews from election to the General Assembly. His pioneering analysis of state constitutions formed the basis of the arguments advanced against this civic disability. In 1790, a Bill of Rights added to the state constitution finally eliminated discrimination against Jews.

Seixas was one of fourteen clergymen who officiated at George Washington's inauguration. For thirty years he was a trustee of Columbia College. He had a scholar's knowledge of Jewish history, eloquently delivering a lecture on this subject in St. Paul's Church.

This miniature, still in its original frame, was set to be hung from a chain or worn as a brooch. Miniatures were often regarded as jewelry and were given to friends, relatives, and loved ones as mementoes.

Notes: 1. As evidenced in many 18th- and 19th-century portraits, these bands were worn by both Protestant and Jewish clergymen. 2. For portraits of his grandparents, see cats. 1 and 2, and for his daughter's family, see cat. 34.

References: This miniature was published in London, Hannah R. *Shades of My Forefathers,* reprinted in *Miniatures and Silhouettes of Early American Jews.* Rutland, Vt.: Tuttle, 1970: 101; and Fraunces Tavern Museum. *The Jewish Community in Early New York, 1654–1800.* Exhibition catalogue. New York, 1979: 15. See also Pool, David de Sola, *Portraits Etched in Stone: Early Jewish Settlers, 1682–1831.* New York: Columbia University Press, 1952: *passim.* Wolf, Edwin 2nd, and Maxwell Whiteman. *The History of the Jews of Philadelphia from Colonial Times to the Age of Jackson.* Philadelphia: Jewish Publication Society of America, 1957: 147-50.

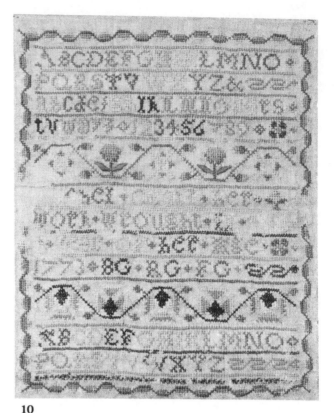

10
Sampler
Rachel Gratz (Mrs. Solomon Etting) (1764–1831)
1773
Wool embroidery on linen
12 x 9½"; 30 x 20.4 cm.
The Maryland Historical Society, Baltimore, Maryland
The Eleanor S. Cohen Collection

This simple example of a young girl's needlework was completed in 1773 by Rachel Gratz, the daughter of Barnard Gratz (see cat. 13) and his wife, Richea Myers-Cohen. As befitted the daughter of an important trader and business-man, Rachel was trained in the useful arts—including needlework—early in life; she worked this sampler utilizing cross-stitch embroidery at the age of nine. As is typical of other samplers of the period, Rachel followed the "fairly rigid pattern of alphabet, numerals, perhaps a text, and often the maker's name and date (probably that when she completed the work)."[1]

At the center Rachel stitched the following inscription:

[Rac]hel Gratz her
work wrought [in the ninth]
year of her age
1773 BG RG FG

The initials BG, RG, and FG refer to her parents and her sister, Fanny, who died as a child.

In 1791, Rachel married Solomon Etting (see cat. 19), the son of Shinah Solomon Etting (see cat. 12).

Note: 1. Glee Krueger, *New England Samplers to 1840* (Sturbridge, Mass.: Old Sturbridge Village, 1978): 8.

Reference: Stern, Malcolm H. *First American Jewish Families: 600 Genealogies, 1654–1978.* Cincinnati: American Jewish Archives and Waltham, Mass.: American Jewish Historical Society, 1978.

Charles Peale Polk, a nephew and pupil of Charles Willson Peale, never achieved the fame or academic skill of his many artist-relatives, remaining poised "between the urbane realism of his uncle and the provincialism of a rustic limner."[1] He was active in Philadelphia and Baltimore, and also worked in Maryland, Virginia, and West Virginia.

Painted under his uncle's influence, Polk's half-length portraits are characterized by a greater attention to draftsmanship than to modeling, but Polk reveals his lack of skill and naïveté in shallow spaces defined by a few props rendered in great detail, in the stiff placement of his sitters in the center of the canvas, and in his insistence on placing objects in their hands. He stressed the decorative qualities of line and detail, accurately depicting fashions in clothing and coiffure. Polk's style during this second Baltimore period (1791–94), when he painted Mrs. Etting and Barnard Gratz (see cat. 13), also emphasized strong colors.

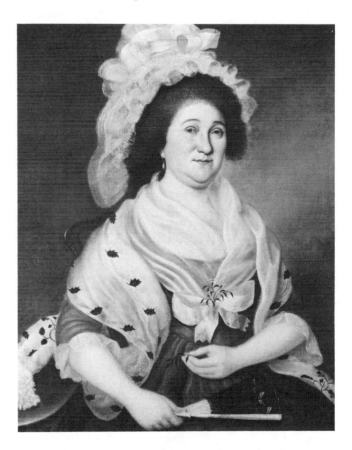

11
Marriage Contract (Ketubbah) of Rachel Franks and Haym Salomon
Ink on paper, 1777
14 x 9"; 30.5 x 20.3 cm.
American Jewish Historical Society, Waltham, Massachusetts

This document records the marriage of Haym Salomon (1748–85), Revolutionary War patriot, to Rachel Franks (1762–1818) on 6 July 1777 in New York. The architectural decoration in the form of a portal may derive from frontispieces of 18th-century printed books.

12
Portrait of Shinah Solomon Etting [Mrs. Elijah Etting]
(1744–1822)
Charles Peale Polk (1767–1822)
Baltimore, Maryland, 1792
Oil on canvas
Signed, lower left; C. P. Polk pin . . . 1792
35⅝ x 27⅝"; 90.5 x 70.2 cm.
The Baltimore Museum of Art, Maryland
Gift of Mr. and Mrs. William C. Whitridge

In this, one of his more successful portraits, Polk captured the lively spirit of the "sprightly and engaging Mrs. E.," as one of her contemporaries described her.[2] She is seated on a Chippendale-style chair, holding a fan and a spray of foliage. She is stylishly dressed, and the décolletage of her russet gown is modestly veiled by a sheer fichu into which is inserted a sprig of verbena. Verbena leaves frequently appear in portraits painted by Charles Willson Peale. A monumental lawn-and-lace cap is precariously attached to her towering coiffure.[3]

Shinah Solomon Etting was born in Lancaster, Pennsylvania. She was the daughter of a merchant, and married

Elijah Etting at the age of fifteen. Etting, a merchant, Indian trader, and supplier to the Revolutionary army, died when Shinah was thirty-four, leaving her with eight children to raise. She moved her family from York, Pennsylvania, to Baltimore, where for over thirty years she ran a boarding house. She survived to see her children achieve prominence in business and civic affairs. Their descendants continued the family tradition of public service.[4]

This painting remained in the family until it was offered for sale in 1967, when it was erroneously identified as her daughter Jane Etting Taylor.

Another portrait depicting her in a more serious vein, with a book and reading glasses, is in the collection of the Maryland Historical Society. Apparently commissioned from Polk at about the same time, it descended through another branch of the family.

Notes: 1. William R. Johnston, "Charles Peale Polk: A Baltimore Portraitist," *The Baltimore Museum of Art, Annual* III (1968): p. 36. Major sources for this entry are the above-mentioned article together with Corcoran Gallery of Art, *Charles Peale Polk, 1767–1822: A Limner and His Likeness,* exhibition catalogue by Linda Crocker Simmons (Baltimore, 1981): essay and cats. 57 and 58; and Sona K. Johnston, *American Paintings, 1750–1900, From the Collection of the Baltimore Museum of Art* (Baltimore: The Baltimore Museum of Art, 1983). 2. Philip Sherman, "The Engaging Mrs. E.," *3rd Annual Maryland Antiques Show and Sale,* exhibition brochure (Baltimore, 1981): 45–48. 3. For a similar portrait of another sitter, see Nina Fletcher Little, *The Abby Aldrich Rockefeller Folk Art Collection* (Boston and Toronto: Little, Brown, 1957): no. 11; or Beatrix T. Rumford, ed., *American Folk Portraits: Paintings and Drawings from the Abby Aldrich Rockefeller Folk Art Center* (Boston: New York Graphic Society in association with the Colonial Williamsburg Foundation, 1981): no. 189. 4. See cats. 19 and 20 for silhouettes of her son and daughter-in-law. Generous patrons of the arts, three generations of Ettings are represented in portraits by various artists in the Maryland Historical Society and the Pennsylvania Academy of Fine Arts. See also Hannah R. London, *Shades of My Forefathers,* reprinted in *Miniatures and Silhouettes of Early American Jews* (Rutland, Vt.: Tuttle, 1970): 21.

13
Portrait of Barnard Gratz (1738–1801)
Charles Peale Polk (1767–1822)
c. 1790–95
Oil on canvas
40 x 35"; 101.6 x 88.9 cm.
Collection of Norman Flayderman

Barnard Gratz and Shinah Etting were related through the marriage of their children.[1] Their portraits exhibited here, though not strictly pendants, are each exemplary of Polk's style and artistic concerns. In addition, the lives of the two sitters demonstrate the participation of the small Jewish community in the emergent nation.

In his portrait of the "merchant venturer" Barnard Gratz, Polk has clearly rendered shelves of books, revealing Gratz's wide-ranging interests. He is seated, holding his glasses, one arm on a table on which also rests the Third Book of Moses – Leviticus. The other four volumes of the Torah identified by their Hebrew titles, are on the upper shelf to the left. On the second shelf is Thomas Stackhouse's *New History of the Bible from the Beginning of the World to the Establishment of Christianity* and Thomas Salmon's *A New Geographical and Historical Grammar . . . ,* which contains several maps of North America. As Polk has abbreviated all the titles, the identity of a third book on the second shelf is not clear, but

may be Rapin de Thoyras's standard *History of England,* which is known to have been in the collection of another Philadelphia Jew.

Gratz was born in Langendorf, Upper Silesia. After an apprenticeship at a relative's counting house in London, he settled in Philadelphia where he was first employed by David Franks.[2] Later, with his brother Michael, he traded up and down the East Coast and in the West Indies. When the settlement of the French and Indian War in 1763 opened up the Western Frontier, the brothers participated in various consortia that pioneered in trading and land development, thus opening up vast tracts of land that are now the states of Ohio, Kentucky, Indiana, and Illinois. One of these groups that formed the United Illinois and Ouabasche Land Companies in 1780 had among its other partners five signatories of the Declaration of Independence.

A vigorous man, Gratz sometimes accompanied his pack trains into hostile Indian territory, assuming great physical and financial risks. His business and family ties to many prominent American-Jewish families resulted in a series of letters, in both Yiddish and English, graphically describing the complexities of life in early America (see cat. 15).

Strongly supportive of the Revolution, Gratz took the oath of allegiance to a free United States in 1777. He also served the Jewish community with distinction, playing a role in Pennsylvania, and later in Maryland, protesting the wording of oaths in these states that prevented Jews from holding public office.

Barnard Gratz, who was also knowledgeable in religious law, certified Solomon Etting (who would later become his son-in-law) as a ritual slaughterer, the first such certification of an American by another American. Gratz lived in Philadelphia until 1791, and was a founding member of Congregation Mikveh Israel. After his daughter's marriage to Etting, he settled with them in Baltimore.[3]

Notes: 1. For a discussion of Polk's style and a portrait of Shinah Solomon Etting, see cat. 12. 2. For Frank's portrait as a youth, see cat. 3. 3. Solomon and Rachel Gratz Etting are depicted in silhouettes, cats. 19 and 20.

References: Letter dated 7 November 1980, from the owner to Linda Crocker Simmons, Corcoran Gallery of Art, who kindly made it available to us. London, Hannah R. *Portraits of Jews by Gilbert Stuart and Other Early American Artists.* Reprinted. Rutland, Vt.: Tuttle, 1969: 121. Corcoran Gallery of Art. *Charles Peale Polk, 1767–1822: A Limner and His Likeness.* Exhibition catalogue by Linda Crocker Simmons. Washington, D.C., 1981: no. 79. Daughters of the American Revolution Museum. *The Jewish Community in Early America, 1654–1830.* Exhibition catalogue. Washington, D.C., 1980: 3 and 23. Wolf, Edwin 2nd, and Maxwell Whiteman. *The History of the Jews of Philadelphia from Colonial Times to the Age of Jackson.* Philadelphia: Jewish Publication Society of America, 1957: *passim.*

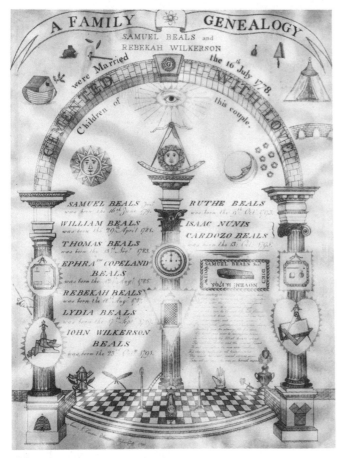

14
A Family Genealogy
Isaac Nunez Cardozo (1751–1832)
Boston, Massachusetts, 1795
Ink on paper
20½ x 15½"; 52 x 30.9 cm.
Collection of Philip and Deborah Isaacson

Isaac Nunez Cardozo, great-grandfather of the American jurist Benjamin Nathan Cardozo, was born in London and was brought to New York by his parents when he was only one year old. As a young man he lived in New York and in Philadelphia, where in 1782 he contributed to the cost of building a new synagogue for Congregation Mikveh Israel,

the second oldest in the country. He married Sarah Hart in 1798 and moved with her to Easton, Pennsylvania, where he tried his hand at various trades including tailoring, schoolteaching, and the sale of patent medicine, none of which made his fame and certainly not his fortune.[1] A more enduring legacy is represented in his illuminated works, two of which are exhibited here.

More complex than his later work, *The Ten Commands* (see cat. 24), Cardozo's *A Family Genealogy* is the record of the marriage and children of Samuel Beals and Rebekah Wilkerson. Despite the greater detail in *A Family Genealogy,* both works are remarkably similar, although over twenty years and residence in separate cities intervene.

Family registers were common forms in the folk art of late-18th- and early-19th-century New England, and hundreds of examples survive, frequently rendered in watercolor and decorated with floral motifs and folk figures. In the Beals/Wilkerson record, Cardozo presents a veritable encyclopedia of Masonic symbols, including the omniscient eye, the beehive, and the compass. As in *The Ten Commands,* the arch bears the inscription, "cemented with love."

The records of the Rising States Masonic Lodge list Samuel Beals as a member in 1794, a year before this genealogy was commissioned. It is interesting to note that Samuel and Rebekah Beals named their youngest child after the artist.

Note: 1. Joshua Trachtenberg, *Consider the Years: The Story of the Jewish Community of Easton, 1752–1942* (Easton, Pa.: Centennial Committee of Temple Beth Shalom, 1944): 91–99.

Reference: Stern, Malcolm H. *First American Jewish Families: 600 Genealogies, 1654–1978.* Cincinnati: American Jewish Archives and Waltham, Mass.: American Jewish Historical Society, 1978.

15
Letter of Barnard Jacobs to Barnard Gratz (not shown)
Chestnut Hill, Pennsylvania, 1768
Ink on paper
Signed and dated
16⅛ x 12½"; 35.2 x 31.7 cm.
The Library Company of Philadelphia, Pennsylvania
(See cats. 6, 13)

16
Mezuzah (not shown)
Philadelphia, early 19th century
Painted tin
4⅞ x ⅞"; 12.4 x 2.4 cm.
The Jewish Museum
Gift of Mrs. Nathan Leavy in memory of her sister,
 Alice L. Miller

A *mezuzah* is a parchment scroll inscribed with passages from Deuteronomy 6:4–9 and 11:13–21, enclosed in a protective container, which is affixed to the doorpost of a Jewish home. This one came from the door of 2 Franklin Street, Philadelphia, the residence of Haym M. Salomon (see cat. 11), son of Haym Salomon, patriot and a financier of the American Revolution. The donor of this piece is a descendant of the Salomon family.

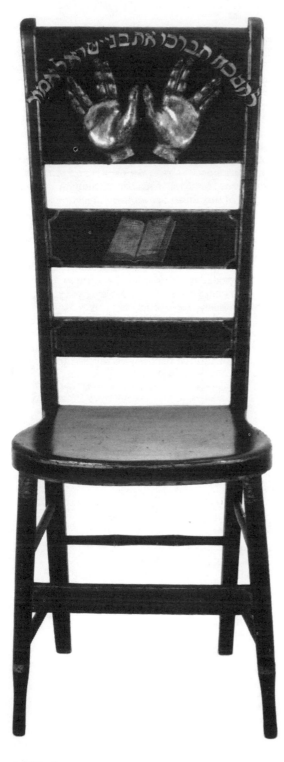

Among the many religious practices that hallow Jewish life, the blessing of the people by the priests (*kohanim*) is one of the most ancient, having its roots in the Book of Numbers. After Moses Lopez of Newport, Rhode Island, a dentist and "bleeder," moved to Philadelphia and established residence there, he joined Congregation Mikveh Israel. In commemoration of his admission to membership, he presented the congregation with this unusual chair in 1816 to hold the ewer and basin for the ritual washing of the hands by the priests prior to their blessing of the congregation.[1]

Two carved hands have been applied to the upper slat of the chair with the fingers separated in the customary manner of the priestly blessing, a common motif in Jewish art (see cats. 60 and 64).

The Hebrew on the upper slat of the chair is from Numbers 6:23 (although the arrangement has been altered slightly): "In this wise ye become the children of Israel;/ye shall say unto them," which precedes God's instructions to Moses for Aaron and his sons to bless the people. The well-known blessing itself continues to be a part of Jewish worship:

> The Lord bless thee, and keep thee; The Lord make His face to shine upon thee, and be gracious unto thee; The Lord lift up his countenance upon thee, and give thee peace.
>
> Num. 6:24–26

The illustration on the middle slat is entitled "The Five Books of Moses," shown here as a book rather than the more customary scroll.

The letter that accompanied Lopez's gift demonstrates a fidelity to his faith and a humble and appreciative spirit:

> Mess[rs.] Hyman Marks/President,
> Levi Phillips/Gabay,[2]
> &
> The Rest of the members of adjunto[3]
> of the Congregation Mickve Israel:Philadel.[a]
> Gentln.
> I beg leave to Present the Congregation of this K[ahal]. K[adosh].[4] Mickve Israel through you; a Chair adapted to hold the Ewer and Bason with Four Damask Napkins for the use of the *Kohanim* which I crave your Acceptance.
> May the Same be used by them, with Health, Long life and Happiness together wishing you and the K[ahal]. K[adosh]. all the Blessings this low World can aford them is the ardent Prayers of – Gentl[n]
> Yours with the greatest
> Consideration
> Phi.[a] 2 Sep. 1816 Moses Lopez

Notes: 1. Edwin Wolf 2nd and Maxwell Whiteman, *The History of the Jews of Philadelphia from Colonial Times to the Age of Jackson* (Philadelphia: Jewish Publication Society of America, 1957): 230–31. 2. Treasurer. 3. Governing board. 4. Holy Congregation.

17
Ceremonial Chair
Artist unknown
Presented 12 October 1816 by Moses Lopez to Congregation Mikveh Israel, Philadelphia
Walnut, painted, stained, and gilded
52½ x 19½ x 18"; 133.4 x 49.5 x 45.7 cm.
Congregation Mikveh Israel, Philadelphia, Pennsylvania
Courtesy of the National Museum of American Jewish History, Philadelphia, Pennsylvania

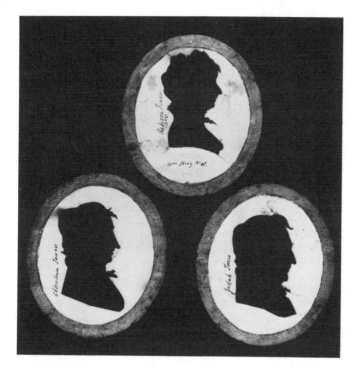

18
Silhouettes of Judah, Abraham, and Rebecca Touro
William King (?–c. 1809)
New England, 1805
Hollow-cut paper mounted under reverse-painted glass
Signed and dated on Rebecca Touro silhouette; Wm. King
 Del. 1805
7½ x 7½"; 19.1 x 19.1 cm.
The Jewish Museum
Gift of Dr. Harry G. Friedman

Prior to the advent of photography in 1839, the profile silhouette was the most popular form of portraiture. Cutout silhouettes were commonly priced from two for twenty-five cents to two dollars. There are two basic types of cutout silhouettes—one cut from black paper and mounted on a light-colored ground; the other, called hollow-cut, in which the profile is cut out from a sheet of white paper, after which the hollowed-out sheet is mounted on a black ground.

This group of three hollow-cuts is the work of William King, who was active in New England. A cabinetmaker by trade, this itinerant silhouettist used a mechanical device to make his profiles. Various contrivances were often employed to steady the sitter and to reduce the actual size of the head to the cut image.[1] King's "Patent Delineating Pencil" permitted him to take a profile in six minutes at a cost of twenty-five cents for two likenesses of the same person.

In his advertisements, he informed the female public that this machine enabled them to pose without being scraped by a machine or obliged to enter a dark room. Although he stated that he cut over 20,000 profiles, they are rare today. Like other silhouettists, King also offered frames, charging from fifty cents to two dollars for a reverse-black glass frame such as the one into which these three profiles are set.

The three children of Rabbi Isaac Touro and his wife Reyna Hays Touro were all born in Newport where Rabbi

Touro served until the arrival of British troops forced the closing of the synagogue. The family subsequently moved to Kingston, Jamaica, returning to Boston after the death of Rabbi Touro in 1783.

Rebecca Touro (1779–1833) married Joshua Lopez, a son of the prominent Newport merchant Aaron Lopez.

Abraham Touro (1777–1822) was tragically killed as he leaped from his chaise when the horse drawing it became frightened during a military parade in Boston. A bachelor and an extremely successful shipowner, he left large sums to the Massachusetts General Hospital and other charitable institutions. Another of his benefactions was a fund for the support of the Touro Synagogue in Newport. This Colonial structure designed by Peter Harrison, now a national historic site, was named for Rabbi Touro, its first rabbi. Abraham Touro also sat for Gilbert Stuart and an unknown miniaturist.

Despite the scope of Abraham Touro's philanthropy, it was surpassed by that of his brother, Judah (1775–1854), whose will designated the then-enormous sum of over half a million dollars to charity. Generous also in his lifetime, Touro supported nonsectarian causes in New England, Jewish congregations in nineteen cities, and various benevolent and educational institutions in Palestine. Gershom Kursheedt (see cat. 34) was one of the executors of Touro's will. Judah Touro founded his fortune on shipping and real estate. From 1802 until his death he lived in New Orleans.

Note: 1. For illustrations of various silhouette-taking techniques, see E. Nevill Jackson, *Silhouettes: A History and Dictionary of Artists* (New York: Dover, 1981; reprint of 1938 edition of *Silhouette: Notes and Dictionary*): pls. 63–71.

References: Carrick, Alice Van Leer. *A History of American Silhouettes: A Collector's Guide, 1790–1840.* Rutland, Vt.: Tuttle, 1968 (reprint of 1928 edition of *Shades of Our Ancestors*): 44–45, 186. Huhner, Leon. *The Life of Judah Touro (1775–1854).* Philadelphia: Jewish Publication Society of America, 1947. London, Hannah R. *Portraits of Jews by Gilbert Stuart and Other Early American Artists.* Reprinted Rutland, Vt.: Tuttle, 1969: 49. London, Hannah R. *Miniatures of Early American Jews.* Reprinted in *Miniatures and Silhouettes of Early American Jews.* Rutland, Vt.: Tuttle, 1970: 25–26, 50–51.

19

Silhouette of Solomon Etting (1764–1847)
Executed at Peale's Museum; embossed "Museum"
Philadelphia, Pennsylvania, c. 1810–12
Hollow-cut paper mounted under reverse-painted glass
5⅜ x 4⅝"; 13.7 x 11.7 cm.
The Jewish Museum
Gift of Dr. Harry G. Friedman

The son of Elijah and Shinah Solomon Etting, Solomon Etting, whose commercial and civic accomplishments made him one of Baltimore's most distinguished citizens, was also well versed in Jewish law. His business ventures included the Baltimore and Ohio Railroad, the Water Company of Baltimore, and the Baltimore East India Company.

He served on a citywide Committee of Vigilance and Safety during the War of 1812 and for twenty-eight years fought vigorously against the Maryland law that prevented Jews from holding office by requiring office holders to swear an oath declaring a belief in Christianity. After the Assembly finally passed its reform measure in 1825, Etting became one of the first Jews elected to public office in that state. Together with Joshua Cohen, he sat on the City Council and later served as president of the First Branch of the City Council.

Etting is remembered for his integrity, philanthropy, and civic spirit. Like his lively mother, he was also noted for his "great wit and drollery."[1]

Note: 1. For his mother's portrait, see cat. 12. See also cats. 13, 20, and Philip Sherman, "The Engaging Mrs. E.," *3rd Annual Maryland Antiques Show and Sale,* exhibition brochure (Baltimore, 1981): 46.

20

Silhouette of Rachel Gratz Etting (1764–1831)
Executed at Peale's Museum; embossed "Museum"
Philadelphia, Pennsylvania, c. 1810–12
Hollow-cut paper mounted under reverse-painted glass
5⅜ x 4⅝"; 13.7 x 11.7 cm.
The Jewish Museum
Gift of Dr. Harry G. Friedman

Rachel Gratz Etting, the daughter of Barnard Gratz (cat. 13), married Solomon Etting in 1791 after the death of his first wife. She is portrayed here wearing a frilled and ribboned cap resembling the one worn when she sat for John Wesley Jarvis, 1810–12.[1] The similarity of costume (a fichu might also be discerned in the silhouette) suggests a like date for this silhouette.

Charles Willson Peale (1741–1826) opened his museum and art gallery at his home in Philadelphia, transferring it to Independence Hall in 1801. A painter, he was also interested in natural history. A silhouette-cutting machine provided an additional attraction in the museum; visitors were aided in making their own profiles.

Note: 1. This Jarvis portrait is in the collection of the Maryland Historical Society, Baltimore. For a sampler Rachel Gratz made in her youth, see cat. 10.

Reference: Colwill, Stiles Tuttle. "The Curator's Choice from the Etting / Cohen Collection." *3rd Annual Maryland Antiques Show and Sale.* Exhibition brochure. Baltimore, 1981: 20.

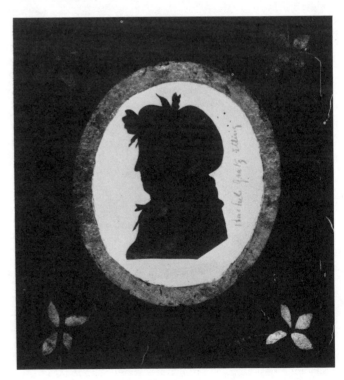

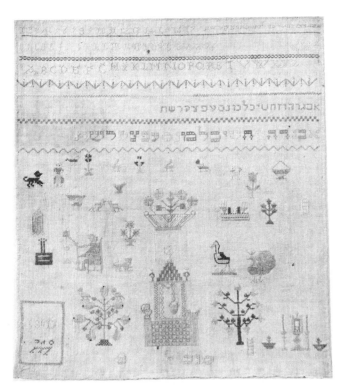

21
Sampler
Signed "S.G.M."
1813
Cotton embroidery on linen
17½ x 15"; 44.5 x 38.1 cm.
National Museum of American Jewish History, Philadelphia,
 Pennsylvania
Gift of Mr. and Mrs. Lawrence Blumenthal

Although the maker of this sampler has utilized a series of conventional motifs, her sampler is distinctive for the inclusion of the Hebrew alphabet in small and large letters. The sampler shows skill in execution, but its design elements are presented without concern for spatial relationships or overall composition.

22
Profile of Mordecai Myers (1776–1871)
Artist unknown
1814
Ink wash on paper
7 x 4"; 17.8 x 10.2 cm.
Collection of Norman Flayderman

This painted silhouette represents another type of inexpensive portrait available in the early 19th century. Usually slightly more costly and personalized than a cut profile, it also required more skill than most common silhouettists possessed.[1]

Mordecai Myers was born in Newport, Rhode Island, and was raised in New York by his Loyalist parents. From 1792

to 1814 he was a member of Congregation Shearith Israel and contributed to its building fund.

In the War of 1812, he acquitted himself bravely as captain and later major in the infantry. He was severely wounded in the battle of Chrysler's Field on the Niagara Frontier. Myers recorded his military experiences in *Reminiscences, 1812–1814.*

While recovering from his wound, he met and married Charlotte Bailey. They lived in Kinderhook (near Albany), New York, and later in Schenectady, where Myers served twice as mayor. He was also elected six times to the New York State Assembly as a representative from New York County. Myers, an active Mason from 1823 to 1834, declined the office of grand master for New York State.

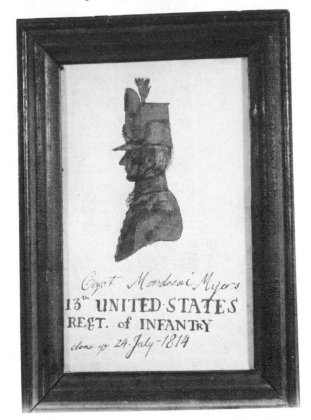

Apparently an attractive and affable man, Myers included among his friends Aaron Burr, DeWitt Clinton, and Alexander Hamilton. His oldest daughter married a nephew of President Van Buren. The family history entitled *Biographical Sketches in the Bailey-Myers-Mason Families, 1776–1905,* was privately circulated.

In addition to posing for this profile, made while he was a captain in the 13th Infantry, Myers sat for a miniature by Elkanah Fisdale in 1799 and a portrait in uniform by John Wesley Jarvis in 1810.

Note: 1. Beatrix T. Rumford, ed., *American Folk Portraits: Paintings and Drawings from the Abby Aldrich Rockefeller Folk Art Center* (Boston: New York Graphic Society in association with the Colonial Williamsburg Foundation, 1981): 29.

References: *Encyclopaedia Judaica* 11: col. 724. London, Hannah R. *Portraits of Jews by Gilbert Stuart and Other Early American Artists.* Reprinted. Rutland, Vt.: Tuttle, 1969: 37–38.

בסימן טוב

23

Marriage Contract (Ketubbah)
Artist unknown
Charleston, South Carolina, 1814
Brown ink on paper
12½ x 9½"; 31.7 x 24 cm.
The Library of the Jewish Theological Seminary, New York

A *ketubbah* is a Jewish marriage contract that bears the names of the bride and groom, the date and place of the wedding, outlines the financial and mutual obligations, and the conjugal responsibilities of the husband toward his wife. In existence since c. 440 B.C.E., the document was designed to protect the woman's rights, and eventually its presentation to the wife by the bridegroom became mandatory before the marriage could be consummated.[1]

Composed of the standard Aramaic formula, with the names of the couple and the date written in Hebrew, this *ketubbah* records the union of Abraham, son of Jacob, with Rebecca, daughter of Moses the Cohen, in 1814. Below the body of the contract appear three English signatures: Myer Moses, Parnas K.K.B.E., and Lyon Levy, the two required witnesses; and A. Isaacks, Jr., the bridegroom. The name Emanuel Carvalho, written in Hebrew, appears at the lower

edge. All the people named, except the bridegroom, can be readily identified.

In 1814 the K.K.B.E., Congregation [Kahal Kadosh] Beth Elohim of Charleston, represented the fourth oldest as well as the largest and wealthiest Jewish community in the United States. Founded in 1749, it followed Sephardic ritual and dedicated its synagogue in 1794. At the time of Abraham Isaacks' wedding, the rabbi was E. N. Carvalho, one of the signatories. Myer Moses (1779–1833), *parnas* (president) of the congregation, was elected a member of the South Carolina Legislature in 1810. He attained the positions of Commissioner of Free Schools and director of the Planters and Mechanics' Bank. Moses served as captain in the War of 1812 and in 1825 moved to New York City where he wrote the *Full Annals of the Revolution in France*. No less prominent was the second witness, the attorney Lyon Levy. Born in England in 1764, Levy was justice of the quorum in 1806.[2] He served as deputy state treasurer in 1813 and as South Carolina state treasurer from 1817 to 1822. Listed as secretary of Congregation Beth Elohim in 1800, Levy probably signed this document in an official capacity.

The decorative element of the meandering vine encircling the two columns may refer to this relevant passage from Psalm 128:3, "Thy wife shall be as a fruitful vine, in the

innermost parts of thy house; thy children like olive plants, round about thy table."[3]

The large Hebrew inscription atop the *ketubbah* reads, "Under a good sign," wishing the bridal pair good fortune in their marriage.

Notes: 1. Glenda Milrod, *Ketubah: The Jewish Marriage Contract,* exhibition catalogue (Toronto: Art Gallery of Ontario, 1980): 12. 2. This office was similar to justice of the peace. 3. Milrod, *op. cit.,* 16–17.

References: Elzas, Barnett A. *The Jews of South Carolina.* Philadelphia: Lippincott, 1905. Rosenbloom, Joseph R. *A Biographical Dictionary of Early American Jews.* Lexington: University of Kentucky Press, 1960. *The Universal Jewish Encyclopedia,* 3: 114–18; 8: 14.

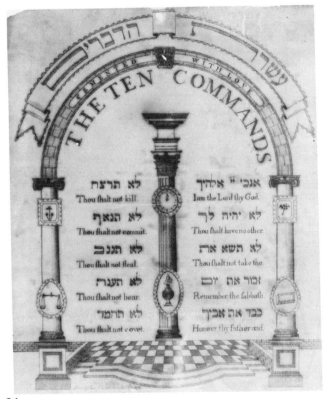

24
The Ten Commands
Isaac Nunez Cardozo (1751–1832)
Easton, Pennsylvania, 1816–17
Ink on paper
21 x 17"; 53.3 x 43.1 cm.
American Jewish Historical Society, Waltham, Massachusetts

The Ten Commands is a straightforward Masonic illumination of the Decalogue. In addition to the words of the Commandments in Hebrew and English, Cardozo utilizes a small repertoire of stock Masonic symbols, including the anchor ("hope"), the scales ("justice"), the sprig of acacia ("immortality"), and the pot of incense ("emblem of a pure heart"). The Decalogue itself is framed by the Temple columns, arch, and mosaic pavement, the black-and-white pattern of which is symbolic of the good and evil in life.[1] Cardozo's intention to create a Jewish document in *The Ten Commands* may be underscored by his use of the Hebrew date, A[nno] M[undi] 5576.

The marked similarity in the placement and use of design elements in the Jewish illuminated records illustrated here and Masonic paintings and decorative art is not surprising. Both take as a common source of inspiration the detailed descriptions of Solomon's Temple in the Hebrew Bible, and much Masonic symbolism and ritual derives from this source. The use of columns and arch to frame both Masonic and Jewish illuminations is particularly noteworthy (see, for example, cats. 23, 38, 51).[2] Cardozo died in New York in 1832.

Notes: 1. Scottish Rite Masonic Museum of Our National Heritage, *Masonic Symbols in American Decorative Arts* (Lexington, Mass., 1976): 47–52. 2. Alice M. Greenwald, "The Masonic Mizrah and Lamp: Jewish Ritual Art as a Reflection of Cultural Assimilation," *Journal of Jewish Art* 10 (forthcoming).

Reference: Stern, Malcolm H. *First American Jewish Families: 600 Genealogies, 1654–1978.* Cincinnati: American Jewish Archives and Waltham, Mass.: American Jewish Historical Society, 1978.

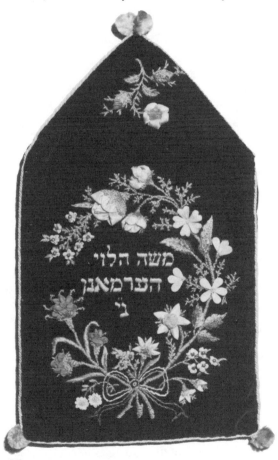

25
Prayer Shawl Bag
New York, inscription date 1820/1
Velvet: embroidered and appliquéd with silk and beads
17⅛ x 9⅝"; 43.5 x 24.5 cm.
The Jewish Museum
Maurice Hermann Collection

The Hebrew inscription of the face of this lavishly decorated bag reads: "Moses Halevy/Hermann/May his candle give light." The reverse reads: "Jerusalem/The Holy City/may it be established and rebuilt."

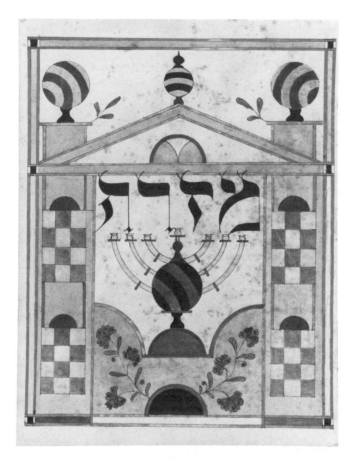

of prayer (i.e., toward Jerusalem). It is inscribed with that word in Hebrew calligraphy; a menorah is depicted below. It is the only known example of his work incorporating Jewish elements, but they are introduced by the artist within the framework of his stock motifs in such a characteristically restrained fashion that the *mizrah* appears wholly consistent with his other work.

The term *fraktur* was coined by Henry Mercer in 1897 to describe the colorful decorated birth and baptismal certificates, family records, house blessings, bookplates, and other illuminated documents of the Pennsylvania Germans. Comparisons between fraktur and the Jewish illuminations illustrated here are inevitable. While in most cases, fraktur utilize more extensive palettes and imagery, a larger repertoire of folk motifs, and the German (or less frequently the English) language rather than Hebrew, some similarities do emerge. They have in common the illumination (or, at least, decoration) of a text and the extensive use of floral designs and bird and animal motifs. In considering the work of the Mount Pleasant Artist, the similarities are more pronounced. The common use in these Jewish art forms of columns and arch to frame a text may be observed in many of the Mount Pleasant Artist's works. Other similarities include the reserved use of thematic materials and bold linear shapes. It would be premature, however, either to suggest a Jewish origin for the Mount Pleasant Artist or a familiarity on his part with Jewish art.

The Mount Pleasant Artist was active from 1813 until 1835, chiefly in Lancaster County and in nearby townships in Berks and York counties, Pennsylvania. Although there was an important early Jewish community in Lancaster, the first Jewish resident, Joseph Simon, having arrived in 1740 or 1741, the community virtually disappeared by the beginning of the 19th century. It was not reestablished until the 1840s, after the period of activity of the Mount Pleasant Artist.

The question of how this unknown illuminator came to create a *mizrah* is an alluring one. It may have been commissioned by one of the remaining Jewish residents for use in a home, there being no active Jewish congregation in Lancaster County at that time. In fact, there is but one known reference to a Jewish presence in Lancaster County between 1804, when Joseph Simon (see cat. 7) died at the age of ninety-two, and 1839, when a public inquiry followed the murder of Lazarus Zellerbach, a Jewish peddler. The will of Lazarus Levi, the owner of property in Reamstown, who died in December 1808, requested that "if the weather permits, they should carry my body to the Borough of Lancaster to be buried in the Jew's burial ground according to their custom."[2]

26
Decoration for the Eastern Wall (Mizrah)
Attributed to the Mount Pleasant Artist
Probably Lancaster County, Pennsylvania, c. 1830
Watercolor and ink on paper
9¾ x 7¼"; 24.8 x 18.4 cm.
Collection of Mr. and Mrs. Stephen Ten Eyck Gemberling

Although fraktur attributed to this artist are well known, his identity remains a mystery. He has been designated the Mount Pleasant Artist from an inscription on the reverse of a certificate recording the birth in 1813 of Henrich Buch:

> For 50 Cents a piece
> You can have as much as you please
> at
> Mount Pleasant Printing Office
> South Cocalico Township Lancaster County
> Pennsylvania[1]

Among Pennsylvania fraktur illuminators, the work of the Mount Pleasant Artist is distinctive; it is notable for its bold linearity, the use of compass and ruler in the creation of simple geometric shapes, a relatively reserved use of traditional thematic materials, and brief inscriptions in German or English. Known examples of his work include bookplates and birth and baptismal records.

This unusual, perhaps unique, example of fraktur from the hand of the Mount Pleasant Artist is a *mizrah* (Hebrew for "east") — a sign that indicates to the worshipper the direction

Notes: 1. Donald A. Shelley, *The Fraktur-Writings or Illuminated Manuscripts of the Pennsylvania Germans* (Allentown: Pennsylvania German Folklore Society, 1961): fig. 222. 2. David Brener, *The Jews of Lancaster, Pennsylvania: A Story with Two Beginnings* (Lancaster: Congregation Shaarai Shomayim, in association with The Lancaster County Historical Society, 1979): 38.

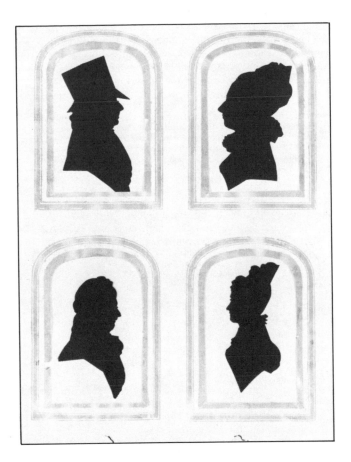

philanthropist. For many years he was associated with the Pennsylvania Company for Insurance on Lives and Granting Annuities, eventually becoming its president. Participating fully in the Jewish community, Gratz was one of the managers of the Jewish Publication Society of America and executed a deed of trust to establish Gratz College, a Jewish institution of higher learning in Philadelphia. Actively interested in the Pennsylvania Academy of Fine Arts, he served as director (1836–37) and treasurer (1841–57).

Rebecca Gratz (1781–1869), familiar from several portraits by Sully, whose career she aided, is at the upper right.[2] This graceful, accomplished woman is remembered for her role in the founding of many nonsectarian and Jewish institutions. She is thought to have been the model for the sympathetic Rebecca, the Jewish heroine of Sir Walter Scott's *Ivanhoe*, a claim never completely proven or denied.

Benjamin Gratz (1792–1884) and Maria Gist Gratz, whom he married in 1819, are shown below. Benjamin, who studied law after serving in the War of 1812, settled in Lexington, Kentucky, where the Gratz family had land holdings. He was the second president of the Kentucky Railroad.

Notes: 1. For Michael Gratz's brother Barnard, see cat. 13. 2. For a similar profile by Hubard, but reversed, see Hannah R. London, *Shades of My Forefathers*, reprinted in *Miniatures and Silhouettes of Early American Jews* (Rutland, Vt.: Tuttle, 1970), 137.

References: Carrick, Alice Van Leer. *A History of American Silhouettes: A Collector's Guide, 1790–1840*. Rutland, Vt.: Tuttle, 1968 (reprint of 1928 edition of *Shades of Our Ancestors*): 85–96. Wolf, Edwin 2nd, and Maxwell Whiteman. *The History of the Jews of Philadelphia from Colonial Times to the Age of Jackson*. Philadelphia: Jewish Publication Society of America, 1957: passim. *The Jewish Encyclopedia*. New York and London: Funk and Wagnalls, 1906, 6: 82–83.

27
Silhouettes of the Gratz Family
William James Hubard (1807–62)
Probably Philadelphia, Pennsylvania, c. 1826–28
Cut paper
Stamped on reverse; Master Hubard
9⅜ x 7⅝"; 23.8 x 19.4 cm.
The Jewish Museum
Gift of Dr. Harry G. Friedman

This artist, called Master Hubard, began his career cutting portraits in his early teens, and came to the United States from his native England in 1824. His advertisements state that he could produce a profile in twenty seconds, and as noted on the stamp on the back of these silhouettes, Master Hubard "cut with scissors. . . without drawing or machine."

Like other silhouettists, Hubard traveled from city to city, showing his works and accepting commissions. Although the examples shown here are undated, he is known to have exhibited his silhouettes at the Philadelphia Academy of Fine Arts in 1826–28, and these profiles were likely cut during those years.

Hubard became a pupil of Thomas Sully and also painted small full-length portraits while continuing to cut silhouettes. A supporter of the Confederacy, he was killed while filling a shell with an explosive of his own invention.

Portrayed in these four small silhouettes are three of the children of Michael Gratz and his daughter-in-law.[1] Hyman (1776–1857), shown at upper left, was a businessman and a

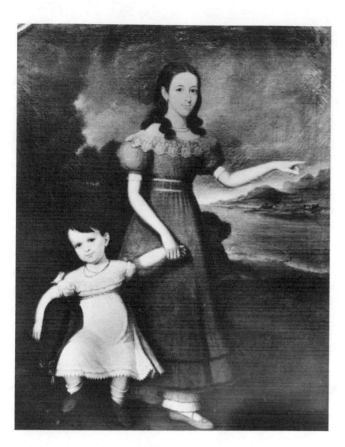

Though her figure dominates the canvas by its size, solidity, and central placement, her younger brother's bouncing energy and precocity seize the viewer's attention. The identical double strand of coral beads they wear, his disordered, hers perfectly arranged, serves to reinforce their disparity in age and disposition.[3]

Notes: 1. N. Taylor Phillips. "The Levy and Seixas Families of Newport and New York," *American Jewish Historical Society Publication* 4 (1894): 213. A portrait of Moses Levy appears in this exhibition (cat. 1). 2. The last photograph of Abraham Lincoln was taken in the Solomons' publishing house, Philip and Solomons, in Washington, D.C. See Adolphus Simeon Solomons, "Reminiscences of Abraham Lincoln," in Jacob Marcus, *Memoirs of American Jews, 1775–1865* (Philadelphia: Jewish Publication Society of America, 1956), 3: 349-56. 3. The wearing of coral as amulets by children was customary at the time. See Abby Hansen, "Coral in Children's Portraits: A Charm against the Evil Eye," *Antiques,* December 1981: 1424–31.

References: Stern, Malcolm H. *First American Jewish Families: 600 Genealogies, 1654-1978.* Cincinnati: American Jewish Archives and Waltham, Mass: American Jewish Historical Society, 1978. *Adolphus S. Solomons—Necrology. American Jewish Historical Society Publication* 20 (1911): 166-70. *The Universal Jewish Encyclopedia,* 9: 642-43. *The Jewish Encyclopedia,* 11: 459.

28
Portrait of Adolphus Simeon Solomons (1826–1910)
 and Mary Jane Solomons (1819–1905)
Artist unknown
1828
Oil on canvas
54 x 43"; 137.2 x 109.3 cm.
American Jewish Historical Society, Waltham, Massachusetts

Adolphus and Mary Jane Solomons were children of the English journalist John Solomons and his wife, the former Julia Levy, great-granddaughter of Moses Levy.[1] A philanthropist, Adolphus Solomons helped Clara Barton establish the American Red Cross, and was appointed with her in 1881 as the United States government representative to the International Congress of the Red Cross in Geneva. He also cofounded Mt. Sinai Hospital in New York and Garfield Hospital in Washington, D.C.

He was elected to the House of Representatives of the District of Columbia, and participated in all inauguration ceremonies from Lincoln to McKinley.[2] Passionately involved with Jewish institutions, Solomons served as trustee and acting president of the Jewish Theological Seminary Association of New York and as a member of the central committee of the *Alliance Israélite Universelle.* His wife, Rachel Seixas Phillips, was a descendant of several illustrious early Jewish-American families.

In this double portrait, brother and sister are depicted against a dark, almost threatening, landscape. Mary Jane, mature beyond her nine years, points to the light, to the river and mountains that subtly echo the contour of her arm.

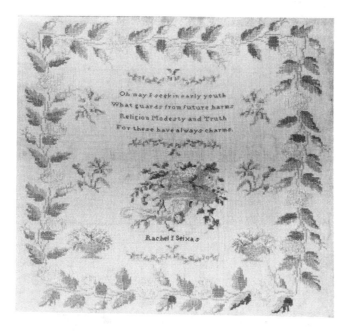

29
Sampler
Rachel I. Seixas
Second quarter of the 19th century
Polychrome silk embroidery on linen
15⅛ x 16"; 30.9 x 40.1 cm.
The Jewish Museum
Gift of Dr. Harry G. Friedman

The Seixas family was among the largest and most important of the early Jewish families in America. In the mid-1800s, at the time the sampler illustrated here was executed, three members of the Seixas family bore the name Rachel, including the daughter of Isaac Benjamin Seixas and Rebecca Judah, who was born in Richmond, Virginia, in 1822 and married Isaac Nunez Cardozo III, the grandson of Isaac Nunez Cardozo (see cats. 14 and 24). Since this sampler descended in the Cardozo family, it is assumed that this Rachel Seixas was its maker rather than either of her cousins.

Although some samplers created by young Jewish girls in America introduce the Hebrew alphabet, most share in the design vocabulary of the samplers of the day and include similar prayers and pious verses (although the samplers by Jewish girls do not display specific Christian allusions or quotations).

Reference: Stern, Malcolm H. *First American Jewish Families: 600 Genealogies 1654–1978.* Cincinnati: American Jewish Archives and Waltham, Mass.: American Jewish Historical Society, 1978.

30 (Plate 15)
Girl in White with Cherries
Attributed to Micah Williams (1782–1837)
New York, c. 1832
Oil on canvas
42 x 24"; 100.7 x 60.1 cm.
Jane Voorhees Zimmerli Art Museum, Rutgers, The State
 University, New Brunswick, New Jersey
Gift of Miss Anna I. Morgan

Little is known about the life and career of Micah Williams, a portraitist who spent most of his working life in and around New Brunswick, New Jersey, except for a brief period of residence in New York City. He may have painted portraits on travels through New York State and Connecticut, where examples of his work have been found, but the records are unclear as to the extent of his itinerancy. Most works attributed to Williams are pastel portraits utilizing a rather standardized pose with little background development, but there is a subtle modeling in the faces of his subjects that results in a more realistic portrayal than is often the case with folk painters.[1]

Although Williams's preferred medium was pastel, a few oils survive, including this painting of a young Jewish girl, thought to have been commissioned while Williams was a resident of New York (1829–33). According to recollections preserved by the artist's family, the child died in the cholera epidemic that claimed almost 3,000 lives in New York in 1832, and her parents never called for the painting. This family tradition was passed on by a daughter of the artist, Eliza Williams Nafey of New Brunswick, who owned the painting for many years, to her grandniece, Anna Morgan, a great-granddaughter of the artist. It was she who presented the painting to Rutgers University in 1959. At that time, a memorandum concerning the painting and the origin of its subject was recorded.

This beautiful canvas is distinctive among other works by Williams, not only because it is rendered in oil but because it is a full-length portrait with considerable attention given to detail beyond the features of the subject. Williams has been noted for his brilliant colors and bold patterns[2]; nowhere else in the work of the artist are these qualities more readily apparent.

Notes: 1. Irwin Cortelyou, "Micah Williams: New Jersey Primitive Portrait Artist," *The Monmouth Historian: Journal of the Monmouth County Historical Association* II (Spring 1974): 4–15. 2. Beatrix T. Rumford, ed., *American Folk Portraits: Paintings and Drawings from the Abby Aldrich Rockefeller Folk Art Center* (Boston: New York Graphic Society, in association with the Colonial Williamsburg Foundation, 1981): 193.

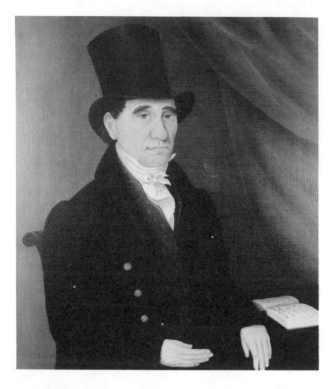

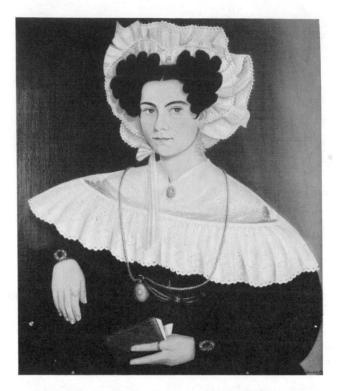

31
Portrait of Simon Content (1785–?)
John Bradley (active 1831–47)
New York, 1833
Oil on canvas
Signed and dated at lower right; I. Bradley Del. 1833
30½ x 26"; 77.5 x 66 cm.
Private collection

32
Portrait of Angelina Pike Content (Mrs. Simon Content) (1805–?)
John Bradley (active 1831–47)
New York, 1833
Oil on canvas
Signed and dated at lower right; I. Bradley Delin. 1833
30½ x 26"; 77.5 x 66 cm.
Private collection

Simon Content, a prosperous New York dry-goods merchant, was born in Holland in 1785. He married Angelina Pike, who was twenty years his junior, and fathered three children (all born in New York), one son, and two daughters who died at the ages of six and fourteen.[1]

Added to this scant knowledge, one personal fact can be deduced about the Contents that has been cleverly provided by their pictorial biographer: the portraits reveal that Simon professed the Jewish faith while Angelina followed the Christian; their intermarriage is implied by the presence of the Hebrew Scriptures lying on the table by his side and the Anglican Book of Common Prayer, inscribed "Comon Prayer" on the cover, held in her left hand.[2] The clearly legible Hebrew inscription in his Bible, with its English translation also in view, reads: "Able sais/ye obey the/Comand/ments of the/Lord your/God which I/commend you/this day."

The couple, depicted at the ages of forty-eight and twenty-eight, though of serious mien, are most fashionably and decoratively attired. The husband proudly wears a top hat, and his white silk tie is rakishly knotted around his throat, while his wife wears an exquisitely scalloped embroidered collar and a satin-trimmed bonnet, which highlights the curls of her coiffure. She is richly adorned with gold jewelry including earrings, a brooch, a pendant on a low-slung chain, sleeve buckles set with emeralds, and two rings, one clustered with pearls, the other a band studded with emeralds.

On the reverse of Simon Content's portrait appears this legend: "Simon Content taken in the year 1833 Dec. A Native from Holland New York America . . ."

John Bradley's *oeuvre* consists of twenty-eight signed portraits executed from 1831 to 1847.[3] His subjects lived mainly in the New York–New Jersey area. Before 1836 he signed his works I. Bradley, the I. being the old English form for J. Though his identity has not yet been conclusively established, it is known he was of British origin, and it is believed that he arrived in New York from Ireland in 1826.[4]

One distinctive characteristic of Bradley's art, evidenced in the portraits of the Contents, is his exactitude in rendering the details of accessories; in this instance, the lettering on the Bibles. This insistence on legibility and precision is observed in three of his other works containing calligraphic elements, two of them musical, and notated clearly enough to be played.[5] Characteristic, too, is Mrs. Content's pose, seated with one arm casually resting on the back of her chair, an attitude found in Bradley's depictions of Mary Ann and Abraham Cole Totten, Mr. Newton, and Mr. Britton.[6]

Notes: 1. Malcolm H. Stern, *First American Jewish Families: 600 Genealogies 1654–1978* (Cincinnati: American Jewish Archives and Waltham, Mass: American Jewish Historical Society, 1978). 2. Mary Childs Black and Stuart P. Feld, "Drawn by I. Bradley from Great Britton." *Antiques* 90 (October 1966): 504. 3. Beatrix T. Rumford, ed., *American Folk Portraits:*

Paintings and Drawings from the Abby Aldrich Rockefeller Folk Art Center. (Boston: New York Graphic Society in association with the Colonial Williamsburg Foundation, 1981): 61. 4. Black and Feld, *op. cit.,* 504, 508. Five portraits of the Totten family of Staten Island bear inscriptions on their backs reading: "Drawn by I. Bradley from Great Britton." 5. *Ibid.,* 502 ff. The subject of *Boy on Empire Sofa* (ill. 18 on p. 509) holds a book with the legend "The History of Robin Hood" visible on its pages. This painting is in the Abby Aldrich Rockefeller Folk Art Collection. *The Cellist* (ill. 1 on p. 502) displays a piece of music entitled "Mildred Court, P.M." It is in the Phillips Collection, Washington, D.C. The portrait of *Margaretta Bowne Crawford,* in the Monmouth County Historical Society, features the ballad, "The Angel's Whisper." See also Ruth Garbisch Manchester, "The Irish Connection: Music and Mrs. Crawford." *Monmouth County Historical Association Newsletter* 12, no. 1 (Fall 1983): 1–2. 6. Black and Feld, *op. cit.* See ills. 9, 10, 13, 16.

Reference: For early research on Bradley see: Lipman, Jean. "I. J. H. Bradley, Portrait Painter." *Art in America* 36 (July 1945): 154 ff.

33

Silhouette of Samuel Myer Isaacs (1804–1878)
Artist unknown
New York, 1839
Cut paper
10 x 8"; 25.4 x 20.3 cm.
The Jewish Museum
Gift of Dr. Harry G. Friedman

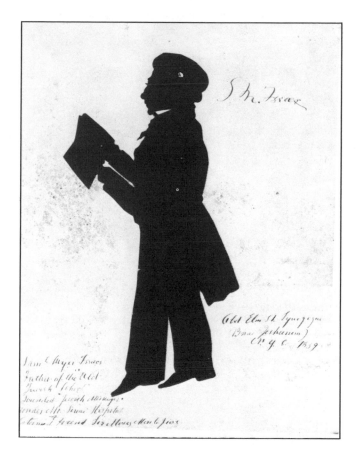

In this full-length silhouette, Samuel Myer Isaacs is portrayed wearing a large soft cap and holding a book, two elements that characterize him as a learned, observant Jew.

The inscriptions on the mount add a brief summary of his career and interests. They read: (at right) "S. M. Isaacs, Old Elm St. Synagogue (B'nai Jeshurun), N.Y.C. 1839," (at left) "Sam'l Myer Issacs [*sic*], Father of the Old Jewish School, Founded *Jewish Messenger.* Founded Mt. Sinai Hospital, Esteemed friend Sir Moses Montefiore."

The inscriptions appear to have been added at a later date, since they refer to events occurring subsequent to 1839.

Isaacs was born in Holland, and came to New York in 1838. He accepted the position of *hazzan* at B'nai Jeshurun, a congregation of Dutch, English, Polish, and German Jews who seceded from Shearith Israel. In addition to leading the service, Isaacs was also expected to deliver regular sermons in English, still a novelty in American synagogues. He remained with the congregation until 1847, when he followed a dissident group of Dutch Jews who left B'nai Jeshurun to form their own synagogue named Congregation Shaaray Tefilla.

For several years Isaacs contributed articles to *The Asmonean* and *The Occident,* English-language newspapers concerned with Jewish affairs. In 1857 he founded his own paper, *The Jewish Messenger,* in which he reflected conservative Jewish opinion. Isaacs also participated in the establishment of the Hebrew Free School Association and the United Hebrew Charities.

References: *The Jewish Encyclopedia,* 6:635. Grinstein, Hyman B. *The Rise of the Jewish Community of New York, 1654–1860.* Philadelphia: Jewish Publication Society of America, 1945: *passim.*

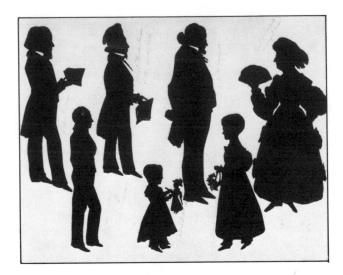

34
Silhouettes of the Kursheedt Family
Augustin Amant Constant Fidèle Edouart (1789–1861)
New York, 1840
Cut paper
Signed lower right; Aug. Edouart fecit, 1840 New York
12¼ x 15"; 31.1 x 38.1 cm.
The Jewish Museum
Gift of Dr. Harry G. Friedman

Silhouettist Augustin Edouart was born in France, where he managed a large china factory prior to emigrating to England in 1814. In his early years in England, he taught French and later produced hair-work pictures that simulated engravings. Grieving over the death of his wife, Edouart began to cut silhouettes as a challenge, and this occupation so suited his abilities that after 1826 he did nothing else. The number of works credited to him is variously given as 100,000 or 200,000.

Meticulous in execution and record-keeping, Edouart cut duplicate silhouettes, one of which he entered into his own folio books marked with the name of the sitter and the date and location of the sitting. As he believed that only the entire figure could reveal the character of the sitter, most of his silhouettes are full-length.

Edouart came to the United States in 1839. He worked in New York, Philadelphia, New Orleans, and many other cities. Unfortunately, on his voyage home in 1849, a shipwreck resulted in the loss of many of his folio books. Nonetheless, several thousand duplicate silhouettes were rescued, which together with extant sitters' copies, place Edouart firmly as the master of this popular portrait medium.

One of Edouart's greatest achievements was the conversation piece, in which silhouettes of family members, pets, and sometimes furniture, are placed against sepia sketches of family drawing rooms.[1] This grouping of Israel Baer Kursheedt (1766–1852) with his wife, brother-in-law, several children and grandchildren, although set against a plain background, nevertheless reveals Edouart's ability at creating a group portrait. Each individual is scaled to size, suggesting relative ages, and each is identified by the artist.

The major figures, Mr. and Mrs. Kursheedt, are placed on the right facing one another, with the child Rebecca between

them. Rebecca, holding a basket, is typical of Edouart's portrayal of children, who often hold toys or other objects.

Israel Baer Kursheedt, a merchant and communal leader, brought his comprehensive knowledge of Hebrew and Jewish law from his native Germany. He married Sarah Abigail Seixas (1778–1854), the favorite daughter of Gershom Mendes Seixas (see cat. 9). She is seen here holding a fan, her head apparently covered by a billowing mobcap.

The young man at the upper left is their son Gershom Kursheedt (1817–63). A newspaper publisher and communal leader in New Orleans, he served as co-executor of the will of Judah Touro (see cat. 18) and traveled to Palestine with Sir Moses Montefiore to carry out its provisions.[2]

Second from the left, the young man holding a book is David G. Seixas (1788–1864), Sarah Kursheedt's brother. David Seixas exemplified the restless 19th-century man who, eager to explore and advance the increasing complex technology available, engaged in a variety of activities. Among his accomplishments are the introduction of daguerreotypes to America, the establishment of a brewery and a crockery factory, the development of a method for burning anthracite, and, most important, the invention of a manual system of speech for deaf-mutes. He founded a small private school for such children, which eventually became the state-supported Pennsylvania Institute for the Deaf and Dumb.

All three adult males wear various types of headgear. (Jewish males traditionally cover their heads as a sign of modesty before God.)

Depicted at the lower left is the youth, Manuel, and in the center, Kursheedt's grandson Edward Isaac Kursheedt (1838–1906). As was customary in that period, he is dressed in a skirt and pantaloons. In an echo of his portrayal of Rebecca, Edouart placed a very small object in the child's hand (here a doll), further demonstrating his virtuosity and adding interest to the profile.

According to a paper label on the back, this group portrait descended in the family for several generations. It is still in its original bird's-eye maple frame of Edouart's own design.

Notes: 1. For an extremely fine example, see E. Nevill Jackson, *Silhouettes: A History and Dictionary of Artists* (New York: Dover, 1981; reprint of 1938 edition of *Silhouette: Notes and Dictionary*): pl. 57. As early as the first half of the 18th century, silhouette group portraits that included accessories and activities of domestic life were popular. 2. For a silhouette of Judah Touro, see cat. 18.

References: Carrick, Alice Van Leer. *A History of American Silhouettes: A Collector's Guide, 1790–1840.* Rutland, Vt.: Tuttle, 1968 (reprint of 1928 edition of *Shades of Our Ancestors*): 139–49. *Encyclopedia Judaica,* 10: Cols. 1301–2. Pool, David de Sola. *Portraits Etched in Stone: Early Jewish Settlers, 1682–1831.* New York: Columbia University Press, 1952: *passim.* Stern, Malcolm H. *First American Jewish Families: 600 Genealogies, 1654–1978.* Cincinnati: American Jewish Archives and Waltham, Mass.: American Jewish Historical Society, 1978. Wolf, Edwin 2nd, and Maxwell Whiteman. *The History of the Jews of Philadelphia from Colonial Times to the Age of Jackson.* Philadelphia: Jewish Publication Society of America, 1957: 324, 331–32.

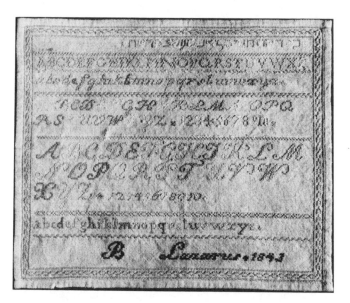

35
Sampler
B. Lazarus
1843
Silk embroidery on cotton
9½ x 11⅛"; 24.1 x 28.2 cm.
Smithsonian Institution, National Museum of American
 History, Washington, D.C.

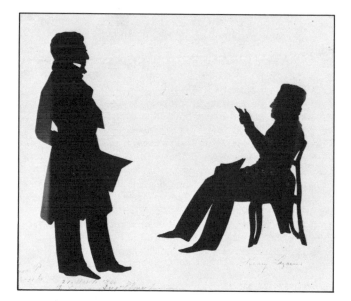

36
Silhouettes of Isaac P. Jacobs and Henry Lazarus
Augustin Amant Constant Fidèle Edouart (1789–1861)
New Orleans, 1844, and Louisville, Kentucky, 1844
Cut paper
Signed lower left; 21 March 1844 Aug. Edouart
8⅜ x 10½"; 21.2 x 26.7 cm.
The Jewish Museum
Gift of Dr. Harry G. Friedman

Edouart cleverly created a semblance of a conversation
piece by juxtaposing two silhouettes cut at different times
and in different cities. The seated Lazarus seems to be
emphasizing a point by strongly gesturing at Jacobs with his
cigar. Lazarus wears a large skull cap while Jacobs holds a
top hat in one hand. An actual connection between these
two men, Isaac P. Jacobs (of whom nothing is known) and
Henry Lazarus (1806–1868), has not yet been established.

Lazarus, a Louisville businessman, sat for Edouart at least
twice.[1] A standing profile against a lithographed background,
likewise dated 30 May 1844, is also in the collection of the
Jewish Museum.

His wife, Mary Moss Lazarus, had her profile taken by
Edouart in Louisville at the same time.

Henry Lazarus, who was born in Philadelphia, died in
Paris. In his will he benefited the Jewish Foster Home and
the Jewish Portuguese Hebra in addition to several friends,
nieces, and nephews.

Note: 1. Another version of the seated silhouette, to which Edouart
added realistic text to Lazarus's newspaper, is published in Hannah R.
London, *Shades of My Forefathers,* reprinted in *Miniatures and Silhouettes of
Early American Jews* (Rutland, Vt.: Tuttle, 1970): 169. The standing figure
against a plain background is also in London, *ibid.,* p. 167.

37 (Plate 10)
Album Quilt
Artist unknown
Frederick County, Maryland, c. 1846
Appliqué on cotton
94 x 92"; 238.8 x 236.1 cm.
Collection of Joanna S. Rose

Album quilts receive their name from the use of separate
squares of varying number "composed of appliqued or
pieced work, or a combination of both" which are laid out in
a pattern approximating items in an album. There is less
emphasis on design composition for the quilt as a whole;
instead, each square contains individual motifs which may
or may not be thematically related to those of other squares.
Album quilts were particularly popular in the mid-19th
century.[1]

A long family tradition associated with this Maryland quilt
holds that the goblet, candles, and canopy (*huppah*) are sym-
bolic of the Jewish wedding. Aside from the distinctive
square containing these devices, this fine example of the
American textile arts contains design elements frequently
found in mid-19th-century album quilts.

Note: 1. Dena S. Katzenberg, *Baltimore Album Quilts* (Baltimore: The
Baltimore Museum of Art, 1981): 13.

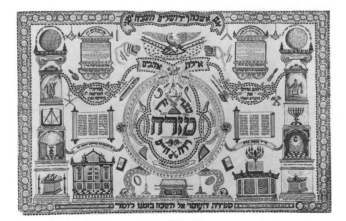

38
**Decoration for the Eastern Wall
(Mizrah) and Omer Calendar**
Moses H. Henry
Cincinnati, Ohio, 1850
Ink on paper
Signed in English, lower left; Moses H. Henry, Cincinnati,
 Ohio, 1850; in Hebrew, lower right, Moshe
25⅝ x 37½"; 65.7 x 95.4 cm.
Hebrew Union College Skirball Museum, Los Angeles,
 California

In countries west of Israel, a *mizrah* (literally, "east") is used
as a marker on the eastern wall of a home to indicate the
proper direction for prayer. There are no religious require-
ments mandating the design of this object, and it has devel-
oped into various forms, frequently in a folk-art vein, reflect-
ing diverse cultural origins. Although the repertoire of motifs
and symbols comprises all those found on other Jewish cere-
monial objects, the *mizrah* often incorporates additional
symbols not generally found in the main body of Jewish
iconography.

This highly complex *mizrah* of Moses Henry combines
micrography, biblical quotations, images drawn from Jewish
ritual practices, and references to the Solomonic Temple
with Masonic emblems and American patriotic motifs.[1]

The uppermost, central inscription and the architectonic
composition suggest that it was Henry's intention to create
an allegorical Temple. The inscription reads: "If I forget you
O Jerusalem, let my right hand wither" (Ps. 137:5).

The images of Moses the lawgiver and Aaron the high
priest are placed on the flanking pillars; the pillars in another
form are themselves Temple attributes. Henry has also de-
picted the menorah, incense altar, table of shewbread, Torah
scroll, and *megillah* (a small scroll). The verbal content of the
mizrah complements the imagery.

Inscriptions adjacent to the Torah ark on the left also
allude to the Temple. Above the ark is the declaration: "This
is the gateway to the Lord; the righteous shall enter through
it" (Ps. 118:20). Below the ark is the description: "How full of
awe is this place; this is none other than the house of God"
(Gen. 28:17). On the Torah scroll itself is the passage: "Let
them make Me a Sanctuary that I may dwell among them,"
together with additional verses giving instructions for
the creation of the Tabernacle and its accoutrements
(Ex. 25:8–14).

In micrography Henry rendered Solomon's prayer dedicat-
ing the Temple (II Chron. 6:1–20). The large central
inscription reads: "From this side the spirit of life, East," an
acrostic based on the letters of the word *mizrah* (east).

Its additional use as an omer calendar (apparent from the
fifty roundels on the border, their content, and another spe-
cific inscription) is a further indication that it was Henry's
implicit plan to create an allegorical Temple.[2] The act of the
counting of the omer serves in part as a remembrance of the
Temple after its destruction. All who regard this *mizrah* are
instructed by the inscription along the bottom: "Do not forget
to say the counting of the omer on time."

The addition of Masonic images to a *mizrah* is relatively
rare, but several other examples are known.[3] Henry has
incorporated a variety of Masonic emblems into the design,
including on the right, the letter "G," signifying God, the
"Grand Architect" to the Masons. Directly below this image
is the inscription: "The stone which the builders rejected has
become the chief cornerstone" (Ps. 118:22). Other elements of
Masonic iconography are seen in the craftsman's tools sus-
pended from the top border – the compass, plumbline, and
square.

In a central position, the American eagle and flag under-
score the inclusion, in the right cartouche, of the standard
prayer for the government found in prayer books. This is
surrounded by the inscription: "Seek the welfare of the city
to which I have exiled you" (Jer. 29:7).

Other inscriptions include references to brotherhood and
justice. At the base of the left-hand column: "How good and
how pleasant it is that brothers dwell together" (Ps. 133:1).
On the borders of the cartouche, upper left: "By justice the
King sustains the land" (Pr. 29:4). In the same cartouche, a
passage from the Yom Kippur liturgy beginning: "Our God
and King, enthroned upon compassion, rules with loving
kindness..."

The correlation between the eagle and its accompanying
inscription is unclear. The inscription reads: "A loving doe
[figuratively, a woman]" (Pr. 5:19).

Two years after he drew this *mizrah*, Moses Henry added a
dedication: "Presented to my friend, M. Henochsberg, Syra-
cuse, N.Y., 1852."

The artist, Moses H. Henry, was the son of Rabbi Henry
(Zvi) A. Henry who served in Temple Concord, a liberal con-
gregation in Syracuse, from 1851 to 1853. Moses Henochs-
berg, the recipient of this plaque, resided at the same ad-
dress as Rabbi Henry (118 Mulberry Street, Syracuse) in the
early 1850s. He presumably met Moses Henry during that
period. Henochsberg was a member of several fraternal
orders that shared ethical values with the Freemasons and
was thus likely appreciative of the Masonic imagery on this
mizrah.

Notes: 1. For a full discussion and analysis of this *mizrah*, see Alice M.
Greenwald, "The Masonic Mizrah and Lamp: Ritual Art as a Reflection of
Cultural Assimilation," *Journal of Jewish Art* 10 (forthcoming). This article is
the primary source of information for this entry which closely follows
Greenwald's interpretations of the *mizrah*. 2. The seven-week period be-
tween the festivals of Passover and Shavuot is known as the *omer*, a word
also signifying the measure of barley offered at the Temple in Jerusalem on
the second day of Passover, the day the counting begins. 3. For *mizrahim*
with Masonic imagery, see cats. 51 and 61.

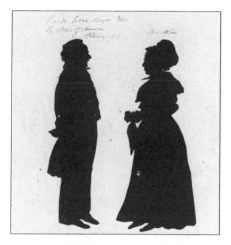

39
Silhouettes of Isaac Mayer Wise (1819–1900)
and Theresa Bloch Wise (d. 1874)
Artist unknown
Albany, New York, c. 1850
Cut paper
10½ x 8⅝"; 26.7 x 21.9 cm.
The Jewish Museum
Gift of Dr. Harry G. Friedman

This double silhouette bears the inscription: "Rabbi Isaac Mayer Wise, the Moses of America," indicating the reverence with which he was regarded. Rabbi Wise was born in Steingrub, Bohemia, and educated in Prague. Soon after his arrival in the United States in 1846, he became rabbi of Congregation Beth-El in Albany, New York. He initiated many changes there, introducing English-language sermons, a mixed choir, and family pews. After serving with an offshoot of Beth-El in Albany until 1854, he settled in Cincinnati, officiating at the Bene Yeshurun Congregation for the remainder of his life.

During his long career, Rabbi Wise wielded greater influence, particularly in the Reform movement, which was stimulated by the growing number of German-speaking immigrants. Exposed to liberal ideas in Europe, the newcomers then sought to establish congregations incorporating innovations that they thought appropriate in the American setting.

Rabbi Wise's accomplishments included the organization of the Union of American Hebrew Congregations and the establishment of Hebrew Union College, a seminary to train American rabbis following Reform principles. His writings encompass some early novels, a Reform prayer book, and books on Jewish history and theology. He founded two newspapers: the English-language *The American Israelite* and the German *Die Deborah.*

Together with Mrs. Wise's brother, Edward Bloch, he founded the Bloch Publishing Company, a Cincinnati-based firm that publishes religious books in English and Hebrew.

Reference: *The Jewish Encyclopedia,* 13: 541–42.

40 (Plate 6)
Hallah Cover
Inscription date: 1851/2
Silk brocade: appliquéd with velvet; embroidered with
 metallic thread; metallic braid; silk and metallic tassels

20 x 19"; 50.8 x 48.2 cm.
Judah L. Magnes Museum, Berkeley, California

At Sabbath and holiday meals, loaves of hallah, a special bread, are placed on the table, unsliced. They remain covered during the *kiddush,* after which the blessing for the bread is recited.[1]

This hallah cover combines biblical Hebrew with American popular imagery.

The Hebrew inscriptions read: "Gedaliah son of Simon Ha-Levy known as Ullman." "Mark that the Lord has given you the Sabbath" (Ex. 16:29), including the chronogram [5]612 [1851/52]. The Latin motto *E Pluribus Unum* ("One out of many") also appears.

The eagle became a widely used patriotic emblem after its incorporation into the Great Seal of the United States in 1782, and particularly following the War of 1812. It symbolized rights and privileges guaranteed by the federal government. The source of the eagle on this cover may be coinage, as various denominations of early American coins also employed a shield of this shape on the eagle's breast, along with thirteen stars, and the same Latin motto.[2]

Notes: 1. Cf. Sabbath Cloth (cat. 41). 2. Coins as the source for this motif on a painted chest are discussed in Monroe H. Fabian, *The Pennsylvania-German Decorated Chest* (New York: Universe Books, 1978): 166–67; figs. 161–62; and in Beatrice B. Garvan and Charles F. Hummel, *The Pennsylvania Germans: A Celebration of Their Arts, 1683–1850,* exhibition catalogue (Philadelphia: Philadelphia Museum of Art, 1982): no. 89. See also cat. 38 for another use of the American eagle.

References: Christensen, Erwin O. *The Index of American Design.* New York: Macmillan, 1950: 185. Schwarz, Ted. *A History of United States Coinage.* San Diego and New York: Barnes, 1980: 83, 105, 111.

41
Sabbath Kiddush Cloth (not shown)
Newark, New Jersey, 1855
Crocheted undyed cotton
33¼ x 29"; 84.5 x 73.6 cm.
The Jewish Museum
Gift of Mrs. Naiman through Rabbi Hershel Cohen

On Friday evening prior to the Sabbath dinner, *kiddush,* a prayer of sanctification, is recited. It includes two benedictions: one for the wine, the other for the holiness of the Sabbath. *Kiddush* is followed by the blessing over the loaf or loaves of hallah.[1]

On this tablecloth, a central wine decanter is flanked by two goblets and foliate forms, all set within a geometric border.[2]

The inscription reads: "In honor of the Holy Sabbath: wine for *Kiddush.*"

The stylized floral motifs decorating this cloth reveal the influence of European taste in textile design and may have been abstracted from an available damask example.[3]

Notes: 1. See *Hallah Cover* (cat. 40). 2. For a similar cloth, see Jewish Museum, *The Fabric of Jewish Life,* exhibition catalogue (New York, 1977): no. 180. Cf. also Abram Kanof, *Jewish Ceremonial Art and Religious Observances* (New York: Abrams, 1969): color plate 11, p. 135. 3. See also David Altshuler, ed., *The Precious Legacy: Judaic Treasures from the Czechoslovak State Collections,* exhibition catalogue (New York: Summit Books, 1983); fig. 170. See also R. D. Barnett, ed., *Catalogue of the Permanent and Loan Collections of the Jewish Museum, London* (London: Harvey Miller, 1974); pls. xxxiii and xliv.

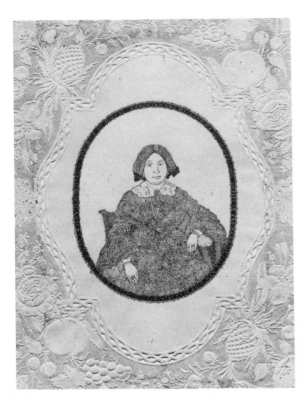

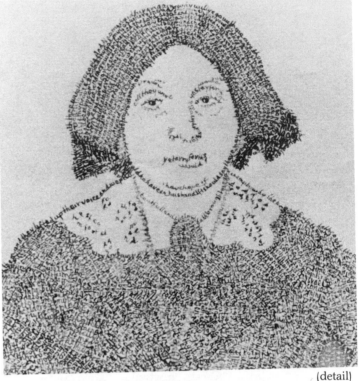

42
Micrographic Portrait of Mrs. S. Brody
David Davidson
New York, 1858
Ink on embossed and perforated paper
Signed and dated; David Davidson, 1858
9 x 6⅝"; 22.9 x 16.8 cm.
The Jewish Museum
Bequest of Herbert Lanning

Hebrew micrography – a uniquely Jewish art form in which minute lettering creates figures, objects, or abstract forms – began in the 9th century and has remained a continuous tradition in Jewish art. In this example, executed in a thoroughly 19th-century sensibility using English text, David Davidson has portrayed Mrs. Brody, her stiffly seated pose suggesting that the portrait was copied from a daguerreotype or a photographic *carte de visite*.[1]

The work is inscribed in English: "This caligraphic [*sic*] likeness of Mrs. S. Brody is composed of the book of Ruth. Executed and written by David Davidson, Artist in Penmanship, city of New York, May 5618 [1858]."

Davidson, highly praised as an artist in the Jewish press of his time, exhibited his works at his residence at 18 Avenue C, and later at 18 Howard Street.[2] In the 1853–54 exhibition at New York's Crystal Palace, he showed two works based on biblical texts, one in Hebrew, the other in English. In addition to commissions such as these of Mr. and Mrs. Brody, Davidson created micrographic portraits of President Buchanan, former President Pierce, and other luminaries.[3]

For his rendition of a visionary temple composed from the text of the Book of Esther, Davidson was described as having the "ingenious gift of penmanship."[4] Skill in penmanship was greatly admired in the 18th and 19th centuries, with many penmen engaged in creating calligraphic pictures.[5]

In addition to his artistic activities, Davidson served as a religious official at Congregation B'nai Israel, 63 Chrystie Street (a notice of his sermon on Saturday, 29 December 1852, appearing in one of the English-language Jewish newspapers).[6]

Embossed lace-paper blanks, such as the one on which this portrait is drawn, were imported from England, primarily for use as Valentines. Particularly popular during the years between 1840 and 1860, they were sold at stationers together with lithographed hearts, endless knots, and other sentimental motifs for homemade Valentines. Menus, messages (romantic and commercial), and religious pictures were also inscribed on these blanks.[7]

This work was bequeathed to The Jewish Museum by the sitter's great-grandson.

Notes: 1. For similar photographs of Jewish sitters, see Allon Schoener, *American Jewish Album: 1664 to the Present* (New York: Rizzoli, 1983): 60. 2. *The Asmonean* 9 (Jan. 20, 1854): 109; and 13 (Dec. 7, 1855): 58. 3. Noted in *The Jewish Messenger* 2 (Nov. 20, 1858): 86. For a continuation of the tradition of presidential portraits, see Leila Avrin, *Micrography as Art* (Paris: Centre national de la recherche scientifique, and Jerusalem: The Israel Museum, 1981): 59, where she cites a portrait of Franklin Delano Roosevelt based on the U.S. Constitution. 4. Hyman B. Grinstein, *The Rise of the Jewish Community of New York: 1654–1860* (Philadelphia: Jewish Publication Society of America, 1945): 222. 5. For examples of calligraphic pictures using Spencerian strokes, see Nina Fletcher Little, *The Abby Aldrich Rockefeller Folk Art Collection* (Boston and Toronto: Little, Brown, 1957): nos. 130 and 132; or Jean Lipman and Alice Winchester, *The Flowering of American Folk Art (1776–1876)* (New York: Viking Press in cooperation with the Whitney Museum of American Art, 1974): nos. 136–39. 6. *The Asmonean* 7 (Dec. 24, 1852): 141. 7. Ruth Webb Lee, *A History of Valentines* (Wellesley Hills, Mass.: Lee Publications, 1952): *passim*.

References: For an extended discussion of micrography, see Avrin, *Micrography as Art, op. cit.* For David Davidson, see: Gutmann, Joseph. "Jewish Participation in the Visual Arts of Eighteenth- and Nineteenth-Century America." *American Jewish Archives* 15 (1963): 29.

44
Micrograph in the Form of a Name
David Davidson
New York, late 1850s
Ink on embossed paper
Signed; David Davidson
7½ x 10"; 19 x 25.5 cm.
Collection of Mrs. Leon Sternberger

In this example of Davidson's *oeuvre*, he has spelled out the name L. Sternberger in a great flourish, using the text of the final two chapters of Deuteronomy.

Leon Sternberger served as both cantor and lecturer of Congregation Anshe Chesed, one of the first Reform congregations organized in New York. Sternberger possessed a fine voice, and he applied his musical training to form a mixed choir composed of men, women, and children. This was the second such choir in a New York synagogue. From 1850 to 1874, the congregation occupied a structure they built at 172 Norfolk Street.

This work was made for the great-uncle of the present owner's late husband.

References: Fine, Jo Renée, and Gerard R. Wolfe. *The Synagogues of New York's Lower East Side.* New York: Washington Mews Book, New York University Press, 1978: 21 and 96. Grinstein, Hyman B. *The Rise of the Jewish Community of New York.* Philadelphia: Jewish Publication Society of America, 1945: *passim.*

43
Micrographic Portrait of Mr. H. Brody
David Davidson
New York, 1858
Ink on embossed and perforated paper
Signed; David Davidson
9 x 6¾"; 22.9 x 17.1 cm.
The Jewish Museum
Bequest of Herbert Lanning

The printed English inscription (below the subject's left elbow) states: "This caligraphic [sic] likeness is composed of the books of the prophet Haggai and of the prophet Zechariah, executed by the artist David Davidson, N.Y."

Beneath the name "H. Brody" a dedication in Hebrew reads: "In honor of our master, t[he] v[ery learned man], H[onor to his] g[lorious] n[ame]. T[he honored] R[abbi] Haym, s[on of] o[ur teacher], t[he Rabbi] Eleazar Lippman Ha-Levy. M[ay his] l[ight shine]."[1]

This is a companion to cat. 42 depicting Mrs. Brody, and was no doubt commissioned at the same time. It, too, seems to be based on a photographic image. Mr. Brody's soft cap is in a style favored by observant Jewish men during this period.[2]

According to family history, Brody and his wife lived in Haiti, where he was a physician. They frequently visited a married daughter in New York.

Notes: 1. Since Hebrew inscriptions frequently utilize standard abbreviations, the complete text is given in square brackets. 2. Cf. photograph cited in cat. 42, note 1.

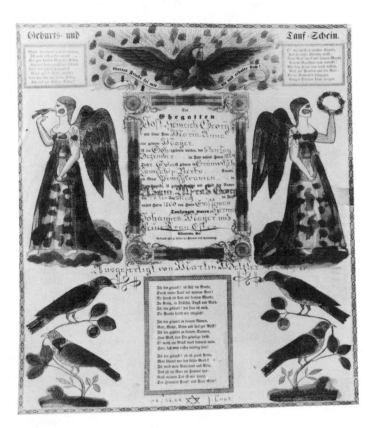

45

Birth and Baptismal Certificate
Allentown, Pennsylvania, printed c. 1860
Printer: Blumer and Leisenring
Hand-colored in ink and watercolor and inscribed by Martin
 Wetzler, 22 March 1860
Relief-printed with metalcuts and letterpress
17¾ x 14"; 45.1 x 35.5 cm.
Collection of K. Mendel

The early development of printing among the Pennsylvania Germans led to the common use of printed birth and baptismal certificates by the last decade of the 18th century. These blank forms incorporated many of the folk motifs common to the manuscript fraktur tradition and allowed the printer, a scrivener, or family member to complete the work by adding inscriptions, occasional decorations, and color. Relief-printed with woodcuts, metal cuts, and letterpress and finished by hand in ink and watercolor, printed fraktur are not as pleasing as the hand-drawn works, but they merit a place in the history of American folk art.

This printed *taufschein,* or birth and baptismal certificate, is included here because of the unusual signature of the scrivener who completed it on 22 March 1860. Martin Wetzler not only signed his name in ornate German Gothic script but added a second signature in red ink at the very bottom of the piece—in Hebrew, his first and last names being separated by the Star of David.

Martin Wetzler has left an interesting trail of printed fraktur. Unlike many anonymous scriveners, he generally signed and dated his work, providing some clues to his identity. It is known that he worked from 1854 to 1862 in Green-

wich, Windsor, and Hamburg Townships, Berks County, Pennsylvania. The *taufschein* illustrated here records the birth and baptism of Adam Alfred Georg in Greenwich Township in 1860. A series of Wetzler *taufscheine* completed in 1859–63, now at Franklin and Marshall College, carry Wetzler's signature in red ink in both German Gothic and Hebrew lettering, and in one case the Star of David is present as well. Other work by Wetzler, such as the Keistler *taufschein* (1863) in the collection of the Lehigh County Historical Society, was completed without the use of the dual signatures.

It has been suggested that Hebrew was often known to Protestant clergymen and schoolmasters, who studied it to permit a more accurate reading of the Bible, and that not a few Pennsylvania German sectarians felt a close kinship with Judaism and Jewish practices. Nevertheless, the use of Hebrew in a signature incorporating the Star of David points to a Jewish identity for Wetzler, whose surname was borne by Christians and Jews in 19th-century Pennsylvania. A search of Berks County records has uncovered no mention of Wetzler. He may have been an itinerant peddler, a common occupation for German Jews in the Pennsylvania countryside of the 1860s, and he may have included blank birth and baptismal certificates among his other stock in trade. The Jewish peddler frequently was a source of news and information. Here he appears as the transmitter of a cultural form.

The *taufschein* illustrated here was printed around 1860 in Allentown, one of the major centers for the production of printed fraktur, by Blumer and Leisenring, successors to a business established in the 1830s. This example represents a rather common form, the various design elements having become standardized. The use of decorated birth and baptismal certificates declined during the second half of the 19th century. Martin Wetzler is known to have been one of the last scriveners.

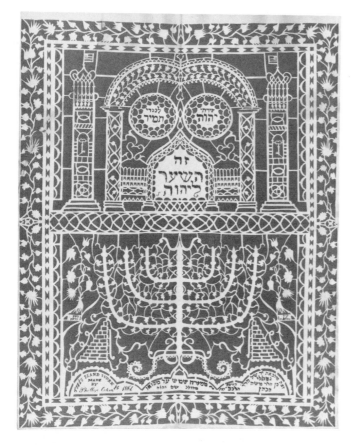

balanced by a large seven-branched candelabrum (menorah) in the lower half.

Cohen has clearly demonstrated his patriotism by proudly flying the United States flag from the top of each column. The keys in the center of each column may refer to the inscription set within the ogee-arched portal: "This is the gateway to the Lord" (Ps. 118:20). Such literal visual associations are found on other paper-cuts in this exhibition (cat. 95, 98).

The menorah is flanked by trees marked: (right) "The tree of life" (Gen. 3:22) and (left) "The tree of knowledge" (Gen. 2:17).

Below the menorah the artist inscribed his work in Hebrew: "This hand work made by the R[abbi]. . . Naftali, son of the R[abbi]. . . Moses Ha-Cohen, in the year [5]622[1861/2] and in English: "This hand work made by Phillip Cohen, 1861."

References: *Encyclopaedia Judaica,* 13: cols. 60–65. Frankel, Giza, "Jewish Paper-Cuts," *Polska Sztuka Ludowa,* 3 (1965): 135–46, 178 (English summary). Greenwald, Alice M. "The Mizrah." *Hadassah Magazine,* October 1979: 12–13.

47 (Plate 5)
Marriage Contract (Ketubbah)
Zemeh Davidson
Utica, New York 1863
Ink and watercolor on paper
Signed at bottom
12½ x 9¾"; 31.7 x 24.8 cm.
The Library of the Jewish Theological Seminary of America, New York

With a fascinating assemblage of decorative and symbolic elements, the artist of this *ketubbah* has imaginatively recorded the New York wedding of Deborah, daughter of Eliezer, to Nathan, son of Yehiel, on Sunday, the 7th of Tishri 5624 [1863]. In addition to the standard body of the text, the traditional phrase *Mazel tov* ("good fortune") is prominently inscribed in ovals above the clocks, while the customary passage from Jeremiah 33:11 "The sound of mirth and gladness, the voice of the bridegroom and the voice of the bride" appears in an arc above the top circle.

The two columns support clock faces cryptically indicating the hour of 6:13, perhaps alluding to the time of the marriage ceremony or to the birth of one of the nuptial pair.[1] Symbolizing union and fidelity, the image of the clasped hands charms with its simplicity and power.[2] The woman's ringed hand is clothed in a loose-sleeved gown, contrasting with the man's, which emerges from a two-buttoned jacket-sleeve, exposing a white shirt cuff. The various interlocking braided designs and the joined circles, connected by the body of the text of the contract, further emphasize the union of the couple.

The artist, Zemeh Davidson, identified himself by this inscription: "I wrote this and drew upon the page, for a splendid and lasting remembrance, I, Zemeh Davidson, the *shohet* [ritual slaughterer] and cantor of Utica, which is in the country of North America."

Notes: 1. The picture of a clock recording one's time of birth conveyed the Pennsylvania Germans' wishes for good luck. See the *Birth and Baptismal Record for Elisa Adam,* 1833, in Beatrice B. Garvan and Charles F. Hummel, *The Pennsylvania Germans: A Celebration of Their Arts, 1683–1850* (Philadelphia Museum of Art, 1982): 62; color plate 24. 2. A similar image is found on a German-Jewish wedding sofa of 1838 in *Danzig 1939: Treasures of a Destroyed Community,* exhibition catalogue (New York, The Jewish Museum, 1980): 62; ill. 10.

46
Shiviti Paper-Cut
Phillip Cohen
1861
Cut paper and ink
Signed at lower left; Phillip Cohen, 1861
25¼ x 19⅜"; 64.1 x 49.2 cm.
Hebrew Union College Skirball Museum, Los Angeles, California

The art of paper cutting originated in China, and became well-established in Europe by the 18th century. A popular form of Jewish folk art traditionally done by men, paper-cuts are usually created by using a knife on a sheet of paper folded in half. The symmetrical composition is then set off against a black or colored background. Many East European examples exist, having been used as markers for the eastern wall of a dwelling or community building (*mizrahim*), as home decorations during festivals, and as amulets. Paper-cuts were also made in Germany, Holland, North Africa, and the Near East. Motifs include animals (real and imaginary), birds, flowers, and objects associated with Jewish religious practices.

The phrase set in roundels beneath the double arch of this paper-cut—"I am ever mindful of the Lord's presence" (Ps. 16:8)—is often found on plaques in the synagogue. The name *shiviti* is derived from the Hebrew text (*Shiviti Adonai le-negdi tamid*) that gives this object its name. Beneath the menorah, the inscription: "From the rising of the sun, to its setting, the name of the Lord is praised" (Ps. 113:3) further emphasizes the object's intent.

Phillip Cohen's delicately cut *shiviti* contains, in its upper half, a double arch over a portal flanked by two columns and

48
Torah Binder (detail)
New York, 1869
Painted linen
8½ x 140"; 21.5 x 356 cm.
The Jewish Museum
Gift of Colonel George Feigel through Miss Augusta Berger
and Mr. Harry Berger

During the late medieval era, a distinctive type of Torah binder developed in Ashkenazic communities in Western Europe. To create such a binder, a square cloth used during the circumcision ceremony was cut into narrow strips which were then sewn end to end and embroidered (or, later, also painted) with a formula stating the child's name, his father's name, his birth date, and a quotation from the circumcision service expressing the wish that he grow up to study Torah, to stand under the marriage canopy, and to perform good deeds. The binder was then presented to a synagogue on an appropriate occasion, such as the child's first visit, and in some communities was later used to wrap the Torah at the child's *bar mitzvah*.

Within a tightly constricted framework of size and content, artists of Torah binders demonstrated a capacity for imaginative, colorful, and often witty use of Hebrew letters, biblical quotations, and local references.

Although binders may be decorated with scenes of a wedding, the reading of the Torah, or figures and foliage, the inscription itself is frequently the major design element. On many binders the ornamentation of the letters seems to have had as an original source the decorated letters of initial-word panels in medieval Hebrew illuminated manuscripts of southern Germany and the Middle Rhine.[1]

German-Jewish immigrants to the United States transplanted the custom of marking the birth of a boy in this manner, a custom which may have a common source and conceptual kinship with Pennsylvania-German fraktur birth and baptismal certificates.

This binder was made for "Gabriel, son of our honorable teacher Rabbi Eliyakim Ha-Levi [the Levite], born under a

good sign on Monday, the 26th of Tammuz, [5]629 [5 July 1869]. May God raise him to the Torah and to the marriage canopy and to good deeds Amen Selah."

Other inscriptions read: (above the pitcher and laver) "This belongs to the Levites"; (above the marriage canopy) "*Mazel Tov* [good fortune]."

The artist of this binder has continued a tradition of ornamenting the ascender of lamed (the Hebrew letter "*l*") by rendering it variously as an American flag, the serpent wrapped around the Tree of Knowledge, a cherry tree, and balsam fir.[2]

The internal embellishment of the letters is highly complex, with almost every letter having its own design or color scheme, a characteristic of many binders. Other decorative elements include a tulip, a dove in a nest with a branch in its mouth, and flowering vines. A pitcher and laver, drawn as typical ironstone china household objects of this period, denote that this child is a Levite (whose religious duties include washing the hands of the priest [*kohan*] before the benedictions). Particularly rich in its imagery, this binder also includes a three-masted sailing ship, perhaps a reference to the family's voyage to America. The poles of the marriage canopy on which the ship appears are painted red, white, and blue, an additional patriotic note.

Notes: 1. For examples of these letters in manuscripts, see Elie Kedourie, ed., *The Jewish World: Revelation, Prophecy, and History* (London: Thames and Hudson, 1979): 88 and 141; Bezalel Narkiss, *Hebrew Illuminated Manuscripts* (Jerusalem: Keter, 1969): pls. 26, 30, 41, 42, 43, and 45. For some examples on Torah binders, see, among others, Braunschweigisches Landesmuseum, *Tora-Wimpel*, exhibition catalogue (Brunswick, 1978): nos. 5, 18, and 21; R. D. Barnett, ed., *Catalogue of the Permanent and Loan Collections of the Jewish Museum, London* (London: Harvey Miller, 1974): no. 547; The Jewish Museum, *Fabric of Jewish Life*, exhibition catalogue (New York, 1977): nos. 150, 159, and 160. 2. See Narkiss, *op. cit.*, 16, for the use of ascenders and descenders as ornamentation.

References: Kirshenblatt-Gimblett, Barbara. "The Cut That Binds: The Western Ashkenazic Torah Binder as Nexus Between Circumcision and Torah." In Turner, Victor, ed. *Celebration: Studies in Festivity and Ritual.* Washington, D.C.: Smithsonian Institution Press, 1982: 136–46. Sed-Rajna, Gabrielle. "The Illustrations of the Kaufman *Mishneh Torah.*" *Journal of Jewish Art* 6 (1978): 16.

49
Decoration For the Eastern Wall (Mizrah)
Joseph A. Michael
c. 1870
Ink and pencil on cut paper
7¼ x 9½"; 18.9 x 24 cm.
Karp Family Collection

This small paper-cut *mizrah* was found by its owner in a first edition (1853) of Isaac Leeser's translation of the Hebrew Scriptures.

Michael has achieved a pleasing harmony and balance between positive and negative space.[1] At the center of this symmetrical composition, a heart emerges from an eight-branched Hanukkah lamp. On the heart is inscribed: "East."

Another heart bisects a flowering-leaf motif along the top border. Between the two hearts, the artist placed an eight-pointed star, which motif is reiterated in the row of stars along the bottom border.

Two rampant lions balanced on flowering trees flank the large central heart, while stylized doves perch on flowering plants that emerge from urns. At either side, flowering vines encircle a column. In each of the four corners is a compass-drawn six-petaled rosette.

Note: 1. For a similar European *mizrah,* see *Encyclopaedia Judaica,* 13: col. 61, fig. 1.

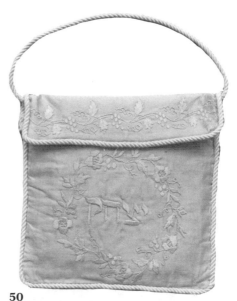

50
Prayer Shawl Bag
Charity Solis-Cohen (1844–1943)
Philadelphia, 1874
Silk satin: embroidered with silk, silk damask lining, linen
 interlining
8⅞ x 9¹¹/₁₆"; 22.5 x 23 cm.
The Jewish Museum
Gift of Charity Solis-Cohen

According to Jewish law, a male is called to the reading of the Torah following his thirteenth birthday. He then becomes a *bar mitzvah* (son of the commandment) and is responsible for carrying out all the religious precepts. Adult males wear a prayer shawl (*tallit*) during morning services, storing it in bags designed for this purpose. Prayer shawl bags embroidered with their owner's name or monogram and floral motifs were popular in Europe and America after the second half of the 19th century.[1]

Charity Solis-Cohen, who made this bag on the occasion of her youngest brother's *bar mitzvah,* donated it to the Jewish Theological Seminary when she was ninety years old. In making the bag, she followed the example of the grandmother for whom she was named, Charity Hays Solis. The latter is included on a list (from about 1782) of women who made the Torah mantles for Mikveh Israel, the first congregation in Philadelphia.

Several of the children of Myer David Cohen and Judith Simha Solis, proud of their ancestry, adopted hyphenated last names.

The inscription on the bag reads: "Isaac." He was named for Isaac Leeser, editor of the influential Jewish monthly, *The Occident.* Isaac Leeser Cohen died in Portland, Oregon, in 1892.

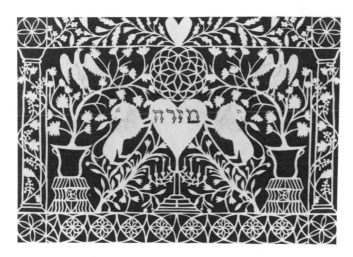

Notes: 1. Cf. The Jewish Museum, *Fabric of Jewish Life,* exhibition catalogue (New York, 1977): nos. 108, 121, and 122; David Altshuler, ed., *The Precious Legacy: Judaic Treasures from the Czechoslovak State Collections,* exhibition catalogue (New York: Summit Books, 1983): nos. 103 and 104.

References: Stern, Malcolm H. *First American Jewish Families: 600 Genealogies, 1654–1978.* Cincinnati: American Jewish Archives and Waltham, Mass.: American Jewish Historical Society, 1978. Wolf, Edwin 2nd, and Maxwell Whiteman. *The History of the Jews of Philadelphia from Colonial Times to the Age of Jackson.* Philadelphia: Jewish Publication Society of America, 1957.

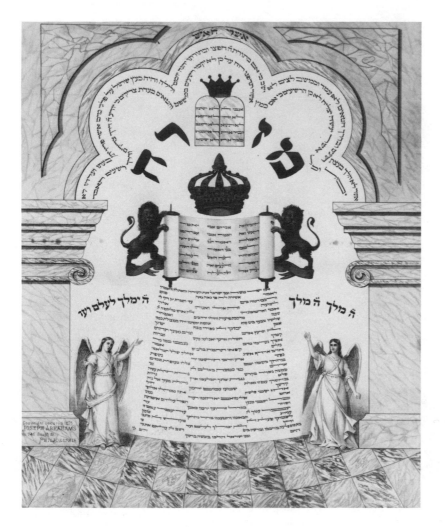

51
Decoration for the Eastern Wall (Mizrah)
Joseph Abrahams
Philadelphia, 1876
Colored lithograph on paper
Marked and dated
20 x 24"; 50.8 x 61 cm.
The Jewish Museum; Museum Purchase, Eva and Morris
 Feld Judaica Acquisition Fund

In addition to the traditional Jewish images of the Crown
of Torah, Tablets of the Law, and lions of Judah, this *mizrah*
includes two elements frequently found on Masonic docu-
ments or ritual objects.[1] Two standing angels point toward a
lengthy inscription: Moses's song of triumph after the cross-
ing of the Red Sea (Ex. 15:1–19). The calligraphy of this pas-
sage is similar to that found on Torah scrolls. The angels and
the bicolored tile floor on which they stand also occur in
Masonic iconography, suggesting either a direct influence or
simply an aesthetic borrowing.[2] Since this *mizrah* dates from
the Centennial year, it is also likely that these figures could
also represent Columbia and the figure of Liberty as shown
on coins, ships' figureheads, and on political banners.[3] Abra-
hams has here achieved an original iconographic synthesis
derived from various sources.

The four bold letters on either side of the Tablets of the
Law spell out "east," indicating the artist's intended use for
this print.

Within the cinquefoil arch, the artist inscribed in minute
letters Psalm 1, which compares the fate of the righteous
man to the wicked. On the Torah scroll are the verses from
Genesis 22 describing the journey of Abraham and Isaac to-
ward Mount Moriah, where Abraham's faith was tested.
Below the lions is the statement uttered before removing the
Torah from the Holy Ark for reading: "The Lord is King, the
Lord was King, the Lord shall be King for ever and ever."

The following is printed on the base of the left column:
"Copyright secured 1876 by Joseph Abrahams No. 746 South
Street Philadelphia."

Notes: 1. See Alice Greenwald, "The Masonic Mizrah and Lamp: Jewish
Ritual Art as a Reflection of Cultural Assimilation," *Journal of Jewish Art* 10
(forthcoming), for a discussion of Masonic imagery. See also cats. 24 and
38. 2. *Bespangled, Painted and Embroidered Decorated Masonic Aprons in
America,* exhibition catalogue (Lexington, Mass.: Museum of Our National
Heritage, 1980): nos. 39 and 87; Allon Schoener, *The American Jewish Family
Album: 1654 to the Present* (New York: Rizzoli, 1983): 96. 3. *Outward Signs
of Inner Beliefs: Symbols of American Patriotism,* Bicentennial exhibition cata-
logue (Cooperstown, N.Y.: New York State Historical Association, 1976).

Reference: Sotheby's, New York, *Important Judaica: Works of Art,* sale
catalogue, June 27, 1984: no. 57.

52

The Russian-Turkeyish [sic] **War, "Pllwna"** [Plevna]
J. S. Kolbe
New York, 1877
Colored lithograph on paper
Printed at bottom left; [Copy]rigth [sic] by Prof. J. S. Kolbe,
 N.Y. Printed at bottom right, Published by J. Richman, 63
 Chrystie [St.]
20⅞ x 26½"; 53 x 67.5 cm.
Collection of Mr. and Mrs. Stanley Albert

 This curious lithograph, published in New York in 1877,
depicts Czar Alexander II reviewing a contingent of Jewish
soldiers on the eve of the Day of Atonement (Yom Kippur) at
Plevna, Bulgaria, during the Russo-Turkish War.[1] It is un-
usual, since it describes an undocumented event, most likely
fictitious, and the motives behind its publication remain
unclear.
 The Battle of Plevna, bitterly waged for five months from
July to December 1877, was won by the Russians (aided by
Romanian troops) after they had suffered devastating losses.
During that entire time, Czar Alexander camped in the
vicinity of the fighting, visiting and comforting his wounded
men. Jewish soldiers in the Russian and Romanian forces

numbered in the thousands. (The Jews in Plevna had fled to
Sofia before the Russian invasion.) Since Alexander II re-
mained in Plevna during September, and since he was not
wholly unsympathetic toward the Jews, he theoretically
might have inspected these Jewish troops in order to bolster
morale during this critical stage of the war.[2]
 The purpose of the print is believed to have been Russian
propaganda: an attempt to gain the sympathy of American
Jews, since the Turks were rumored to be recruiting for their
army in New York.[3] The picture may also have been pub-
lished to counteract the pro-Turkish British press, which
publicized atrocities committed by the Russian army against
the Jewish civilian population.[4]
 The title of the work and accompanying legends, num-
bered from right to left, are printed in Yiddish and English.
The four captions read:

 1. *Religious Service before the Czar on the previous Day of
Atonement*
The Czar inspects Jewish soldiers whose faith is evi-
denced by their prayer shawls and the *tefillin* they
bear in their right hands.
 2. *Punishment of death for denial of faith*
Under a tree near the banks of the river a man is exe-
cuted by a firing squad.

3. *Temporary Synagogue for the Day of Atonement*
On the dome and the pediment of the place of worship appears this inscription in English and Hebrew: "The earth and the fulness thereof are the Lord's." Above the rabbi, dressed in white, and eleven soldiers standing on a raised platform, the following passage from Leviticus 16:30 is written in columns on the scroll: "For on this day you shall be forgiven for all of your sins. Before God you shall be cleansed."
4. *Bridge over the Danube*
The Russians crossed the Danube at the end of June and controlled the bridge.

While the majority of the Jewish soldiers wear the dark-green uniforms of the Russian infantry, twelve carry swords indicating the rank of officer. This detail represents a conspicuous falsehood since, at that time, Jews were not permitted to be officers in the Russian army.[5]

Related in theme but different in intent and audience is the Commemorative Panel, by an anonymous German artist in 1870, depicting Jewish soldiers holding Yom Kippur services in the German army camp at Metz.[6] Based on a historical incident, but greatly exaggerated, the panel also portrays an outdoor service on the Day of Atonement, in which 1,200 Jewish soldiers participate.

This print of the Battle of Plevna attests to the naïveté of the artist in its presentation of four simultaneous narrative episodes, a problematic perspective, and the arrangement of figures forced into decorative patterns.

Notes: 1. Another version of this print, smaller and without color, was published in 1888 in New York. See Alfred Rubens, *A Jewish Iconography*, Supplementary Volume (London: Nonpareil, 1982): Addendum, 7–8; cat. no. 2194A, color plates 72–73. 2. *Ibid.* 3. *Ibid.* 4. *Ibid.* 5. *Ibid.* 6. One example is in the collection of The Jewish Museum. See *Fabric of Jewish Life: Textiles from the Jewish Museum Collection*, exhibition catalogue (New York, 1977): ill. 246, p. 127.

References: Williams, Henry Smith. *The Historians' History of the World*, Encyclopaedia Britannica, Inc., New York, 1926, XVII, 602–5. Schorsch, Ismar. "Art as Social History: Oppenheim and the German Jewish Vision of Emancipation." In *Moritz Oppenheim: The First Jewish Painter*, exhibition catalogue. Jerusalem: The Israel Museum, 1983, 54–56.

53
Tablet with Blessings
Baruch Zvi Ring (1870–1927)
Varznik(?), Lithuania, 1880
Crayon on cut paper
Signed bottom center and dated
15¼ x 12"; 38.7 x 30.5 cm.
Collection of Mr. and Mrs. A. Harvey Stolnitz, grandson of
 the artist

This delicate, unfinished paper-cut represents the earliest known work by the artist prior to his arrival in the United States. Its command of design and virtuosity of technique are demonstrated in the myriad lines and shapes. Bending geometry to his will, Ring revels in intricate patterns created with circles, rectangles, hexagrams, zigzags, and the like. Though astonishingly complex, the composition possesses a balance and clarity attesting to the eye and hand of a master craftsman, most remarkable for a ten-year-old.

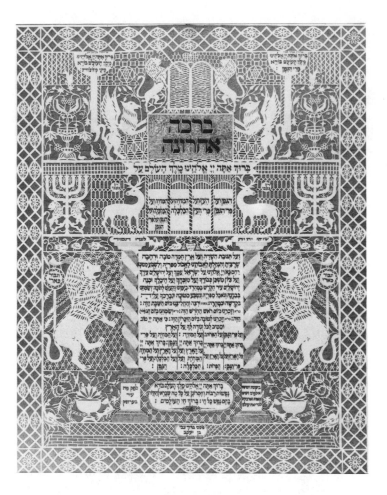

In all Ring's works, traditional iconographic images such as the menorah, Crown of Torah, and Tablets of the Law are combined with relevant biblical and talmudic writings. The major portion of this paper-cut's text cites the grace said after eating a meal in which bread is not served. In addition, the customary passage "as strong as a lion" and "as swift as a deer" (*Ethics of the Fathers* 5:23) is accompanied by the specific animals. Atop the blue-and-white twisted columns, a motif found on numerous Jewish ceremonial objects, appears this inscription: "I am ever mindful of the Lord's presence" (Ps. 16:8). Below the columns, in a centered cartouche, Ring dated and signed his work: "Here in the city Varznik[?]. From me, Baruch Tzvi, son of Jacob."

Among the multitude of animals and birds, squirrels, swans, storks, and peacocks appear. Visible, too, is the legendary griffin, with its lion's body and eagle's head, claws, and wings.

Born in Vishya, Lithuania, Baruch Zvi Ring emigrated to the United States in 1902. He was a widower with five children, and earned his living as a Hebrew teacher and scribe (*sofer*) in Rochester, New York. His memorial plaques and *mizrahim* were admiringly displayed in synagogues.

Three of Ring's later paper-cuts appear in this exhibition (see cats. 77, 80, and 95). Larger-scaled, they demonstrate a greater boldness and freedom in color and design. A stylistic change is observable, too, in the emphasis on the religious text and symbolism rather than on finely detailed cutting.

54 (Plate 1)
Quilt
Adolph Schermer (1846–1934)
New York, c. 1887
Satin: edged with velvet; and black satin appliqué;
 backed in velvet
57 x 71¾"; 140.5 x 180.2 cm.
Collection of The Hudson River Museum, Yonkers,
 New York
Gift of Miss Lillie Schermer

Although quilting is generally considered a woman's art,
men also have created quilts throughout much of the history
of American folk art. Many Jewish men who emigrated to
the United States in the late 19th and the first quarter of the
20th century were trained in needlework in their country of
origin, which may account for their involvement in this art
form here.

Adolph Schermer was a tailor in his native Austria-
Hungary, and emigrated to New York in the early 1880s; he
settled on the Lower East Side, where he married, had seven
children, and lived for approximately forty years. Although
he did not work as a tailor in this country, Schermer con-
tinued to use his skill to create a number of quilts, including
the one pictured here, which he made around 1887.

During the late-Victorian period, the quilt became a col-
lage of silks, velvets, and fragments of ribbon fancifully em-
bellished with embroidered designs, in keeping with the
then-popular emphasis on detailed decoration. This quilt
includes many unusual circular, petaled motifs set in the
separate squares that differ from the traditional patterns
commonly encountered in silk and satin quilts from this era.
Wheels within wheels, pentagrams, stars, and petal-like
forms create a curious imagery amid the embroidered and
pieced fragments. The figured background velvet is slightly
more elaborate than the usual backing of polished cotton,
plain velvet, or satin. Schermer also introduces an American
flag in combination with a Star of David, symbols of his
patriotism and religious heritage.

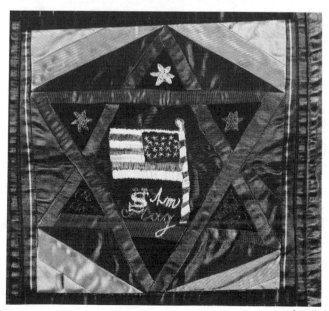

(detail)

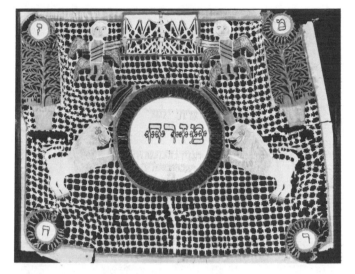

55
Decoration for the Eastern Wall (Mizrah)
Jacob Hochfelder
Plattsburgh, New York, 1887–89
Cut and painted paper
Signed in the inscription; Jacob Hochfelder, Cantor
16½ x 20"; 41.9 x 50.8 cm.
Collection of Temple Beth Israel, Plattsburgh, New York

This naïvely drawn and cut *mizrah* bears the inscription:
"I am ever mindful of the Lord's presence (Ps. 16:8), East.[1]
This was made by my hands, Jacob Hochfelder, cantor." The
letters in the four corners also spell out *mizrah* (east). A
paper label on the back indicates that the *mizrah* was made
of butcher's paper, and is dated 1887–89.

The cutting of the overall netted background is similar to
that also found in German parchment-cuts.[2] Here, a heavy
vertical band in the center is the result of poor technique in
cutting and folding the paper. Two rampant lions support the
central roundel, and two potted trees are placed under the
upper two roundels at either side. Two potted plants are bal-
anced on the lions' heads.

In the upper center, two creatures support a rectangular
panel criss-crossed with a sharply webbed design. These fig-
ures may represent a personal view of the quartet of four-
faced, four-winged creatures in Ezekiel's vision, while the
panel might be the bright fire from which lightning flashed
(Ezek 1:1–14).

Cantor Hochfelder, evidently unskilled at drawing and
paper-cutting, has unconsciously created—through lack of
perspective and the flattened features of the figures—an
abstract evocation of Ezekiel's vision of creatures capable of
traveling in four directions "without turning when they
moved" (Ezek. 1:12).

Notes: 1. For a discussion of the use of this quotation, see cat. 46.
2. For an example of this netted design, cf. *Encyclopaedia Judaica*, 13,
following col. 44, pl. 1.

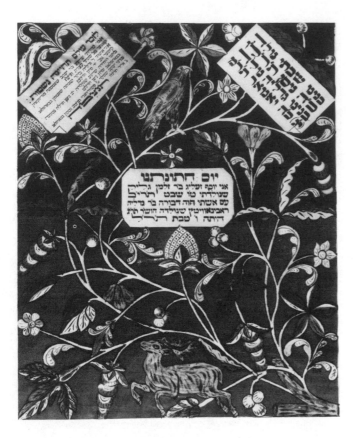

56
Family Record
Joseph Zelig Glick (1852–1922)
Pittsburgh, Pennsylvania, 1888
Cut and painted paper
Signed along the bottom, J. Z. Glick, 1888,
 Pittsburgh, America.
17⅞ x 15"; 45.5 x 38.1 cm.
Collection of Evelyn Glick Bloom, granddaughter of the
 artist

Russian-born Joseph Zelig Glick emigrated to the United
States in 1887 with his wife and two sons. In Russia he
taught the Talmud, the Bible, Hebrew, Russian, German,
calligraphy, and penmanship; he was also a shop owner.
Immediately after his arrival here, he supported his family
by giving Hebrew lessons, but soon began to publish the
Volksfreund, the first Yiddish periodical issued west of the
Alleghenies. A weekly magazine composed of witty talmudic
discussions, each issue also contained a Hebrew crossword
puzzle, one of the first publications to offer this feature.

In 1903, Glick began a second weekly, *The Jewish Post of
Pittsburgh.* At its inception, it was printed only in Yiddish;
later English was added. Obviously a man of many diverse
talents, Joseph Zelig Glick also wrote poetry in Yiddish and
Hebrew, as well as many essays, pamphlets, and Zionist
editorials.

According to his granddaughter, the current owner, this
richly colored plaque is the only paper-cut he ever made.
Unusual in its asymmetry, the work comprises intricately

curved and branched tendrils growing from a single branch
at the lower right. This single bough sprouts a variety of
flowers, leaves, and fruit, suggesting that Glick, a very
subtle man, may have intended it to represent a bough from
the Tree of Life, a major theme in East European ceremonial
art.[1] In a continuation of this imagery, an orange-and-green
parrot perches on an upper stalk, while a fully antlered deer
races across the bottom. Glick divided the work into two
registers by superimposing it on black paper at the top and
glazed blue paper at the bottom.

This paper-cut served to document significant events in
the family history. The inscription at the upper right refers
to the birth of two of his children: "Our son Shabbati was
born 25th of Nisan [5]636 [1876]. Our son Gedaliah was
born, Tuesday, 25th of January, [5]640 [1880]."

Inscribed as a memorial, the panel at upper left reads:
"May these souls be for eternal rememberance: My
mother and teacher Sheina d[aughter of] Jacob who
is buried in Grinkshick Kanor [?], Shemini Atzeret
(the eighth day of Sukkot) [5]616 [1856]."[2]

My mother's father Gedaliah s[on of] Shabbati Santman,
who is buried in the province of Waclav [?], Koivar 14th
of Sivan, [5]639 [1879]."

"Our only daughter Sheina, who was born 12th of
Nisan [5]638 [1878], and buried in Waclav [?] eruv
Rosh Hodesh Nisan [5]639 [1879] (on the eve of the new
moon).

"Our son Yaakov who was born February. . .[5]642
[1882] was buried in Waclav [5]646 [1886].

In the central panel Glick recorded his marriage,
inscribing:

"Our marriage day,
I, Joseph Zelig s[on of] Zalman Glick, who was born
the 15th of Shevat [5]612 [1852], with my wife Chava,
Deborah d[aughter of] Gedaliah Rabinowitz who was
born Hashanah Rabbah [5]613 [1853], was the 6th of
Tevet [5]630 [1870]."

Additionally, this family history hung in the household as
a *mizrah.* It also functioned as an acceptable proof of Glick's
son Samuel's age in lieu of a birth certificate, enabling him to
receive his Social Security benefits.

Notes: 1. See Zofja Ameisenowa. "The Tree of Life in Jewish
Iconography," *Journal of the Warburg Institute 2 (1939)*: 344–45, for a
discussion of the Tree of Life as a motif in Jewish paper-cuts, and Stephen
Kayser and Guido Schoenberger, *Jewish Ceremonial Art* (Philadelphia: Jewish
Publication Society of America, 1955): 10. 2. In giving dates, reference is
often made to holy days and festivals occurring at the same time.

Reference: *Who's Who in Pennsylvania.* New York: Hamersly, 1904.

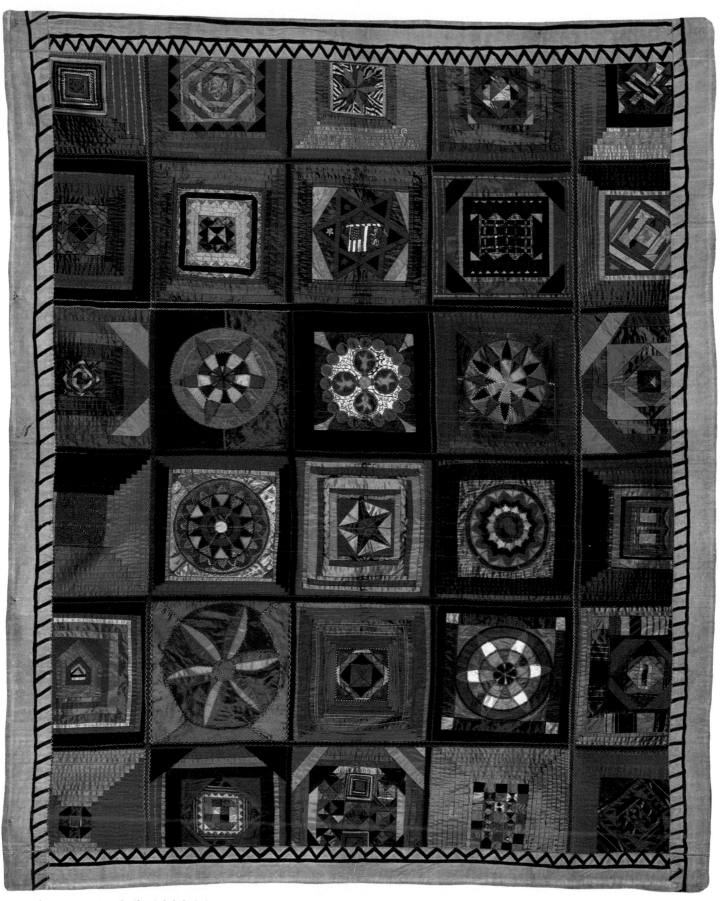

Plate 1 (cat. 54). Quilt. Adolph Schermer (1846–1934); New York, c. 1887.
Satin: edged with velvet and black satin appliqué; backed in velvet.

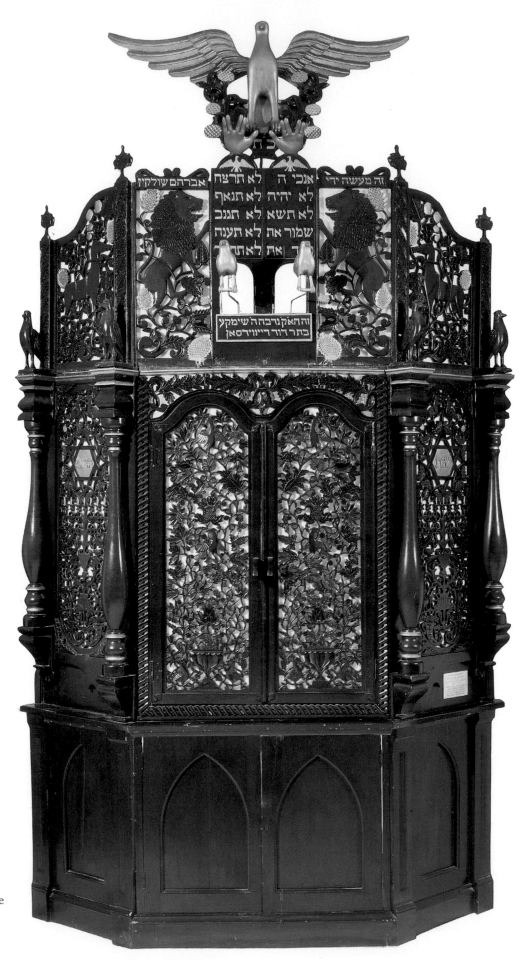

Plate 2 (cat. 64). Torah
Ark from Adath
Jeshurun Synagogue.
Carved by Abraham
Schulkin; Sioux City,
Iowa, 1899. Carved pine
with wood stain and
gold-colored bronze
paint.

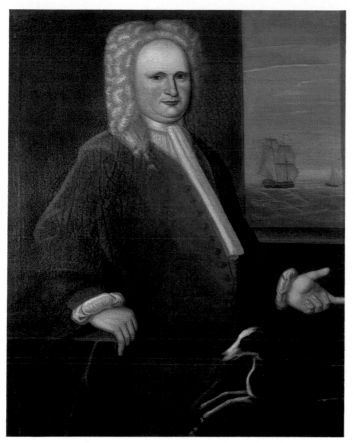

Plate 3 (cat. 1).
Portrait of Moses Levy
(1665–1728). Attributed
to Gerardus Duyckinck;
New York, c. 1720–28.
Oil on canvas.

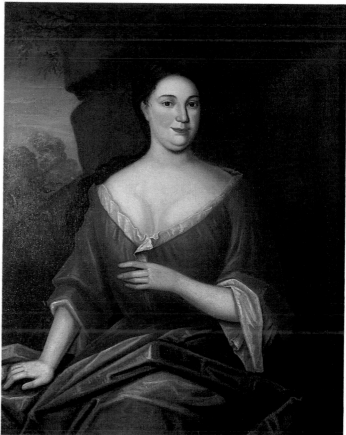

Plate 4 (cat. 2). Portrait
of Grace Mears Levy
(Mrs. Moses Levy)
(1694–1740). Attributed
to Gerardus Duyckinck;
New York, c. 1720–28.
Oil on canvas.

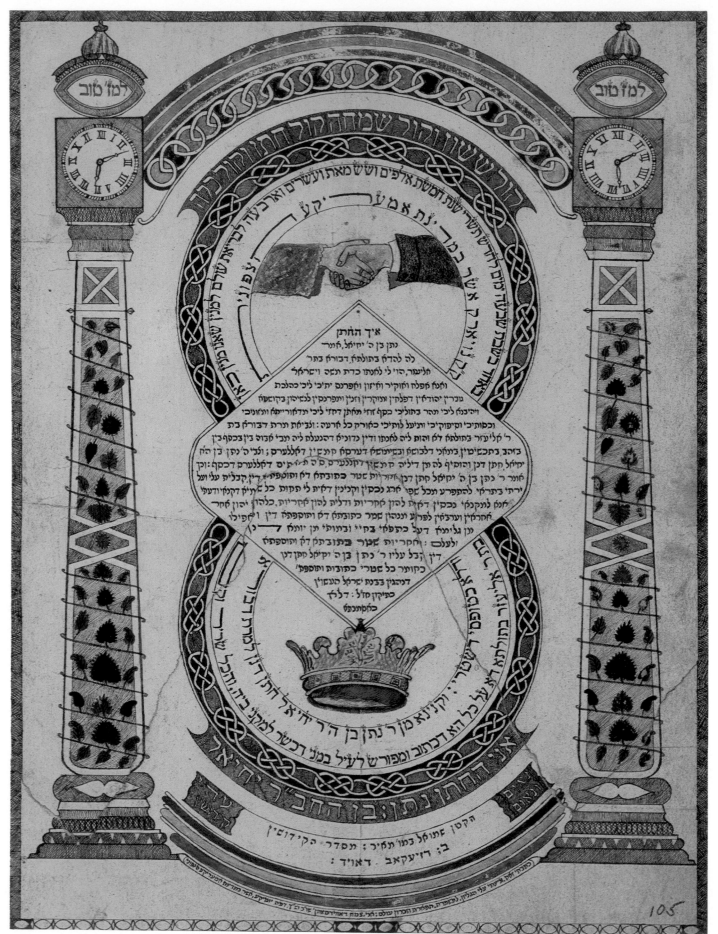

Plate 5 (cat. 47). Marriage Contract (Ketubbah). Zemeh Davidson;
Utica, New York, 1863. Ink and watercolor on paper.

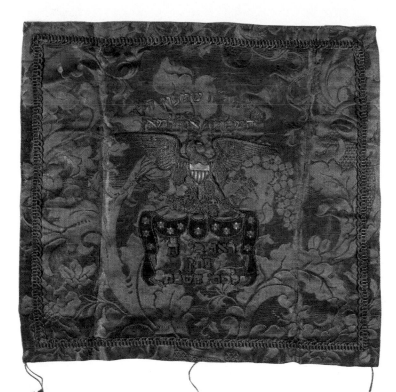

Plate 6 (cat. 40). Hallah
Cover. Inscription date:
1851/2. Silk brocade:
appliquéd with velvet;
embroidered with
metallic thread; metallic
braid; silk and metallic
tassels.

Plate 7 (cat. 96). Etrog
Box. G. Friedman; New
York, 1918. Carved and
painted wood, plated
copper and brass.

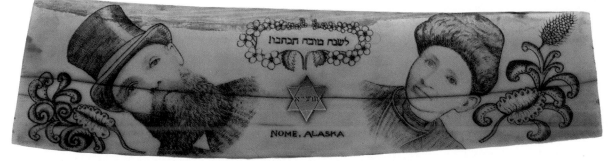

Plate 8 (cat. 87). Jewish New Year's Greeting. Artist unknown;
Nome, Alaska, 1910. Engraved tusk with brass inset.

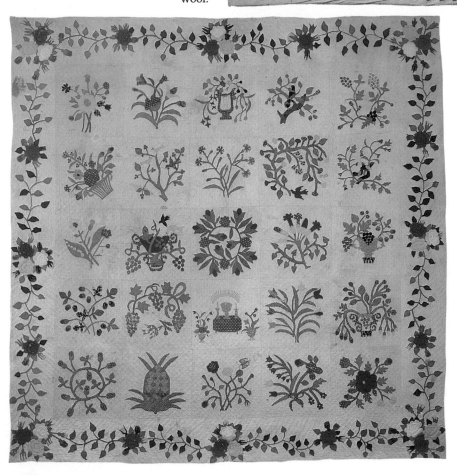

Plate 9 (cat. 58). Album
Quilt. Katie Friedman
Reiter and Liebe Gross
Friedman; McKeesport,
Pennsylvania, c. 1891–92.
Appliquéd cotton and
wool.

Plate 10 (cat. 37). Album
Quilt. Artist unknown;
Frederick County,
Maryland, c. 1846.
Appliqué on cotton.

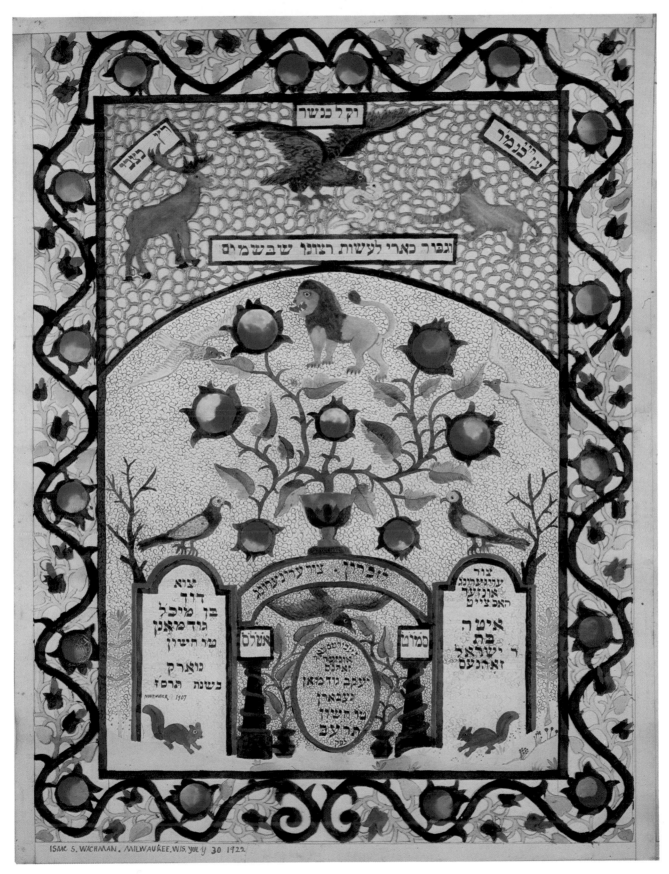

Plate 11 (cat. 100). Family Record. Isaac S. Wachman;
Milwaukee, Wisconsin, 30 July 1922. Ink and watercolor on paper.

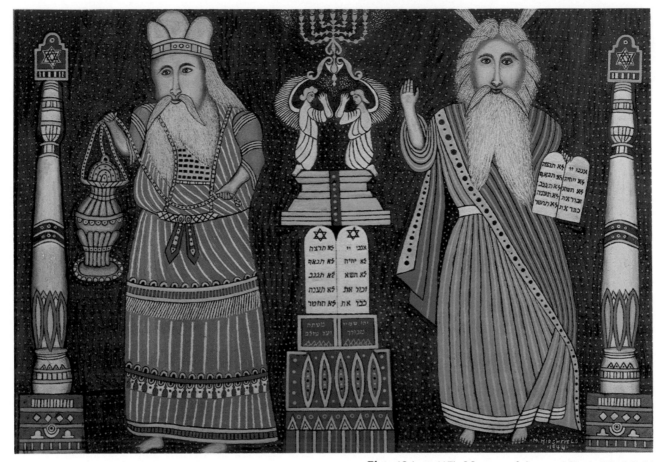

Plate 12 (cat. 117). Moses and Aaron. Morris Hirshfield
(1872–1946); 1944. Oil on canvas.

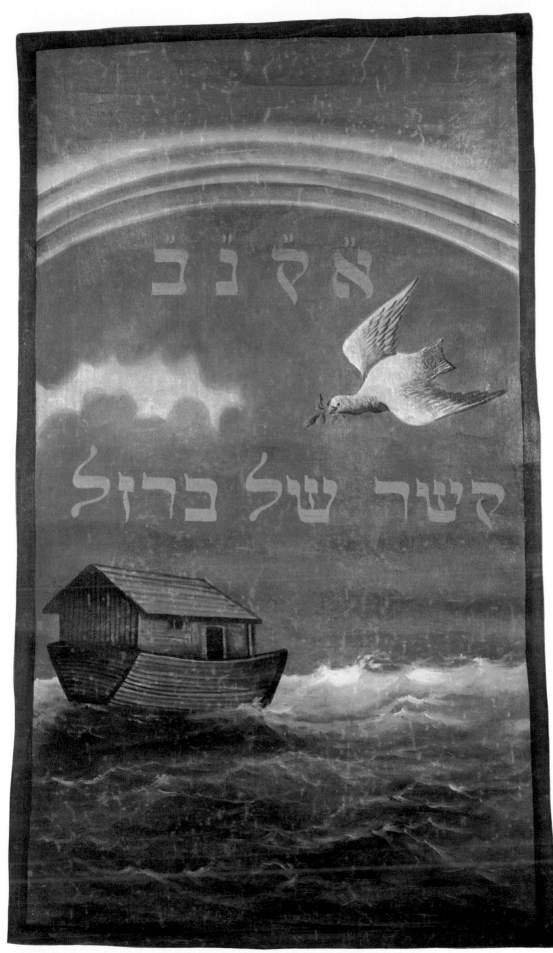

Plate 13 (cat. 66). Banner of the Fraternal Organization Kesher shel Barzel. Artist
unknown; last third of 19th century. Oil on canvas windowshade.

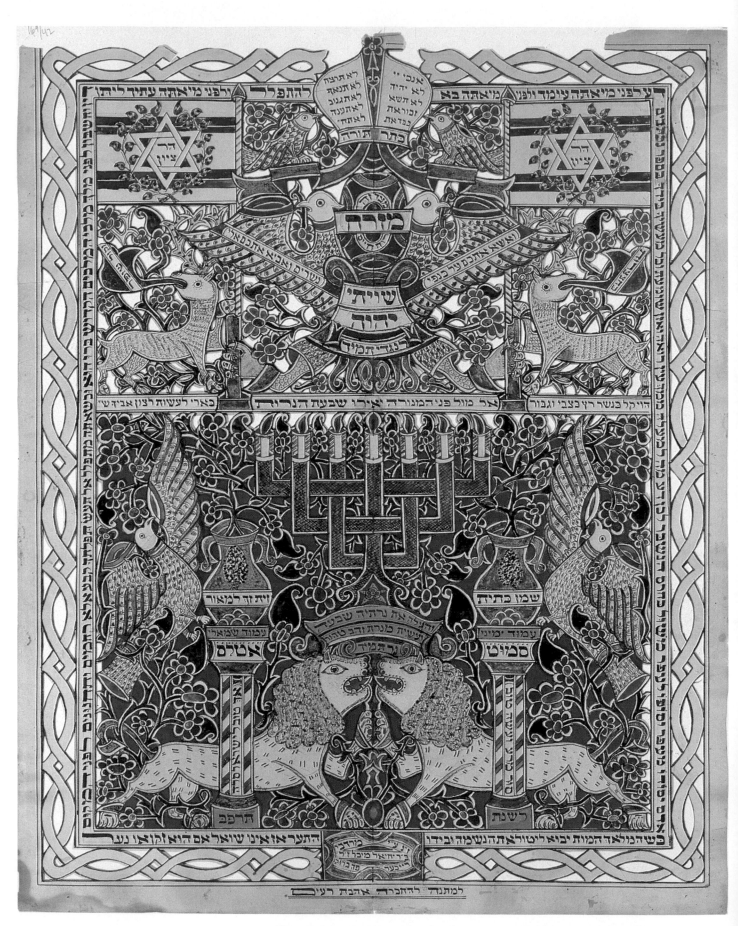

Plate 14 (cat. 99). Decoration for the Eastern Wall (Mizrah and Shiviti). Mordechai
Reicher (1865–1927); Brooklyn, New York, 1922. Ink and watercolor on cut paper.

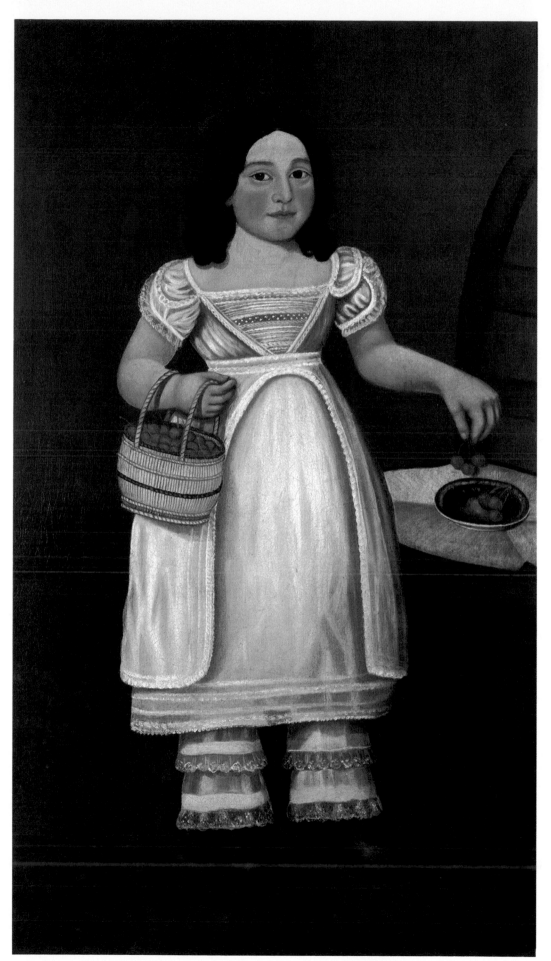

Plate 15 (cat. 30). Girl in White with Cherries. Attributed to Micah Williams
(1782–1837); New York, c. 1832. Oil on canvas.

Plate 16 (cat. 127). Esther and Ahasuerus. Malcah Zeldis; New York, 1976.
Oil on Masonite.

Plate 17 (cat. 126). Hanukkah Lamp. Mae Shafter Rockland (1937–);
Princeton, New Jersey, 1974. Wood covered in fabric with molded plastic figures.

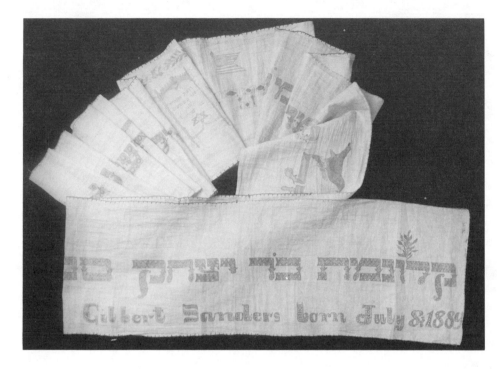

57
Torah Binder
Trinidad, Colorado, 1889
Painted linen with silk thread edging
9½ x 141"; 24.1 x 358.8 cm.
Hebrew Union College Skirball Museum, Los Angeles,
 California

This binder was made for: "Kalonymus s[on of] Isaac Sanders, born under a good sign on the 9th of Tammuz, [5]649 [1889]." The name and date "Gilbert Sanders, July 8, 1889," are also added in English. This addition is rare, as the vernacular is not usually found on binders. An ornate Torah scroll is inscribed: "This is the Torah that Moses set before the Israelites" (Deut. 4:44). This binder includes an American flag in its ornamentation.

Trinidad was a coal-mining center in the late 19th century, and was one of the earliest Jewish communities in Colorado. It was founded shortly after the 1859 gold rush swelled Colorado's population. A synagogue, Temple Aaron, was erected in 1889, the same year this binder was made.

Gilbert Sanders, a lawyer, became a president of this congregation. The recipient of an honorary degree at Hebrew Union College, Sanders donated his binder to the college's collection.

58 (Plate 9)
Album Quilt
Katie Friedman Reiter and Liebe Gross Friedman
McKeesport, Pennsylvania, c. 1891–92
Appliquéd cotton and wool
101 x 101"; 257.5 x 257.5 cm.
Collection of Theresa Reiter Gross and Leba Reiter Wine

As a girl of twelve, Katie Friedman left her native town in Slovakia, then a part of the Austro-Hungarian Empire, and traveled by herself to a new life in America, arriving in 1885. Married five years later to Benjamin Reiter, she moved with her husband to McKeesport, Pennsylvania, where she soon was joined by her mother, Liebe, and her brother and sister. In 1891, the year her family arrived from Europe, Katie's first-born son died in infancy and her brother drowned. It was while she was mourning the loss of her son and brother that Katie, with the help of her mother, created this vibrant appliquéd album quilt.

It is interesting to note how quickly Katie Reiter became familiar with American quiltmaking methods and design resources, no doubt because she took up residence in a small steel-mill town in Pennsylvania rather than in one of the larger cities where Jewish life tended to remain more insular. Most of the images and motifs that she incorporated into her quilt are floral in nature and are typical of Pennsylvania-German appliqués. The unusual introduction of figures in black, however, may have been more personal in origin. A family tradition holds that the two riders (the family name means "rider" in German) astride black steeds represent the two lost boys for whom Katie and Liebe were mourning. The use of black cloth for the animals associated with childhood pets or toys seems to support this tradition. Julie Silber has written that "Katie Reiter's quilt is a remarkable object, but its function and meaning go far beyond the visual and utilitarian. In its imaginative design, the quilt reminds us of the independent and resourceful twelve-year-old who left home alone to make her way in a new land. In quiltmaking she found a creative form characterized by tradition and continuity, concerns especially meaningful to an immigrant."[1]

Note: 1. Julie Silber, "The Reiter Quilt: A Family Story in Cloth," *The Quilt Digest* (San Francisco: Kiracofe and Kile, 1983). This entry is based upon this interesting and well-documented account of a remarkable American quilt.

59
Scholar's Table in a Bottle
Herman Leo Winer (1875–1936)
1894
Glass bottle, wood, feather, pen and ink on paper
Signed and dated on inkwell; H. L. Weiner, 1894
Signed and dated on paper; Tzvi Leib, son of R[abbi] Chaim
 Isaac Weiner, 1894
10 x 2½ x 3¼"; 25.3 x 6.2 x 8.3 cm.
Collection of Herbert I. Winer, son of the artist

Family legend relates that Herman Winer created this
unique construction either on board the ship bearing him to
America or shortly after his arrival. Winer was born in
Spigenye, Lithuania, and studied in a yeshiva in Vilna; he
left for New York in 1894. At first a peddler, he soon worked
for the *Yiddisches Tageblatt* (the first Yiddish daily newspaper
in the United States) and later for the *Yiddische Gazetten.*
Eventually, he established the English-Yiddish *Daily Food
News* and the H. L. Winer Special Agency, which offered
foreign-language advertising services. He was a founder of
the Society for the Advancement of Judaism, and also served
as an officer of the Federation of Lithuanian Jews.

A paean to knowledge, the assemblage *Scholar's Table in a
Bottle* is executed with a simplicity and straightforwardness
of conception designed to glorify the word. It consists of a
sturdy wooden table upon which rest an open book and a
sheet of paper – both bearing legible texts – and an old-
fashioned inkwell containing a graceful quill pen. The book
is inscribed in Yiddish with the reflective motto: "To see and
to copy is permitted; to ask and to say is forbidden." Labels
on the inkstand record "H. L. Weiner, *Tinte* [German for ink]
1894," and in Russian, "G. L. Vainer." The artist's identity is
further documented on the text on the sheet of paper, which
states: "Tzvi Leib s[on of] Chaim Isaac Weiner." The bottle is
sealed with a stopper with a crosspiece running through it
preventing its removal.

Traditionally, objects in bottles were crafted by men who,
forced to live in cramped, depersonalized quarters, remained
spiritually isolated, such as sailors, lumberjacks, and inmates
of institutions.[1] While American bottled objects (other than
ships) commonly represent Christian subjects, such as varia-
tions on the cross, one secular example exists that shares
similarities with *Scholar's Table* in content, if not in style.[2]

Found in New England, this work, *Table with Vase of Dried
Flowers and Rushes, Books, and Bugle,* also presents a table on
which rests an open book, presumably a Bible, and a second,
closed, book entitled *By the Sea.*[3] Dried flowers and other
memorabilia complete this tribute to or by a sailor. But its
sentimental tone is in sharp contrast to Winer's mood of
religious solemnity.

Notes: 1. B. H. Friedman. "The Message in the Bottle," *Art in America,*
March 1981, 91–97. 2. A European assemblage with a Jewish subject,
Model of the Second Temple in a Bottle, was constructed by Moses Form-
stecher in Germany in 1813. This object is in the collection of The Jewish
Museum (JM 21–79, a, b). 3. Friedman, *op. cit.,* fig. 18, p. 95.

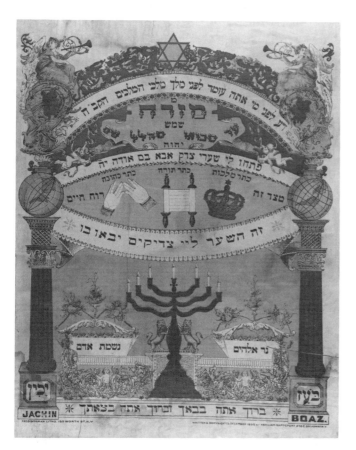

60
Decoration for the Eastern Wall (Mizrah)
Abraham Rappaport
New York, 1895
Four-color lithograph on paper
Printed at bottom left: Fred Wogram Litho. 180 Worth St.,
 N.Y.; at bottom right: Written & Copyrighted, December
 1895 by Abraham Rappaport, 248 E. Broadway N.Y.
20 x 16"; 51 x 39.7 cm.
Collection of David M. Wagner

In this *mizrah,* Abraham Rappaport incorporated a variety
of artistic styles and numerous standard printing elements.
Certain forms have their sources in Baroque and Rococo de-
signs, while the globes of the world and the winged female
heralds are contemporary representations.

In his selection of specific images, Rappaport seems to
have relied on stock examples from a printer's style book,
but his unsophisticated juxtaposition of these sophisticated
details has resulted in an amalgam consistent with folk art
traditions.

Like Moses Henry (cat. 38), Rappaport produced a *mizrah,*
which is itself a physical reminder of the Temple and incor-
porates visual and verbal references to this end. Images
alluding to the Temple include the pillars—prominently
labeled "Jachin" and "Boaz"—the menorah, the fire pans of
the sacrificial altar, lions, the crown, the Torah, and the
hands of priestly blessing.

At the top, the heralds advise: "Know before whom you
stand [variant of Babylonian Talmud, Berakhoth 28b], before

the supreme King of Kings, the Holy One, Blessed be He"
(*Ethics of the Fathers* 3:1).

Below, Rappaport indicates that he intended his work to
be used as a *mizrah* by inscribing: "From the rising of the sun
to its setting, the name of the Lord is praised" (Ps. 113:3).

Linking the globes are two inscribed bands with the re-
quest: "Open the gates of righteousness for me, that I may
enter them and praise the Lord" (Ps. 118:19); "This is the gate-
way to the Lord, the righteous shall enter through it" (Ps.
118:20).

Between the two bands, Rappaport depicted and labeled:
"The crown of royalty, the Crown of Torah, and the crown of
priesthood" (*Ethics of the Fathers* 4:17).

On the fire pans adjacent to the menorah, Rappaport has
inscribed: "The soul of man is the lamp of the Lord" (Pr. 20:27).

On the bases of the pillars: "Jachin" and "Boaz."

Across the bottom is the inscription: "Blessed shall you be
in your comings and blessed shall you be in your goings"
(Deut. 28:6), from Moses's address to the Israelites exhorting
them to obey the Commandments.

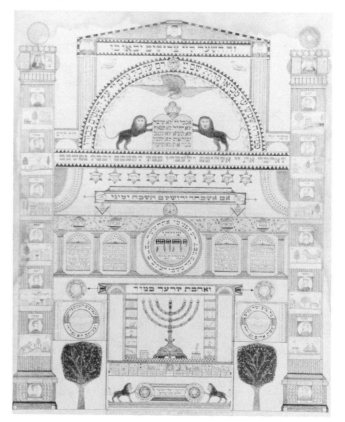

61
Decoration for the Eastern Wall (Mizrah)
Zelig Abe Goldsmith (1861–1925)
Denison, Texas, 1896
Colored ink and crayon on paper
Signed and dated; Zelig Abe Goldsmith, 1896
27 x 21½"; 68.6 x 54.6 cm.
Collection of Leonard L. Rosenthal

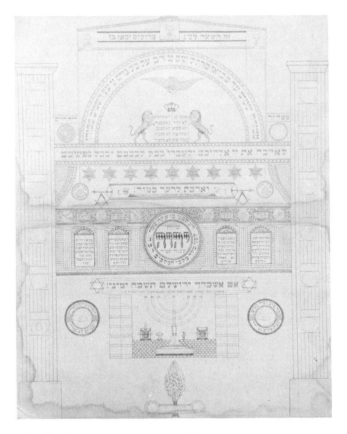

62
Decoration for the Eastern Wall (Mizrah)
Zelig Abe Goldsmith (1861–1925)
Troy, New York, prob. before 1909
Colored ink and crayon on paper
27 x 21½"; 68.6 x 54.6 cm.
Collection of Leonard L. Rosenthal

Zelig Abe Goldsmith was born in Russian Poland and came to the United States as a youth. He first settled in Denison, Texas, residing there until 1879. Except for the period 1890–99, when he returned to Denison, Goldsmith lived in Troy, New York, until his death. He was the proprietor of a grocery store, and later became an employee of the Troy Water Works. During his lifetime Goldsmith was active in several fraternal organizations including the Maccabees, Modern Woodmen, Lone Star F. & A.M. of Denison, Texas, the Knights of Zion, American Israelite Club, Independent Order of Brith Abraham, and the Hebrew Benevolent Association. For thirty years he served as secretary for his synagogue, Beth Israel Bikkur Cholim, an Orthodox congregation, and was its president for a decade.

After this completed work, intended by the artist to serve as a *mizrah,* Goldsmith began another similar one which remained unfinished. In a note added on the back of the unfinished *mizrah* in 1920, Goldsmith stated that, "sight is bad, disappointed in business, lost courage [I am] putting it away here." The "here" presumably referred to the backing behind the frame of his earlier, completed work, which is where it was found. The tone of the note further suggests that the second *mizrah* was begun before 1909, the year Goldsmith became president of his congregation, and it

remained neglected for many years before he safeguarded it.

Goldsmith's knowledge of the Hebrew Scriptures and his membership in the Freemasons are both evident in the extensive iconography on both of the *mizrahim.*[1]

The architectonic composition in both examples recalls that employed by the earlier Moses Henry (cat. 38) and Goldsmith's contemporary, Abraham Rappaport (cat. 60). In the top register, a Classical temple capped with a triangular pediment bears the bilingual inscription: "The gate of the eternal, the righteous shall enter" (Ps. 118:20). Below the row of Stars of David, he emphasizes a companion bilingual inscription: "If I forget you O Jerusalem, let my right hand wither" (Ps. 137:5), by drawing at each end of its enclosing cartouche a hand with an extended index finger, reiterated in an arrow pointing in the opposite direction.

Under an archway containing the Hebrew inscription (translated in the columns of the pediment): "From the rising of the sun unto its setting thereof, praised be the Eternal's name. Exalted above all nations is the Eternal, above the heavens is His glory" (Ps. 113:3–4), the artist has placed the Tablets of the Law, guarded by two rampant lions, and surmounted by a dove hovering over the Crown of Torah. Centered in the archway is the six-pointed Star of David within which is placed the Masonic omniscient eye. Further integrating a Masonic symbol with a Judaic one, Goldsmith twice inserted the Star of David into Masonic insignia of the intersecting compass and right angle.

On the large flanking columns are profiles of the leaders of the twelve tribes, each accompanied by a tribal emblem. Other images in this highly complex *mizrah* include the signs of the zodiac accompanied by the names of the signs and the Hebrew months; depictions of biblical patriarchs and kings; references to Jewish holidays, festivals, and rituals; and the menorah, and altar of the Temple. The black-and-white checkerboard pattern of floor tiles below the menorah is an element frequently found in Masonic documents, where it symbolizes the good and evil in life.

The biblical and talmudic inscriptions are in praise of God, the Torah, and brotherhood. These previously unpublished *mizrahim* further confirm the inclusion of Masonic imagery in American *mizrahim.*

Note: 1. For a discussion of Masonic imagery on a *mizrah,* see cat. 38 and Alice M. Greenwald, "The Masonic Mizrah and Lamp: Ritual Art as a Reflection of Cultural Assimilation," *Journal of Jewish Art* 10 (forthcoming).

Reference: *Bespangled, Painted and Embroidered Decorated Masonic Aprons in America 1790–1850.* Exhibition catalogue. Lexington, Mass.: Scottish Rite Masonic Museum of Our National Heritage, 1980.

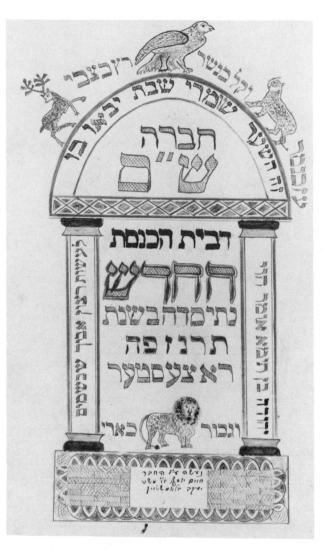

63
Register (Pinkas)
Hayyim Joseph Blumstein
Rochester, New York, 1897
Ink and watercolor on paper; bound
14¼ x 8¾ x ⅝"; 36.5 x 22.5 x 1.5 cm.
Karp Family Collection

Upon the arrival at these shores of large numbers of East European Jews—which commenced in the last two decades of the 19th century—communal organizations modeled on European patterns were established in American Jewish communities. In the *shtetlach* of Eastern Europe, Jewish life was organized in *hevrot*, associations organized around religious or charitable functions, or as trade groups. Each *hevrah* recorded its rules and regulations, the names of its founders and members, and the minutes of its meetings in a *pinkas,* or register. *Pinkasim* were treated with veneration by the members of the community; the home in which a *pinkas* was kept was considered especially blessed. Community *pinkasim* are frequently the only source available to us on the life and times of the *shtetlach*.

There was much folklore associated with the *pinkas*. In the Ukraine, for example, there was a belief that the home in which a *pinkas* was kept would always be preserved from fire, and that the woman of the house would never have trouble giving birth.[1] A former resident of a *shtetl* in Poland has recalled his attempts as a boy to discover the essential nature of the *pinkas* without success, until his teacher, with great ceremony, explained it to him:

"A *pinkes, Leybele,* is a book in which all of the unusual events and occurrences that take place in a town are recorded, both good things and, God forbid, not such good things." He continued slowly, sipping [tea from a glass] after each phrase: "The good things are recorded, so that the generations that follow us will learn to behave well and will also perform good deeds. The bad things that happen, may we be spared, are recorded so that people may know not to do them, and also so that the One Above will pity us and see that no evil harms us in the future. Amen."[2]

Because of their importance, pages of early European *pinkasim* were generally parchment and were bound in fine leather with gold lettering, but most American *pinkasim* are standard large blank journal or account books purchased from commercial stationers. Many European and American *pinkasim* were written by professional scribes, or *soferim,* frequently in the same script reserved for the scrolls of the Torah. The title pages and headings of a *pinkas* were frequently illuminated with fine ornamentation and drawings, folk figures, and decorated letters.[3]

The nature of American life was such that many traditional *hevrot* were supplanted by other forms of communal organization, but *pinkasim* documenting them survive. The records they provide allow a fascinating insight into the lives of immigrants who, even as they wrested a living from their new environment, established societies for the granting of interest-free loans, the study of the Talmud, and the reading of psalms.

The decorated title page of the *pinkas* of a *Hevrah Shas* in Rochester, New York, shown here incorporates traditional folk images from the *Ethics of the Fathers,* a popular treatise from the Mishnah, concerned with ethical instruction. "Judah ben Temah said, 'Be as strong as a leopard, light as an eagle, swift as a deer and brave as a lion to do the will of our Father in heaven.'" (*Ethics of the Fathers* 5:23). A *Hevrah Shas* met regularly to study "Shas," which is the Hebrew abbreviation of *Shishah Sedarim*—the "six orders" into which the Mishnah is divided—and is also popularly used as a name for the entire Talmud. Similar iconographic figures may be found in the Goodman family record (cat. 100).

Notes: 1. Abraham Rechtman, *Yidishe etnografye un folklor,* quoted in Diane K. Roskies and David G. Roskies, *The Shtetl Book: An Introduction to East European Jewish Life and Lore,* 2d rev. ed. (New York: Ktav, 1979): 181-82. 2. Jack Kugelmass and Jonathan Boyarin, eds., *From a Ruined Garden: The Memorial Books of Polish Jewry* (New York: Schocken, 1983): 25. 3. Rechtman, *op cit.:* 182.

64 (Plate 2)
Torah Ark from Adath Jeshurun Synagogue
Carved by Abraham Schulkin
Sioux City, Iowa, 1899
Carved pine with wood stain and gold-colored bronze paint
10′ 5″ x 8′ x 30″; 305 x 244 x 76 cm.
The Jewish Museum
Gift of the Jewish Federation of Sioux City, Iowa

The carving and construction of this three-tiered carved semihexagonal Torah ark[1] embodies close stylistic parallels to its often more complex counterparts in Polish wooden synagogues. Wooden synagogues were a common vernacular form of architecture in the forest-covered areas of Eastern Europe, where official permits to build masonry synagogues were often difficult to obtain.[2] However, the proliferation of wooden churches in these same areas indicates that pragmatism, cost factors, local traditions, and available craftsmen may have played a greater role in the choice of wooden structures than did legal restrictions.

Such European synagogues often contained arks with two central doors covering the niche that houses the Torah scrolls and side panels that angle back to the rear wall. One or more superstructures usually incorporated carving and symbolic elements such as the Tablets of the Law, the hands of the high priests (kohanim), disposed in a gesture of benediction, and animals such as lions and eagles.

Abraham Schulkin used such a plan for carving the panels of the ark made for the Adath Jeshurun synagogue, the first Jewish congregation founded in Sioux City in 1884. According to his family, the artist was an amateur, although he was paid for his work. The unorthodox construction of this large piece of synagogue furniture attests to his lack of training.

The three-tiered ark rests on a base featuring four Gothic arches. Four carved panels form the main part of the ark in which the Torah scrolls are housed. On the two central doors which open to receive the Torah, Schulkin has carved an intricate low-relief cut-out of dense foliage emerging from vasiform containers. Partially hidden in the branches are eagles deriving from Polish stylistic sources. Curiously, a similarity can also be observed in the eagles of the Pennsylvania-German carver Wilhelm Schimmel.

On each of the two side panels, foliate forms into which are woven a seven-branched candelabrum surmounted by a Star of David emerge from cornucopias. The date 1899, in Hebrew, is contained within these stars. Four cantilevered free-standing turnings, two with each of the side panels, terminate in three-dimensional stylized doves.

On the superstructure of the uppermost screen, the artist has centered the Tablets of the Law. Above are a Crown of Torah and a pair of hands, the fingers opened in the traditional gesture of priestly blessing. Below the tablets are two cutout niches housing three-dimensional movable doves. Below the doves is the inscription in Hebrew: "The ark is a gift of Simhah the daughter of Rabbi David Davidson."

Two rampant lions in flat relief flank the Tablets of the Law. Following his predilection in the lower section, Schulkin has again allowed these playful creatures to emerge from the luxuriant foliage. Above the lions, Schulkin has inscribed in Hebrew: "This was made by the hands of Abraham Schulkin." Two side panels with s-shaped tops following the 45-degree angle of the lower portions complete the screenlike superstructure, here incorporating stags into the foliate forms.

Atop this screen stands a large carved dove with outspread wings. The wings are detailed with stylized feathers, but the bird's body has been so simplified as to border on abstraction.

Stylistic comparisons can be made to the carvings of the Torah arks at Janow Sokolski[3] and Izabielin,[4] especially in the delineation of the round sunflowers. These Polish examples are, however, more exuberantly carved and have greater three-dimensionality. Also, it is interesting to note that, in their similar openwork and motifs, many of the paper-cuts may well have been modeled on such carved Torah arks.

Notes: 1. A Torah ark is a cabinet set in or against one wall of a synagogue, holding the Torah scrolls. 2. Rachel Wischnitzer, *The Architecture of the European Synagogue* (Philadelphia, Jewish Publication Society of America, 1964): 127. 3. Maria and Kazimierz Piechotka, *Wooden Synagogues,* English ed. (Warsaw: Arkady, 1959), fig. 63. 4. Wischnitzer, *op. cit.,* 140.

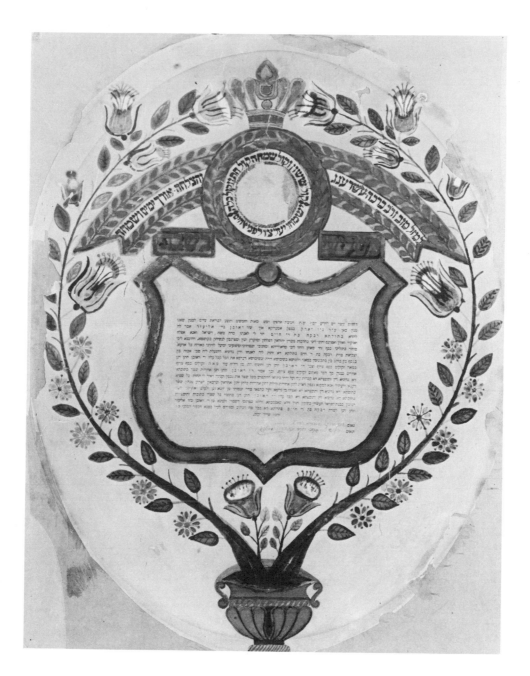

65
Marriage Contract (Ketubbah)
Artist unknown
New York, 1899
Ink and watercolor on paper; with printing and calligraphy
Oval 25½ x 20″; 64.8 x 51 cm.
The Jewish Museum
Gift of Dr. Harry G. Friedman

This *ketubbah* documents the marriage of Reuven, s[on of] R[abbi] Eliezer to Rebecca, daughter of Hayyim in New York City on Tuesday, the twelfth day of the month of Tammuz in the year 5659 [1899]. The standard marriage contract is printed in the central shield-shaped cartouche, while hand-written blessings and biblical passages appear in the circle and the arc behind it. The couple is wished "good fortune" (*mazel tov*) and "many blessings [of] wealth, joy, success, length of days, and happiness." "The sound of mirth and gladness, the voice of the bridegroom and bride" (Jeremiah 33:11) and "[But the righteous] shall rejoice, they shall exult in the presence of God" (Ps. 68:4) are also inscribed.

The lush decoration of verdant foliage is enhanced by a dark palette of blues, purples, greens, and golds. The urn of flowers, a motif found in American folk art, here assumes a particularly significant role: two separate branches that issue from it are rooted in a single vessel and may symbolize the union of the newlyweds.

66 (Plate 13)
Banner of the Fraternal Organization
 (Kesher shel Barzel)
Artist unknown
Last third of 19th century
Oil on canvas windowshade
60 x 36"; 152.4 x 91.5 cm.
Buccleuch Mansion, on loan to Jewish Historical Society of
 Central Jersey, New Brunswick, New Jersey

This colorful painting is the banner or sign of the *Kesher
shel Barzel,* a national Jewish fraternal organization which,
founded in 1860, existed throughout much of the United
States until 1903. The familiar images of Noah's Ark and the
dove refer to the passage in Genesis 8:11, "And the dove
came in to him at eventide; and lo in her mouth an olive-leaf
freshly plucked; so Noah knew that the waters were abated
from off the earth." The upper Hebrew inscription abbre-
viates the passage, "I have set my bow in the cloud [and it
shall be for a token of a covenant between Me and the
earth]" (Gen. 9:13). The lower inscription is "Knot or Bow, of
Iron," which is the name of the organization and which itself
embodies an allusion to the rainbow.
 The banner was found in the attic of Buccleuch Mansion,
a historic house in New Brunswick, New Jersey. It was
labeled "[f]rom the old Vanderbilt House" which is a local
residence where Commodore Cornelius Vanderbilt lived in
the early 19th century. It has been suggested that a branch of
Kesher shel Barzel may have met in the Vanderbilt residence
many years later, but the existence of a lodge in New Bruns-
wick has not been established. In view of the inscription and
image, it is possible that the banner was the symbol of the
Kesher shel Barzel branch in Poughkeepsie, New York, which
was known as "Ark Lodge."

67
Hanukkah Lamp
Possibly New England, 19th century
Crimped and punched tin
7⅛ x 10¼ x 1⅞"; 18.1 x 26 x 4.7 cm.
Collection of Manfred Anson

 Hanukkah is a joyous festival commemorating the success-
ful Maccabean revolt of the Jews against their Greco-Syrian
conquerors in c. 165 B.C.E., and it symbolizes the achieve-
ment of religious freedom. The word Hanukkah means dedi-
cation, and refers to the rededication of the Temple after it
had been desecrated. Lights are burned during the eight days
of the festival, one on the first night and an additional one on
each succeeding night, until the final night when all eight
are lit. A ninth light, the servitor (*shammash*), is used each
evening to light the others.
 Shiny when new, inexpensive and easily worked, tin was
known as "poor man's silver." Lighting fixtures, pots and
pans, and other household utensils were items most often
fabricated from sheet tin by cutting, hammering, and
soldering.[1]
 This handsomely designed hanging Hanukkah lamp is
composed of a semicircular reflector below which are
aligned crimped pans for holding the oil. The back is embel-
lished with a pattern of lilies, a motif common on New
England tinware. Found in Newburyport, Massachusetts,
this lamp was possibly made in that area.

Note: 1. Priscilla Sawyer Lord and Daniel J. Foley, *The Folk Arts and
Crafts of New England* (Radnor, Pa.: Chilton, updated ed., 1975): 72–85.

68
Hanukkah Lamp (not shown)
Possibly American, 19th century
Tin
2¼ x 8⅞ x 2¼"; 5.4 x 20 x 5.6 cm.
The Jewish Museum
Gift of Harry G. Friedman

 This lamp is in its own tin box and features a detachable
servitor lamp. Such lamps were generally made so that they
could be packed for travel.

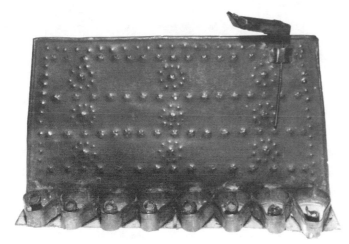

69
Hanukkah Lamp
Possibly American, 19th century
Punched tin
7 x 9⅞ x 1⅝"; 18 x 25 x 4.2 cm.
Collection of Sylvia Zenia Wiener

On this standing-form Hanukkah lamp, the trapezoidal backplate is embossed with horizontal rows of stars and with vertical rows of stars that are circled by smaller dots. Oval burners are set in a row along the bottom, and a removable servitor lamp is attached at the upper right of the backplate.

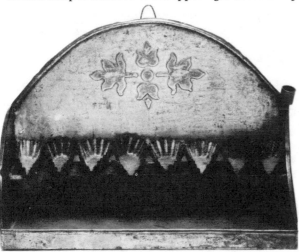

70
Hanukkah Lamp
Possibly Pennsylvania, mid-19th century
Punched and crimped tin
7½ x 10⅛ x 4⅛"; 18.2 x 25.5 x 10.2 cm.
The Jewish Museum
Museum Purchase, Eva and Morris Feld Judaica Acquisition Fund

This crimpware and punched-tin Hanukkah lamp is one of a group that are thought to be American. While the decoration here relates to Pennsylvania-German motifs, the fact that these decorative elements were closely adapted from European sources might also suggest a Continental origin for this object.

Reference: Sotheby's, New York. *Important Judaica: Works of Art.* Sale catalogue, June 27, 1984: no. 55.

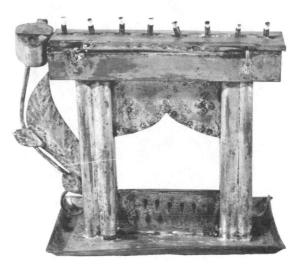

71
Hanukkah Lamp
Las Vegas, New Mexico, early 20th century
Hammered and pierced tin
6½ x 6¾ x 3⅛"; 16.5 x 17 x 8 cm.
Spertus Museum, Chicago, Illinois

Probably made by an American Indian, this unique Hanukkah lamp strangely resembles a curtained theater box. The oil is contained in a reservoir on the top, and the wicks are pulled through minute openings. A leaflike appendage constitutes the servitor light.

Las Vegas is the site of the oldest congregation in New Mexico.

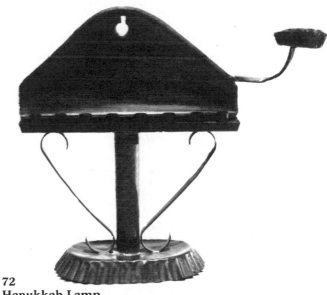

72
Hanukkah Lamp
Possibly American, early 20th century
Cut and crimped tin
10⅞ x 12¼ x 4"; 27.5 x 31.1 x 10.2 cm.
Collection of Esther and Samuel Schwartz

The crimped surface on the base and servitor of this standing Hanukkah lamp provides a contrast to the smooth surface of the backpiece. The unknown craftsman has added a further decorative note in the scroll supports linking the candle holder to the base.

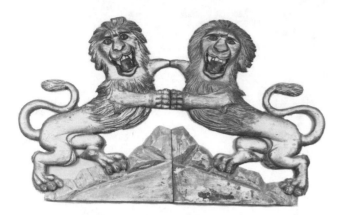

73
A Pair of Carved and Gilded Lions from a Torah Ark
Artist unknown
Congregation Linas Hazedek, Kansas City, Missouri, c. 1900
Carved and painted wood
25⅛ x 42½ x 1⅝"; 63.8 x 108 x 4.2 cm.
Karp Family Collection

The use of lions to support the Tablets of the Law—a long-standing iconographic convention of synagogue architecture and decoration—has its roots in ancient Jewish art and in "the poetry of the Jewish people."[1] Lions frequently appear in Jewish folk art "both as a vague symbol (e.g., of power, kingship, and so on) and as a purely decorative motif."[2] This gleeful pair from a Kansas City synagogue once adorned its ark.

Notes: 1. Nahman Avigad, *Beth She'arim* (Jerusalem: Massada Press, 1976), 3:285. 2. *Ibid.*

74
Scroll of Esther (Megillah) (not shown)
Rabbi David Isaac Cohen (1825?–1941)
Chicago, Illinois, late 19th–early 20th century
Brass case, vellum, and ink
Case: 7 x 8" circumference; 17.8 x 20.2 cm.
Collection of Mr. and Mrs. David A. Gerber, Buffalo,
 New York

Humbly encased, this scroll (*megillah*) of Esther bears eloquent testimony to the faith of its maker, Rabbi David Isaac Cohen. The Book of Esther relates the triumph of Mordecai and Queen Esther in circumventing Haman's plot to destroy the Jews, and is recited in the synagogue on Purim, the feast celebrating those events. Unlike the larger Torah scrolls, the *megillah* has only one roller. Though illustrations were forbidden on synagogue *megillot* read aloud in a congregation, scrolls for individual use were often lavishly decorated.

The artist who created this *megillah* brought his craft, tools, and dedication with him from Europe. Rabbi Cohen, who lived to be somewhere between 107 and 117 years of age, was born in a small village (*shtetl*) in Lithuania. He was trained as a ritual slaughterer (*shohet*), and he established a school training other men in this occupation. A man of intellectual courage, Rabbi Cohen befriended the village priest,

who later protected, and even hid, him and his family during anti-Semitic pogroms. In 1885, after receiving an invitation to serve as both rabbi and *shohet* in Pottstown, Pennsylvania, Cohen and his wife, Chasa Shryer, a descendant of the Vilna *Gaon*[1], decided to emigrate to America. While working in Chicago, after 1893, for the meat-packing firm Libby, McNeil, Cohen completed this *megillah*, a project that occupied him for many years.[2] He wrote in meticulous script on animal skins found in the stockyards.

Notes: 1. The honorary title *Gaon* was conferred on a person who possessed a great knowledge of Torah. Elijah Ben Solomon Zalman (1720–97), the *Gaon* of Vilna, Lithuania, was an influential spiritual and intellectual leader of modern Jewry. 2. Libby, McNeil provided kosher meat for the growing Jewish community.

Reference: Wischnitzer, Rachel B. "Megillah." *The Universal Jewish Encyclopedia,* 7:438–40.

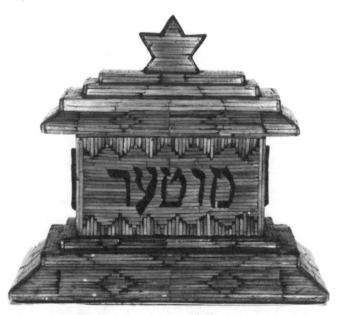

75
Decorative Box
Early 20th century
Wood overlaid with wooden strips
8½ x 8 x 5½"; 20.5 x 20 x 14 cm.
The Jewish Museum
Gift of Dr. Harry G. Friedman

This box, inscribed *muter* ("mother" in Yiddish) and crowned with a Star of David, is similar in construction to those objects in the American folk-art tradition that are somewhat inaccurately called "tramp art." The common feature of tramp art is the use of "chip-carved" wood—frequently taken from cigar boxes or fruit or vegetable crates—to create utilitarian or decorative objects. The total effect is achieved by gluing or nailing the layers together, and intricate designs and inlays are often incorporated into the finished piece.

From the 1870s through the beginning of the second quarter of the 20th century, chip-carving was a popular pastime. A tradition that objects in this style are almost always associated with tramps and gypsies cannot be substantiated.

In fact, popular magazines of that time frequently contained instructions for chip-carving; and although the craft was not limited to vagrants, the name "tramp art" has persisted.[1]

The box illustrated here, perhaps used for jewelry, cosmetics, or knicknacks, was fashioned from used wooden matchsticks, their burnt edges arranged to create patterns. Also featured on this box are one sun and two crescent moons in relief.

Note: 1. See Helaine W. Fendelman, *Tramp Art: An Itinerant's Folk Art* (New York: Dutton, 1975).

76
Marriage Contract (Ketubbah)
New York, inscribed 1901
Printed paper with handwritten additions
Marked in Yiddish: Printed by Zenger and Co., NY, Publishing
 house of Pinchas Friedman, 172 Rivington St., NY
14½ x 9½"; 36.8 x 23.9 cm.
Collection of Sylvia Zenia Wiener

The top portion of this marriage contract is ornamented by a scene of the wedding ceremony. The bride and groom stand under the marriage canopy with the rabbi. Their witnesses stand on either side. The male witnesses wear frock coats and top hats, the day dress of the 1890s; they sport side whiskers and trimmed beards. The women's clothing reflects the fashion of the early 1890s (somewhat earlier than the inscription date), indicating that copies of this printed *ketubbah* may have been used over a period of several years or that the clothing worn by the models for this scene was somewhat *retardataire.*

Swags and two medallions framed in a Greek-key design separate this scene from the text below, which is further set off by its placement between two stylized columns surmounted by vases (all formed of stock printers' ornaments).

Two mottoes, typical of those used on a *ketubbah,* appear: "The sound of mirth and gladness, the voice of the bridegroom and bride" (Jer. 33:11) and "Good fortune."

According to the main text, this contract was written on "Tuesday, Lag b'Omer, on the 18th day of Iyyar, [5]661 [1901] from the creation of the world to the counting that we count. Here in the holy community of [unclear] in the country of North America."

The groom and bride are: "Yehudah Leib. . . and the bride Beilah Paula, daughter of Isaac." The signatures are of the witnesses and Rabbi Isaac Halprin, 121 Attorney Street.

Attorney Street is on New York's Lower East Side, a neighborhood which—at the turn of the century—was home to the largest Jewish community in the world.

Reference: Bradley, Carolyn G. *Western World Costume: An Outline History.* Englewood Cliffs, N.J.: Prentice-Hall, 1954: 325–35.

77

Omer Counter and Memorial Plaque
Baruch Zvi Ring (1870–1927)
Rochester, New York, 1904
Ink and crayon on cut paper
Signed and dated
21¾ x 15½"; 55.4 x 39.5 cm.
Karp Family Collection

The counting of the Omer, the first sheaf offered to God in thanks for the harvest, for forty-nine days from the second day of Passover until Shavuot (Feast of Weeks), is prescribed in the Torah (Lev. 23:15–16). This seven-week period symbolically links the Israelites' exodus from Egypt with their receiving of the Torah on Mount Sinai. The days of the Omer are also associated with mourning.[1]

As the symmetry of this piece permitted only forty-eight roundels for the reckoning of the Omer, the count for the first day is presented together with preparatory blessings in the top border. (Psalm 67 – recited after the counting of the Omer has been completed – is found in the right-hand corner of the bottom frame.) The rampant lions support a circular medallion on which huge letters spell *Yahrzeit* (i.e., anniversary of a death), indicating the dual function of the object. Dominating the central area below are the four memorial blocks containing the names of the deceased – not members of Ring's immediate family – and their dates of death:

> *Top right:* "...my dear father, a God-fearing man, our teacher and rabbi, Solomon S[on of] R[abbi] Eliezer, [who] died...in the year [5]660 [1899/1900]..."
> *Bottom right:* "...my dear mother, the modest woman Hayya, daughter of R[abbi] Moses, died...in the year [5]630 [1869/1870]..."
> *Top left:* "...my father, my teacher, a God-fearing man, our teacher and rabbi, Aryeh Leib s[on of] R[abbi] Shevah, who died...in the year [5]673 [1912/1913]..."
> *Bottom left:* "...my dear mother, the modest woman Leah, daughter of R[abbi] Joshua...died... in the year [5]670 [1909/1910]..."

The discrepancy between two of the memorial dates and that of the work's execution may be accounted for by the artist's provision for the inclusion, at a later time, of additional names.

In the arches capping the tablets appear these plaintive phrases: "This day shall not depart before my eyes for all time (forever?)," and "I shall not forget as long as the breath of the Lord keeps me alive." Below the memorials Ring has depicted a row of cypresses, trees symbolic of death.[2]

The artist signed his work with the following text: "My handiwork in which I glory" (Is. 60:21), "From me [?] Baruch Tzvi s[on of] Jacob Ring from the city of Vishya."

Notes: 1. *Encyclopaedia Judaica*, 12: cols. 1385–86. 2. George Ferguson, *Signs and Symbols in Christian Art* (New York: Oxford University Press, 1980): 30.

Reference: *Encyclopaedia Judaica*, 12: cols. 1382–89.

78
Matzah Cover
Designed by Baruch Zvi Ring (1870–1927)
Embroidered by Ida Ring Stolnitz (1890–1961)
Rochester, New York, 1903/4
Cotton, embroidered with cotton
Signed and dated
15½ x 12¼"; 39.3 x 31.2 cm.
Collection of T'Mahry Axelrod, granddaughter of Ring and
 daughter of Mrs. Stolnitz

At the Passover seder, the three pieces of matzah, or un-
leavened bread, that constitute part of the ritual meal, are
generally covered. This appealing matzah cover, embroi-
dered in brilliant crimson, is decorated with a pair of doves
perched on branches amid a setting of swirling, stylized
flowers, leaves, and buds.

Inscribed in Hebrew across the top and sides appears:
"Blessed art thou O Lord, King of the Universe, who has
sanctified us with Thy commandments and commanded us
about the eating of matzot. Year [5]664 [1903/4]." The large
outlined letters centrally placed command: "For seven days
thou shall eat unleavened bread" (Ex. 12:15). Along the
bottom is embroidered the designer's original name: "Rabbi
Baruch Tzvi Ringiansky."

Although matzah covers traditionally have been designed
and created by women, this example was sketched by Rabbi
Ring in 1904 and embroidered several years later by his
daughter, Ida. Born in Vishya, Lithuania, Ida came to
America with her family in 1904. She helped raise three
brothers and a sister after her mother's premature death
several weeks after their arrival. After her marriage she
remained in Rochester, and became a member of Congre-
gation Beth Hamedresh Hagadol.

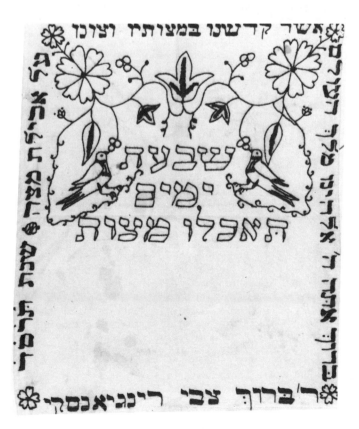

79
Seder Towel
Designed by Baruch Zvi Ring (1870–1927)
Embroidered by Ida Ring Stolnitz (1890–1961)
Rochester, New York, 1903/4
Cotton, embroidered with cotton
8 3/16 x 19⅞"; 20.8 x 50.5 cm.
Collection of T'Mahry Axelrod

A companion piece to the matzah cover (cat. 78) this
crimson-stitched towel was used for the ceremonial washing
of the hands during the Passover seder.

The design on the towel consists of an elaborate floral
pattern bordered on one side by an elegantly manicured and
cuffed hand.[1]

Note: 1. Compare the delicate hands found on a center cloth for the seder
table in The Jewish Museum, *Fabric of Jewish Life: Textiles from The Jewish
Museum Collection,* exhibition catalogue (New York, 1977); ill. 201, p. 111.

80
**Paper-cut Made for a Learned Society
 (Hevrah Mishnaiot)**
Baruch Zvi Ring (1870–1927)
Rochester, New York, 1904
Ink, gold and silver paint, colored pencil, and watercolor
 on cut paper
Signed and dated
55 x 50"; 139.7 x 127 cm.
The Jewish Museum
Gift of Temple Beth Hamedresh–Beth Israel, Rochester,
 New York

This monumental paper-cut documents a *Hevrah Mishnaiot*
founded in 1904 in Rochester, New York. Its name indicates
a group organized for the purpose of studying the Mishnah,
a collection of oral commentaries on biblical law, compiled
by Rabbi Judah ha-Nasi in the 3d century C.E., and consti-
tuting part of the Talmud. In addition, the *Hevrah* honored
deceased relatives by saying prayers for the dead (kaddish)
and observing the anniversaries of their deaths (*yahrzeit*).
 A band of Hebrew across the top of the work proclaims
the significance of Torah and wisdom in these quotes from
the Bible: "She is a tree of life to those who grasp her" (Pr.
3:18); "For it is your life and length of days" (a variation on

Deut. 30:20); and "In her right hand is length of days and in her left are riches and honor" (Pr. 3:16). On two white banners, the words *Hevrah* (group) and *Mishnaiot* are boldly stated while, below each, a pair of deer flank a Star of David. Eagles perched on bands containing passages from Exodus 19:4 and Deuteronomy 32:11 guard a crown inscribed "The crown of Torah, the crown of priesthood, the crown of royalty, but the crown of a good name excels them all" (*Ethics of the Fathers* 4:17), while rampant lions flank the Ten Commandments.

Forty-eight roundels, serving as a calendar for the Omer, form the outer ring of the concentric circles, while on either side large tablets display memorial prayers and the names of the deceased. The open book, supported by two griffins, contains pages from the Mishnah.

The borders on three sides of the image contain the names of sixty-nine congregation members and their wives. Paralleling two of these borders, the artist has ingeniously incorporated the twelve signs of the zodiac.

Barely visible at the base of the right tablets is inscribed: "My handiwork in which I glory" (Isaiah 60:21). In a corresponding location on the left side, the artist who undertook the challenge of this large composition simply signed: "From Barukh Tzvi son of Jacob Ring [?]."

The box was found in the vacated premises of the Aitz Chaim Synagogue on Eden Street in East Baltimore, an area where many recent immigrants had settled at the turn of the century. The congregation, composed largely of Jews from Eastern Europe, moved into the building in 1902. Now dissolved, in 1902 the congregation was one of the oldest in Baltimore.

Note: 1. Cf. David Altshuler, ed. *The Precious Legacy: Judaic Treasures from the Czechoslovak State Collections* (New York: Summit Books, 1983); cat. 83; and Franz Landsburger, *A History of Jewish Art* (Port Washington, N.Y. and London: Kennikat Press, reissued 1973); fig. 15.

81
Alms Box
Baltimore, Maryland, c. 1906
Copper; carved wood
8⅞ x 9¾ x 9⅛"; 22.5 x 24.6 x 23.4 cm.
Collection of Mr. and Mrs. Richard D. Levy

This copper and wood alms box is embellished with a skillfully carved open hand to symbolize the need to aid the poor. It follows several European examples of alms boxes decorated with outstretched arms.[1] On a brass plaque affixed to the box is inscribed in English: "Represented by Louis Singer, Apr. 12, 1906," suggesting the renewal of an earlier gift.

82
Congregational Register (Pinkas)
Artist unknown
1908
Ink and watercolor, bound
16 x 11 x 1½"; 41.3 x 27.9 x 3.8 cm.
Philadelphia Jewish Archives Center, Pennsylvania

Congregation Atereth Israel was located in South Philadelphia, the heart of immigrant Russian-Jewish life in that city at the turn of the century. The title page of this congregational register, dated [5]668 in Hebrew, corresponding to 1908 in the civil calendar, uses the conventional columns and arch to frame the title.

83
Carousel Horse
Marcus Charles Illions's Workshop
Brooklyn, New York, c. 1900
Carved and painted wood, glass, horsehair, leather, metal
48 x 47 x 10"; 120 x 117.5 x 25 cm.
Museum of American Folk Art
Gift of the City of New York, Department of Parks and
 Recreation

Marcus Charles Illions was born in 1871 in Lithuania and
came to the United States at the age of seventeen with Frank
C. Bostock, an impresario who brought his wild-animal
show from England for a tour throughout the United States.
Bostock hired Illions to carve the sides of wagons for the
menagerie. When he completed this work, Illions remained
in this country, and achieved renown as a master carver
both in wood and in stone.

Illions is perhaps best known for his carousel carving. By
1892 he had his own workshop on Dean Street in Brooklyn
where he carved horses and other decorative figures for
Charles I. D. Looff's merry-go-rounds as well as for the
"Bumgarz Steam Wagon and Carousele [sic] Works." Around
the turn of the century he was hired by William F. Mangels
to create the figures for a merry-go-round Mangels had been
contracted to repair at Coney Island. Illions moved his shop
to Mangels's factory, where he worked for the next nine
years on a variety of contracts. Illions's reputation continued

to grow and his business expanded greatly; he hired many
young apprentice carvers who carried on a wood-carving tra-
dition well-established among Jews in Eastern Europe, al-
though in a different setting and with a new design vocabu-
lary. Some of these carvers, such as Solomon Stein, Harry
Goldstein, and Charles Carmel, went on to become master
carvers in their own right.

In 1909, Illions left the Mangels factory. Assisted by his
four sons and various other family members, he established
his own workshop on Ocean Parkway in Coney Island.
During the heyday of the carousel business at Coney Island
in the early 1920s, there were at least ten Illions carousels in
operation; although by the time Illions produced his last
grand-scale carousel in 1927, the industry had gone into a
marked decline. However, until his death in 1949 at the age
of seventy-eight, Illions continued to work as a carver. He
refused to employ the mass-production techniques adopted
by others, and continued to carve each figure by hand.

Barney Illions described his father's work as follows: "[He]
used wood to create form that suggested flesh and move-
ment, and animated it with his superb ability at carving both
the realistic and impressionistic, so that the wooden figures
seemed endowed with life." These qualities are evident in
the handsome steed illustrated here.

References: Evans, Sondra. "Marcus Charles Illions." *Carrousel Art,* issue
18 (July/August 1982): 2–5. Fried, Frederick. *A Pictorial History of the
Carousel.* New York: Barnes, 1964.

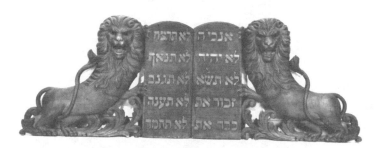

84

A Pair of Lions and Decalogue from a Torah Ark
Marcus Charles Illions's Workshop
Brooklyn, New York, 1910
Carved wood
30 x 42¼ x 7"; 70.6 x 100.8 x 17.5 cm.
The Jewish Museum, Gift of Dr. Ruth W. Berenda

Illions did not limit his work to the amusement industry. He also carved ornamental façades in wood and stone for public buildings and private residences in Brooklyn and Manhattan, and was even commissioned to undertake work for buildings on the Boston Commons. Illions also designed and carved religious ornaments for churches and synagogues, an example of which is shown here.

Reference: Evans, Sondra, "Marcus Charles Illions." *Carrousel Art*, issue 18 (July/August 1982): 2–5.

85

Advertising Sign
Artist unknown
Brownsville Fruit Distilling Co., Brooklyn, New York
c. 1900
Printed on paper
20 x 18"; 50 x 45 cm.
Moriah Antique Judaica

The seder, the traditional Passover meal and service conducted in the home, is illustrated here in naive style. The inscription in Hebrew and Yiddish offers wine, cognac, and slivovitz (plum brandy) ritually acceptable for Passover use.

86

Register (Pinkas)
Artist unknown
Russell Street Synagogue
Boston, Massachusetts, 1910
Ink and watercolor on paper
15 x 9"; 38.1 x 22.9 cm.
American Jewish Historical Society, Waltham, Massachusetts

The *pinkas* shown here served as the record book of the *Hevrah Mishnaiot* (Mishnah study group) of the Beth Hamedrash Hagadol Anshei Sphard or Russell Street *shul* in Boston. The page is surmounted with a crown bearing the inscription "crown of a good name."

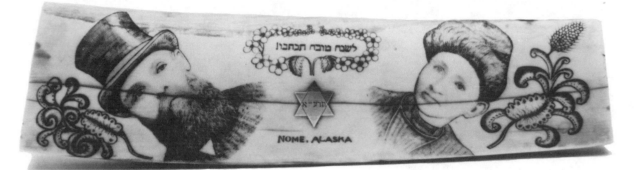
לשנה טובה תכתבו

NOME, ALASKA

87 (Plate 8)
Jewish New Year's Greeting
Artist unknown
Nome, Alaska, 1910
Engraved walrus tusk with brass inset
10 x 1" dia. ; 25.5 x 2.5 cm. dia.
Collection of the Family of Minnie Kanofsky

The genesis of Alaska's Jewish community coincided with the purchase of the territory by the United States in 1867. It is believed that some Jews sailed there with the Russian fishing fleets in the 1830s and 1840s, but it was not until a Jewish-owned firm, the Alaska Commercial Company, secured the seal-fishing rights that known Jewish traders began regular visits to the territory. In 1885, the first permanent Jewish settlers arrived in Juneau.

The Klondike gold rush of 1897, soon followed by another discovery of gold near Nome, brought thirty thousand miners, fortune-hunters, and businessmen into Cape Nome. A number of Jews joined the immigration, and Eskimos also sought a share of the bonanza. Several hundred of the latter rapidly established a market for native clothing, along with carved ivory figurines, cribbage boards, and other souvenirs.

The tradition of walrus-tusk carving is centuries old in Alaskan Eskimo communities, and developed quite separately from the whaleman's scrimshaw. However, with the coming of the whalers in the 19th century, both expanded their repertoires as Eskimo carvers and scrimshanders exchanged techniques and materials. The complexity and diversity of Eskimo subjects increased as more sophisticated interpretations displaced schematic figure and linear ornamentation.

Eskimo carvers quickly learned to copy illustrations or photographs in what is termed a Western pictorial style.[1] The most innovative and influential of the carvers was a Bering Strait Eskimo nicknamed "Happy Jack." He is credited with the introduction after 1892 of engraving walrus tusks with a very fine needle, resulting in an almost perfect imitation of newspaper halftones and fabric textures. The carvers enhanced the incised lines by filling them with India ink, graphite, or ashes.

Most of the engraved walrus tusks are unsigned, but several known to be the work of a man called Happy Jack closely resemble the object shown here. Although Happy Jack, for instance, could not read or write English, he is thought to have been the artist who copied the image of a label of Packer's Tar Soap on a walrus tusk, reproducing a portrait of a woman, pine cones and needles, and the slogan.[2] Several other native carvers, as well, had the skill to copy the inscriptions and photographs provided by their customers.

On this tusk, the artist has ably recorded the faces and attire of a religiously observant Jewish couple. The woman wears a wig and is dressed in a typical turn-of-the-century style. (Many Jewish women utilized wigs, faithful to the laws requiring a married woman to cover her natural hair.) The man's beard is neatly trimmed; his top hat suggests a holiday or formal occasion.

The Hebrew inscription delivers the traditional Jewish New Year salutation: "May you be inscribed for a good year, 5671 [1910]." In English is added: "Nome, Alaska." The greeting refers to a belief expressed in the rabbinic literature of the 2d century that on New Year's Day God judges, decides, and records the fate of the clearly righteous and the wicked for the coming year. On the Day of Atonement, the fate is sealed for those who required this additional ten-day period to attain merit.[3]

This walrus tusk was formerly in the collection of Dr. Morris Last, and is assumed to portray his parents.

Notes: 1. For a full discussion of this style of Eskimo carving see Dorothy Jean Ray, *Artists of the Tundra and Sea* (Seattle: University of Washington Press, 1961): 3–12, 134–36; and her *Eskimo Art: Tradition and Innovation in North Alaska* (Seattle: Henry Art Gallery, University of Washington, 1977): 27–45, and figs. 262–69. 2. This is published in Ray, *Artists*, fig. 53 and in E. Norman Flayderman, *Scrimshaw and Scrimshanders* (New Milford, Conn.: Flayderman, 1972): 244. 3. Hayyim Schauss, *Guide to Jewish Holy Days: History and Observance*, 7th ed. (New York: Schocken, 1970): 156.

References: Bloom, Jessie S., "The Jews of Alaska." *American Jewish Archives* 15 (1963): 97–116; Postal, Bernard. "Alaska," *American Jewish Year Book* 61 (1960): 165–69; and Tordoff, Ruth E., "Scrimshaw, Alaskan or Whaler Art?" *Alaskan Journal* 2 (Summer 1972): 54–56.

88
Memorial Plaque
1911
Ink on parchment
11¾ x 10⅝"; 29.6 x 27 cm.
Collection of Paul and Toby Drucker

Commemorating the anniversary of the death of certain
relatives is one of the most widely observed rituals in
Judaism. Called *yahrzeit* (Yiddish, literally, time of year), the
memorial anniversary occurs on the Hebrew date of death.
Observances take place in the home, the synagogue, and the
cemetery.

This memorial plaque is embellished only with a braided
motif. The black letters, stark against the white paper, serve
to accentuate the plaque's purpose: to remind the family of
the *yahrzeit*.

The text reads:
"For these things do I weep, my eyes flow with tears"
(Lam. 1:16).
"Zion."
"My dear father Nathan Nata s[on of] Isaac died on the
holy Sabbath the 26th of Tammuz [5]671 [22 July 1911].
May his soul be bound up in the bond of ever-lasting life."[1]
"Yahrzeit."
"26th of Tammuz."
In English: "1911, 22 July."

Note: 1. From the memorial service for the dead.

References: *Encyclopaedia Judaica,* 16: cols. 702–3. Lamm, Maurice, *The
Jewish Way in Death and Mourning.* New York: Jonathan David, 1969: 201–4.

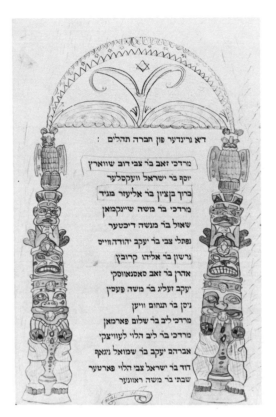

89
Register (Pinkas)
Benjamin J. Wexlar
1911–12
Ink, watercolor, and crayon on paper, cloth bound
19⅛ x 12¾ x 1⅝"; 48.5 x 32.4 x 4.2 cm.
Philadelphia Jewish Archives Center, Pennsylvania

This is a page of the *pinkas* for the *Hevrah Tehillim* (psalm-
recital group) of Congregation Atereth Israel, Philadelphia.
Selections from the Book of Psalms may be found through-
out the Jewish liturgy, but a regular recital of the whole book
is viewed as an act of piety. The psalms are particularly
emphasized in connection with memorial services, when
verses are recited incorporating the name of the deceased.
This *Hevrah Tehillim* also served as a *Hevrah Gemilut
Hasadim,* or free-loan society. Among the rules and
regulations of the *Hevrah Tehillim* set forth in Yiddish in the
pinkas is one requiring the payment of dues of ten cents per
month, and another requiring members to be available to
recite psalms during the week of *shivah* (mourning for a
deceased member), as well as upon the *yahrzeit* of a member.
Noted in the *pinkas* is the fact that: "Women can belong to
our *Hevrah Tehillim* with the same rights as men."

The decorated title page incorporates symbols for various
holidays in each of the two columns framing the inscrip-
tion—a shofar, symbol of the New Year; a *grogger* (a noise-
maker used during the reading of the *Megillah* on Purim); a
Haggadah, representing Passover; and a tree with fruit, a
symbol of the harvest festival, Shavuot.

Also illustrated is a page from the *pinkas* listing founders
of the *hevrah.* In a surprising juxtaposition of thematic
materials, the artist introduces a pair of northwest coast
Indian totem poles.

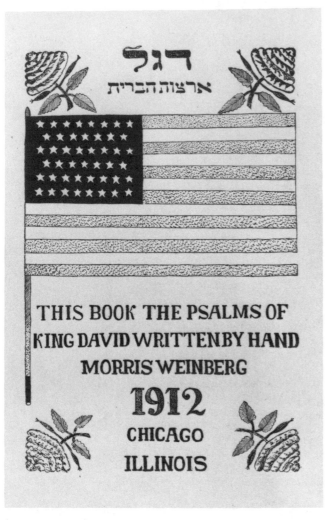

דגל
ארצות הברית

THIS BOOK THE PSALMS OF
KING DAVID WRITTEN BY HAND
MORRIS WEINBERG
1912
CHICAGO
ILLINOIS

90
Psalms of King David
Morris Weinberg
Chicago, Illinois, 1912
Ink on paper
10½ x 7"; 26.2 x 17.5 cm.
The Library of The Jewish Theological Seminary of America,
 New York

This extraordinary Book of Psalms in Hebrew was the
work of Morris Weinberg, who hand-lettered the text and
drew the delightful illustrations that illuminate it. Weinberg's
illustrations are drawn from the psalms themselves as well
as from the traditional themes of Jewish folk art. The inclu-
sion of the image of the American flag is not as surprising as
it may appear, in view of the patriotic sentiments of immi-
grants for whom America provided a haven. Indeed, patri-
otic symbolism is a recurrent theme in American folk art.

In view of the association of the Book of Psalms with
Jewish mourning customs, Weinberg has provided a page for
listing the civil calendar dates of the *yahrzeit* for the parents
of the owner of the book.

91
Alms Box (not shown)
New York, c. 1913
Engraved copper
6 x 4⅞" dia.; 15.3 x 12.5 cm. dia.
Collection of Manfred Anson

Resembling a tankard, this alms box has a scroll handle
and a flat top pierced with a slit to receive the offerings.[1] The
Yiddish inscription states that it belonged to the First
Warsaw Congregation. The box was presented to the
congregation by "Abraham Jacob, s[on of] Zvi Aaron the
Kohan."

In 1913 the First Warsaw Congregation erected a small but
impressive synagogue at 60 Rivington Street. Although the
congregation has since been dissolved, the now-unoccupied
building still stands.

Immigrants from the same cities or towns in Russia and
Poland commonly united to form self-help organizations and
congregations based on, and named for, the members' place
of origin. Called a *landsmanschaft* (literally a society of fellow
countrymen), the first such organization was formed in 1864;
and between 1880 and 1914 about five hundred such congre-
gations were established in New York.

Note: 1. For a similar alms box depicted on a Torah binder see cat. 121. See
also R. D. Barnett, *Catalogue of the Permanent and Loan Collections of the Jewish
Museum, London* (London: Harvey Miller, 1974): no. 580.

References: Fine, Jo Renée and Gerard R. Wolfe, *The Synagogues of New
York's Lower East Side.* New York: Washington Mews Book, New York
University Press, 1978: 105, Postal, Bernard, and Lionel Koppman, *Jewish
Landmarks in New York,* New York: Hill and Wang, 1964: 25, 28, and 111.

92
Miniature Scroll (not shown)
1914
Silk and parchment
15 x 8"; 38.1 x 20.3 cm.
Smithsonian Institution, National Museum of American
 History, Washington, D.C.
Gift of Israel Fine

This scroll celebrates the one-hundredth anniversary of
"The Star Spangled Banner." The flag of the United States is
prominently featured on the continuous border at either end
of the silk cover, as well as in the central device.

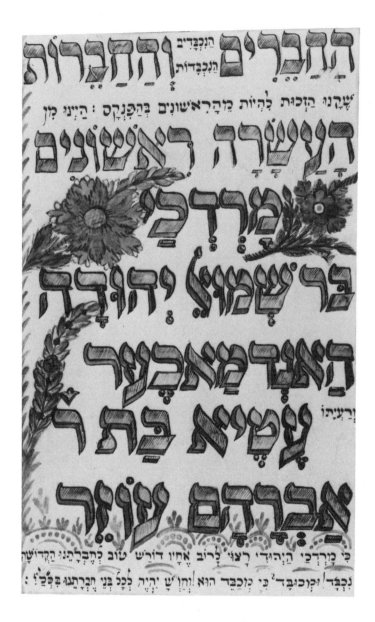

93A
Register (Pinkas) (not shown)
Artist unknown
Congregation Ohavei Shalom Mariampol, Chicago, Illinois,
1872
Watercolor on paper
14 x 9¼ x 1¼"; 35.5 x 23.5 x 3.4 cm.
Saul Silber Memorial Library, Hebrew Theological College,
 Skokie, Illinois

93B
Register (Pinkas)
Libby and Belle Newberger and Rev. Dr. Abel Mohel Lane
Hevrah Mishna U'Gemorah of Congregation B'nai Joseph,
 Chicago, Illinois, 1915
Ink and watercolor on paper
16¼ x 11½ x 2⅜"; 41.2 x 29.2 x 6.1 cm.
Saul Silber Memorial Library, Hebrew Theological College,
 Skokie, Illinois

Spring and autumn leaves, grape vines bearing lush fruit,
floral rosettes, and draped curtains decorate the conven-
tional columns framing the vibrant title page of this Chicago
congregational *pinkas* (93A). The artist carries the leaf motif
into the large letters of the title itself, while column finials in
the form of vases bear flowering plants. A chronogram con-
taining the phrase "the lovers of peace be blessed" is at the
bottom of the page. It incorporates both the name of the
congregation and the Hebrew equivalent of 1872.
Chronograms are a traditional convention for dating Hebrew
books and manuscripts. Because the Hebrew numbering
system is based on the alphabet, it is possible to include a
relevant phrase in which the date of the work is contained.
A systematic collation of American *pinkasim* has not been
undertaken; these are examples of the many from Chicago
assembled by Leah Mishkin at the Hebrew Theological
College at Skokie, Illinois.

also a point of origin for the design of several types of Hanukkah lamps.[1] The convention of a portal surmounted by Tablets of the Law and confronting pairs of animals or birds is also found on both arks and Hanukkah lamps. Easily transported by an immigrant, a European Hanukkah lamp is a likely direct design source for this plaque.

The double-headed eagle in the top register, an imperial symbol of the Holy Roman Empire, of its successor state the Austro-Hungarian Empire, and of Russia and partitioned Poland, further suggests a European influence. It is widely found on European objects, but less frequently in America where the eagle deriving from the Great Seal of the United States is more common.[2]

The architectural forms in the bottom register of this eclectic paper-cut are similar to those found on a variety of objects made for Jewish visitors to Palestine in the late 1800s and early 1900s. These include carved stoneware cups, embroidered cloths, and prints and watercolors, all bearing illustrations of Jewish sites.[3]

The form of the menorah on this paper-cut and its base is clearly derived from Polish-Jewish paper-cuts of the 19th century.[4]

Notes: 1. Stephen Kayser and Guido Schoenberger, *Jewish Ceremonial Art* (Philadelphia: Jewish Publication Society of America, 1955), no. 138; M. Narkiss, *The Hanukkah Lamp* (Jerusalem: Bney Bezalel, 1939; Hebrew with English summary): pls. 96 and 118. 2. Cf. cats. 38 and 40. 3. Richard Barnett, "A Group of Embroidered Cloths from Jerusalem," *Journal of Jewish Art* 2 (1975): 28–41; Abram Kanof, *Jewish Ceremonial Art and Religious Observance* (New York: Abrams, 1969): fig. 75; Elie Kedourie, ed., *The Jewish World: Revelation, Prophecy, and History* (London: Thames and Hudson, 1979): 294. 4. Giza Frankel, "Jewish Paper-Cuts," *Polska Sztuka Ludowa* 3 (1965): 135–46, 178 (English summary). For the endless-knot base, cf. Haifa Municipality Ethnological Museum and Folklore Archives, *The Paper-cut: Past and Present,* exhibition catalogue (Haifa, 1976): no. 22; Kayser and Schoenberger, *op. cit.,* no. 176.

Reference: Sotheby's, New York, *Fine Judaica: Works of Art,* sales catalogue, Nov. 9, 1983: no. 126 (ill. upside down).

94
Memorial Plaque
Gardiner, Maine, c. 1915
Paper, cut and painted
18 x 14½"; 45.8 x 37 cm.
The Jewish Museum
Museum purchase, Eva and Morris Feld Judaica Acquisition
 Fund

This plaque served as the reminder of the anniversary of a death (see also cat. 77, 88, and 95).

The Hebrew inscriptions read:

"In memory of my mother."

"May her memory be a remembrance for eternity. And then God will open her grave at the end of time, and she will rest in peace on her bed until the righteous redeemer will come to us shortly."

"The soul of the woman."

"Shime, daughter of Solomon David, who went to the next world Monday, the 29th of Kislev [5]676 [1915]."

Typed English inscriptions are:

"Memory of my beloved mother Shime[.] Died Monday 29th day Kislev, 5676."

"Mother died Monday Dec. 6, 1915."

The use of a typewriter for inscriptions on such a document is highly unusual. This discreet addition may have been necessary to indicate the date for someone who could not read Hebrew.

The composition memorial plaque derives indirectly from the elaborately carved and constructed wooden Torah arks of Eastern Europe. Frequently consisting of three tiers and decorated with foliate, bird, and animal forms, these arks are

95
Memorial Plaque
Baruch Zvi Ring (1870–1927)
Rochester, New York, 1916
Ink, graphite, colored pencil, and watercolor on cut paper
Signed and dated
29½ x 29½"; 75 x 75 cm.
Collection of T'Mahry Axelrod, granddaughter of the artist

This memorial plaque represents another example embodying Ring's sense of monumental design and fine craftsmanship.[1] Its theme of mourning is emphasized by an interplay of delicate geometric patterns and symbolic images, enhanced by warm reds and greens contrasted against a solid black background.

The work's religious purpose is firmly established with the word "*Yahrzeit*" found in the two circles topped by doves. Separating the upper and middle registers is a continuous horizontal band inscribed with this lament: "A bitter day, every year my memory remembers, this is a day of mourning and shock, this day shall not depart from in front of my eyes for all eternity. I shall not forget it as long as the breath of the Lord sustains me."

In the central section, the names of the four deceased—not

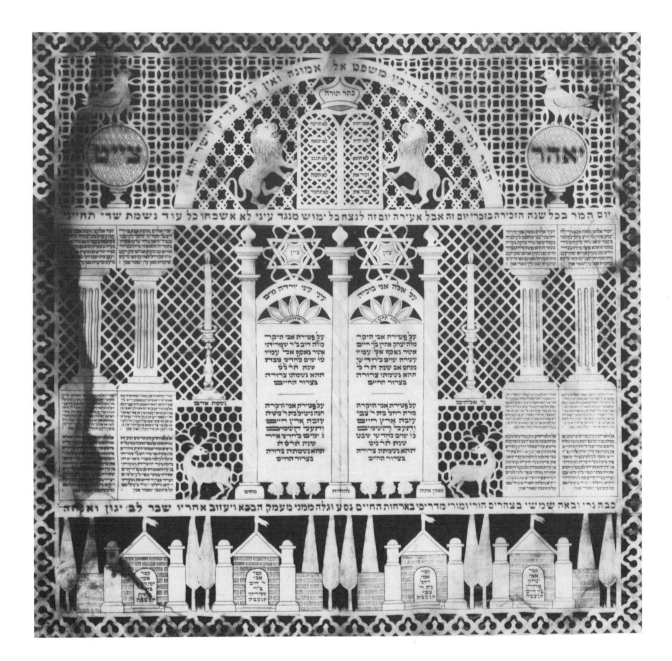

members of Ring's immediate family – are inscribed on tablets flanked by three tall pink-and-white columns. Repeated on the façades of the red-brick structures below, they read:

"...my dear father o[ur teacher] and R[abbi], Isaac Aaron s[on of] R[abbi] Hayyim...in the year [5]630 [1869/70]."

"...my dear mother Rachel daughter of R[abbi] Tzvi...in the year [5]649 [1888/89]."

"...my dear father o[ur teacher] and R[abbi] Dov, s[on of] R[abbi] Shemaryahu...in the year [5]639 [1878/79]."

"...my dear mother, Hannah Gittel, daughter of R[abbi] Moses...in the year [5]665 [1904/5]."

Accompanying these names, above and below the four pillars, are prayers for the dead in both Hebrew and Yiddish. Visible, too, beneath the candlesticks, is the biblical passage, "The soul of man is the lamp of the Lord" (Pr. 20:27). The text on a second dividing horizontal band sustains the sentiment of its counterpart with "My candle has gone out, and my sun has set in the afternoon; my parents and teachers who have led me in the paths of life have moved and departed from me, from the valley of tears; and they have left after them a broken heart, grief, and lamentation."

Below, a frieze composed of cypresses and tombs symbolically alludes to death by representing the graves of the remembered dead amid a grove of trees generally associated with mourning.

Note: 1. See cat. 77.

99

96 (Plate 7)
Etrog Box
G. Friedman
New York, 1918
Carved and painted wood, plated copper and brass
5 x 6 x 4⅛"; 12.5 x 15.3 x 10.5 cm.
The Israel Museum, Jerusalem
Gift of Mr. and Mrs. John Wilcox to the American Friends of
the Israel Museum

The citron (*etrog*)—a thick-rinded citrus fruit—is one of the
four species of flora (see below) used during the liturgy for
the Feast of Tabernacles (Sukkot). Owing to the require-
ments that this fruit must remain in perfect condition for the
recitation of the blessings during the festival, it is generally
kept in a protective container. Special containers are made,
or sometimes adapted, for this purpose.

This carved box, constructed of mortise-and-tendon joints,
is embellished with shallow reliefs depicting symbols of the
holiday, accompanied by appropriate inscriptions. The back-
ground for the reliefs and inscriptions is patterned with fine
tool marks.

On the cover, the artist carved the *etrog* itself, together
with the traditional cluster of palm shoots bound with wil-
low and myrtle (the *lulav*), depicted in a woven holder. The
inscription gives the instructions for the ceremony: "On the
first day you shall take the product of the *hadar* trees,
branches of the palm tree, boughs of leafy trees and willows
of the brook" (Lev. 23:40).

The back of the box bears the felicitation in a circular car-
touche, "Good fortune" and the Hebrew dedication: "We are
offering this on the wedding of the son of my dear brother-
in-law Hayyim Isaac Gelbmann, M[ay his light] s[hine].
From your uncle Joseph Rosenberg and his wife Esther
Rebecca. May she live, in the year [5]678 [1917/18]." Decor-
ated boxes were commonly given as wedding gifts in
America as early as the 18th century.

On the front face of the box, Friedman has carved the
blessing said over these plants on each day of the festival.

Carved panels on either side include representations
which allude to both the holiday and to marriage. The right
side panel bears a carved relief of a burning altar with the
pitcher symbolic of the Levites, the attendants of the priests.
A man drawing water from a well stands to the right of the
altar. The inscription above the scene is from Isaiah 12:3,
"You shall draw water and happiness." During this festival in
biblical times, a special ceremony of "water libation" was
based on this passage. The reference seems to be to the
happiness that could be anticipated from the nuptial union.

The scene on the left side panel depicts a house with a
pelican or stork perched on top, a tabernacle nearby, and
three other birds in flight. The tabernacle obviously refers to
the holiday, Sukkot. Pelicans or storks, known for their love
of their young, generally symbolize a good mother, and the
house stands for the home the couple will make together.[1]

Carved *etrog* boxes of this quality are uncommon, although
examples from Eastern Europe do exist. In the late 19th and
early 20th century, an influx of carved souvenir boxes from
Palestine bearing low-relief scenes of holy sites may have
served as a point of departure for this artist.

The box is signed "G. Friedman," in cursive Hebrew.

Note: 1. Rachel Wischnitzer, *The Messianic Theme in the Paintings of the
Dura Synagogue* (Chicago: University of Chicago Press, 1948): 65 and 89.

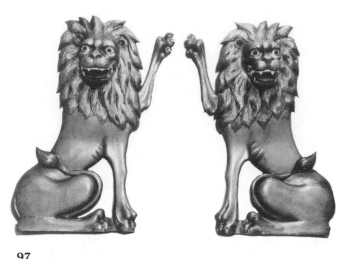

97
Two Lions from a Torah Ark
Philadelphia, Pennsylvania, 1917
Carved wood, polychromed and gilded, repainted with gold
metallic paint, inlaid glass
47 x 33 x 12"; 119.4 x 83.8 x 30.5 cm.
National Museum of American Jewish History, Philadelphia,
Pennsylvania

The presence of carved lions on Torah arks was estab-
lished as early as the third century,[1] and since the Baroque
era two rampant lions flanking the Tablets of the Law has
become one of the most widely used motifs in synagogue
decoration. This ubiquity has given rise to an astonishing
variety of leonine depictions.

The charm of these two lions that once supported the
Tablets of the Law above the monumental Torah ark of Con-
gregation Shaarei Eli is underlined by the unknown artist's
attempt at ferocity; however, he achieved only a toothy grin.

The synagogue of Congregation Shaarei Eli, located at 8th
and Porter Streets in Philadelphia, opened for worship in
1919 but is now deserted. Its Torah ark has been removed,
and is currently being restored through the efforts of several
concerned Philadelphians and the National Museum of
American Jewish History, whose collection it will even-
tually enter.

Note: 1. E. M. Meyers, J. F. Strange, and C. L. Meyers, "The Ark of
Nabratein—A First Glance," *Biblical Archeologist* 44 (Fall 1981): 237–43.

98
Decoration for the Eastern Wall (Mizrah)
Mordechai Reicher (1865–1927)
Brooklyn, New York, 1922
Ink and watercolor on cut paper
Signed and dated
17 x 21⅝"; 43 x 55 cm.
Collection of Mr. and Mrs. Arthur Sheiner
On loan to The Israel Museum in memory of Sophie Sheiner
Reicher, New York

The *mizrah* is an ornamental plaque affixed to the eastern
wall in the home or synagogue to indicate the direction of
prayer toward Jerusalem.

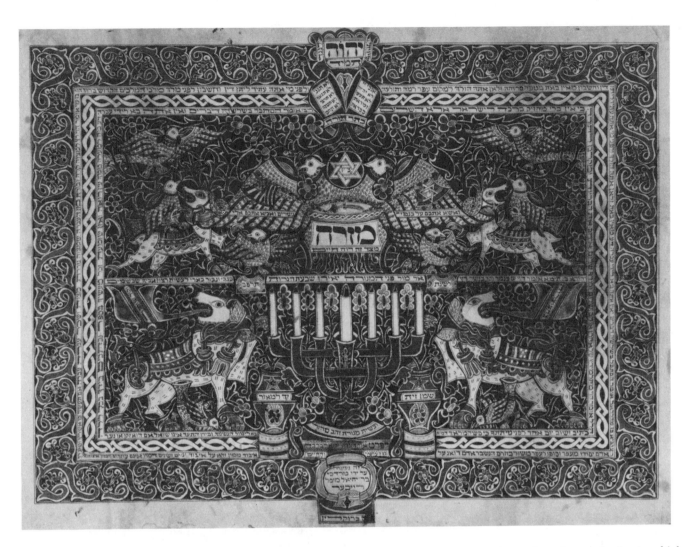

In this extraordinary paper-cut (and in the following item), Mordechai Reicher incorporates traditional Jewish symbols such as the seven-branched menorah, the Ten Commandments, Star of David, and Crown of Torah. The highly stylized symbolic animals and birds include lions, eagles, and rams. Their colors and bold graphic designs contribute to the energy of the composition.

A talmudic scholar, Reicher probably learned the art of paper-cutting during his religious training, as it was learned as a hobby in Hebrew school and practiced by men.[1] Reicher was born in the Ukraine, in Ulshaner, near Kiev. He owned a flour mill there, before emigrating to the United States in 1910. In this country, he worked as a peddler until severe illness during the influenza epidemic of 1918 tragically resulted in the loss of one of his legs. Incapacitated, Reicher concentrated on teaching the Talmud and mastering the art of paper-cutting.

In his pairing of image with text, Reicher demonstrates his mastery both as papercutter and scholar.

In this composition, elaborately framed with an S-shaped meander enclosing red florets, two continuous bands of Hebrew inscriptions from the *Ethics of the Fathers* (1:12, 2:1, and 3:1) and Psalm 128:2 frame the central part. A sheet of gold foil serves as a backing, enriching the overall effect of the cut-out. Attention is focused on the word *mizrah*, which is centrally placed, while the *shiviti* text occupies a cartouche in the center of the upper border. Superimposed on the double-headed eagles' wings are the flags of Zion and the United States, and the passage "How I bore you on eagles' wings, and brought you to me" (Ex. 19:4). (Here Reicher may be referring to his own emigration from Europe.)

Above the dominating image of the menorah is stated, "The seven lamps shall give light at the front of the lampstand" (Num. 8:2), while the lions roar "with trumpets and the blast of the horns" (Ps. 98:6). The pair of vases preserve "clear oil of beaten olives for lighting" (Ex. 27:20), and are joined by the chronogram "The light of the righteous will come to a blessing. [5]682 [1921/22]." The cartouche at the base of the frame bears the artist's signature, "This was made by Mordechai son of R[abbi] Yehiel Meichel Reicher here in Brooklyn."

Note: 1. Giza Frankel, "Paper-cuts Throughout the World and in Jewish Tradition," in Haifa Municipality Ethnological Museum and Folklore Archives, *The Paper-cut: Past and Present*, exhibition catalogue (Haifa, 1976): 24.

Reference: Greenwald, Alice M. "The Mizrah: Compass of the Heart." *Hadassah Magazine*, October 1979: 12–13.

99 (Plate 14)
Decoration for the Eastern Wall (Mizrah and Shiviti)
Mordechai Reicher (1865–1927)
Brooklyn, New York, 1922
Ink and watercolor on cut paper
Signed and dated
19¾ x 15¾"; 50 x 40 cm.
Collection of Mr. and Mrs. Arthur Sheiner
On loan to The Israel Museum in memory of Esther Laiken,
 California

This paper-cut proudly displays a Star of David in each
upper corner, and three passages from *Ethics of the Fathers*
(2:1, 3:1, 2:18) frame the entire complex.

In the upper section of the paper-cut, a double-headed
eagle encloses the word *mizrah*, while the inscription "From
this side the spirit of life" is in the cartouche below its breast.
On the eagle's wings is written, "How I bore you on eagles'
wings and brought you to me" (Ex. 19:4) while at their
juncture is read, "I am ever mindful of the Lord's presence"
(Ps. 16:8). Dividing the two registers is a sentence from *Ethics
of the Fathers* (5:23): ". . . Be as light as an eagle, as swift as a
deer and strong as a lion to do the will of your Father in
heaven."

The menorah in the lower register is supported by bands
containing the injunctions: "And you shall make its seven
lamps" (Ex. 25:37) and "Thou shalt make a lampstand of pure
gold" (Ex. 25:31), all set against the brilliant red background
of the lower register. Two of the lions' paws rest on a
rectangular cartouche stating, "This was made by Mordechai
son of Reb Yehiel Meichel may his memory be blessed
Reicher here Brooklyn." Below appears an inscription
indicating that this work was a gift to a fraternal order,
Hevrah Ahavat Reiyim ("love of friends").

100 (Plate 11)
Family Record
Isaac S. Wachman
Milwaukee, Wisconsin, 30 July 1922
Ink and watercolor on paper
Signed and dated at lower left
24 x 18"; 61 x 45.7 cm.
Collection of Francisco F. Sierra

This appealing record of the marriage of David and Ida
Goodman and the birth of their son Jacob, was the work of
Isaac S. Wachman, a manufacturer of "hand-made artificial
flowers for all occasions," who lived in Milwaukee during
the first quarter of the 20th century. Unlike the artists who
produced many of the other works on paper illustrated here,
Wachman apparently was not a trained *sofer*, or scribe. He
therefore achieves an unrestrained and exuberant result.

Wachman's name first appears in *Wright's City Directory of
Milwaukee* in 1903, as a partner of Harry Ottenstein in a
business that dealt in "artificial palms." Two years later, his
wife joined him in business, and for most of the next two
decades, Isaac and Rachel produced artificial flowers and
plants, although they apparently lived separately for a while.
Isaac is listed as an "agent" in the 1907 directory and as a
"peddler" in 1909, the same year in which Rachel is listed as
a florist.

A love of flowers and of the natural world is evident in the

register Wachman produced for the Goodman family. Here,
the stock Temple columns and arch are reduced in size and
given less importance in the overall composition of the piece
and in the placement of its elements. Rather than framing
the entire work, they are used to enclose only the lower cen-
tral portion in which a roundel applied with an adhesive re-
cords in Yiddish the birth of the Goodmans' son on the 15th
day of Heshvan in the Hebrew year [5]672, or 6 November
1911. The attenuated columns carry the initial letters of tradi-
tional Hebrew verses, "turn away from evil and do good," on
the right pillar and "yet be kind to Israel, selah" on the left.

Major emphasis in the Goodman family record is given to
the fruit tree springing forth from a large applied chalice,
which is the central motif in the work, as well as to the vine
of fruit and flowers that frames it. A subtle lack of symmetry
in both the tree and vine creates a sense of motion. Both the
upper portion of the work and the vine contain cut-work,
but this is neither as detailed nor as refined as in more
traditional paper-cuts.

Among the folk figures introduced are four animals on the
upper portion of the work illustrating the Hebrew inscrip-
tion, which is from *Ethics of the Fathers*, "Be strong as a
leopard, light as an eagle, swift as a deer and brave as a lion
to do the will of our Father in heaven" (5:23). As in the case
of much folk art, the figures are rendered in a flat, two-
dimensional fashion with no attempt at modeling. The eagle
carries a serpent in its beak, a not uncommon image in
Jewish folk art; indeed, much of the work appears reminis-
cent of the great decorative wall paintings found in wooden
synagogues of Eastern Europe, although the squirrels seen at
the base of the monuments recording the marriage of Ida
and David Goodman are an American innovation.[1]

The date of the Goodmans' marriage is inscribed following
the Hebrew inscription on the monument at the left. This
appears to be an error, a complication caused by the com-
mencement of the Hebrew year in the autumn: the corres-
ponding civil year is 1906. The monuments bear an inscrip-
tion in Hebrew and in Yiddish heavily influenced by
German:

"For remembrance/of our/marriage
Ita/daughter of/Israel
Sohnes [or Zohnes]
to
David/son of Michael/Goodmann[2]
Newark
in the year [5]667"

A marriage record for the couple in Newark, New Jersey,
has not been located, but it is known that David Goodman, a
painter, decorator and paperhanger for more than thirty
years, died in Milwaukee in 1945, and his wife, Ida Jones
Goodman, died there in 1950. They are both buried in Beth
Hamedrash Hagadol–Anshe Sfard Cemetery. Of the artist
Isaac S. Wachman, little more is known. Indeed, the curtain
seems to fall on his life in 1922, the very year he completed
this remarkable family record.

Notes: 1. Avram Kampf, "In Quest of the Jewish Style in the Era of the
Russian Revolution." *Journal of Jewish Art* 5 (1978): 52–53, figs. 3–5. 2. In
the Hebrew, Ida Goodman's name is given as "Ita" and her maiden name as
"Sohnes" or "Zohnes," although she was known as Ida Jones Goodman in
English. Wachman's spelling of "Goodman" in the Hebrew contains a second
"n." Jacob Goodman, the couple's son, was also known as Jack, the name by
which he was last listed in the Milwaukee city directory.

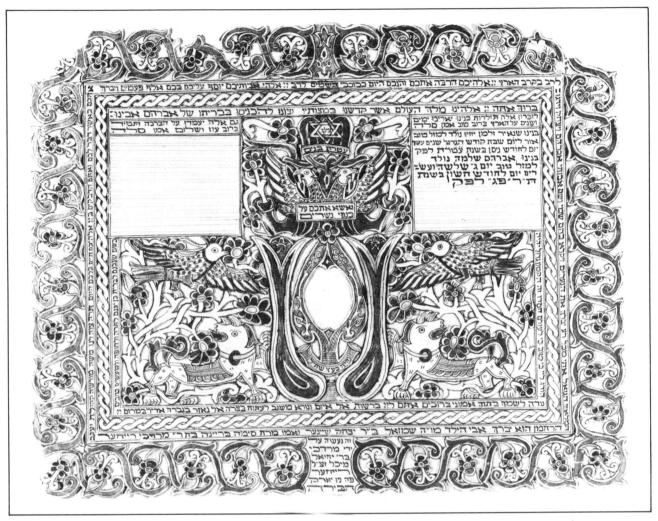

101
Birth Record
Mordechai Reicher (1865–1927)
New York, 1923
Ink and watercolor on cut paper
Signed at bottom
13 x 15¼"; 33 x 38.7 cm.
Collection of Mr. and Mrs. Arthur Sheiner

Mordechai Reicher designed this record in honor of the births of his grandsons, and inscribed it with good wishes for the infants and their parents. The document records that this is "a remembrance. These are the offspring, may our sons live many days and years on the earth with much good. Amen, Selah." "Our son Schneir Zalman may he live, was born under a good sign, on the holy 'Great Sabbath,' on the 12th day of the month of Nisan in the year [chronogram] [5]679 [1919]," and "Our son Abraham Solomon was born under a good sign on Wednesday the 23rd day of the month of Heshvan, in the year [5]683 [1923]."

A blessing for the parents occupies the lower border: "[May] God the merciful bless the father of the child our T[eacher] the R[abbi] Samuel S[on of] R[abbi] Isaac Schneir, and his mother Mrs. Simah Bryna daughter of R[abbi] Mordechai Reicher." Relevant biblical passages surround the remaining sides: "The angel who redeemed me from all harm bless the lads, in them let my name be recalled and the names of my fathers Abraham and Isaac and may they be

teeming multitudes upon the earth" (Gen. 48:16), and "The Lord your God has multiplied you until you are as numerous as the stars in the sky, may the Lord the God of your fathers increase your numbers a thousandfold and bless you as he has promised you" (Deut. 1:10–11). In accordance with Jewish law regarding a newborn male, a circumcision was performed, which the artist noted by including part of the ceremony text and this customary response: "Just as he entered into the covenant so may he enter into Torah into marriage and into good deeds."[1]

Illustrated with traditional motifs – including the Star of David, Crown of Torah, eagle, and bull – the paper-cut also possesses the apt metaphor of a Tree of Life rooted in the words: "He shall be like a tree planted by the waters" (Jer. 17:8). Together with red and blue accents, the color gold predominates in the S-curved meander of the outer frame and creates highlights on the crown, eagles' wings, and the tails of the animals, whose bodies remain unpainted. Gold rings on bands encircling the bulls' necks constitute the work's most curious detail.

As on his other works, the artist's signature is inscribed in the center of the lowest part: "This was made by Mordechai [Son of] R[abbi] Yehiel Meichel may his memory be blessed Reicher. Here in New York the capital."

Note: 1. This same inscription appears on all Torah binders of Western Ashkenazic origin. See cats. 57, 113, 121, and 122.

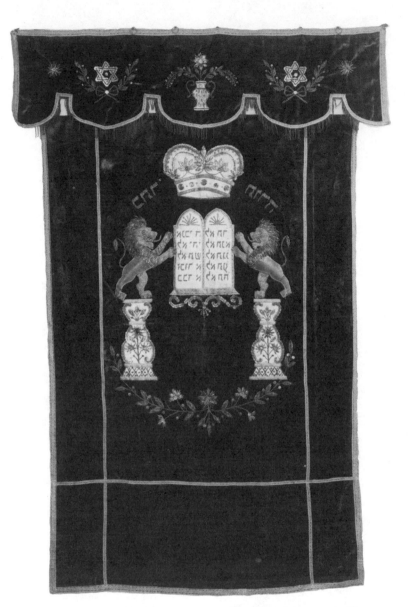

102

Torah Curtain and Valance

J. Levine Co.

New York, before 1930

Rayon plush pile embroidered with metallic thread and
 tinsel; appliquéd with silk, embroidered with tinsel;
 metallic braid; glass beads; metallic fringe; metal sequins

Curtain: 70 x 46¾"; 177.8 x 118.7 cm.

Valance: 16½ x 55¼"; 41.9 x 140.3 cm.

The Jewish Museum

Gift of Mrs. Benjamin Plotkin, Eda Plotkin, and Selda
 Plotkin in memory of Dr. Benjamin Plotkin of
 Congregation Emanu-El of Jersey City, New Jersey

Beginning in the 1880s, the migration of Jews from Eastern
Europe brought more than two million Jews to the United
States by 1924. In the Lower East Side of New York, five
hundred new congregations were established by 1915, a
phenomenon that created a demand for inexpensive
synagogue textiles.

Changing tastes, as well as economic factors, resulted in
commercially produced textiles that were a simplification of
traditional Baroque European prototypes. The newer
curtains could not include the usual antique and costly
textile insets, even though the same iconography was
retained.[1] As is seen in this curtain and cat. 103, a popular
combination of motifs comprises a crown, Tablets of the
Law, and lions (sometimes perched on pedestals deriving
from the vine-covered twisted columns seen on Baroque-
period curtains). Stars of David are frequently found on the
valance.

A cardboard template often designed by the workshop
proprietor served as the basis for the appliquéd and
embroidered elements. Women did the hand embroidery,
while men operated the sewing machines used for some of
the embroidery, for applying the braid, and for finishing.
Few curtains are identical, owing to variations in design
from workshop to workshop, or within the same workshop
over a period of time. The choice of the design elements was
also dependent on the size of the curtain and its cost.

Curtains were frequently replaced as the metallic thread tarnished or the synthetic fabrics deteriorated. The cost of one of these curtains in the 1920s was between $75.00 and $100.00.

One of the several makers of religious textiles on the Lower East Side during the 1920s, J. Levine Co. is the oldest workshop still in existence; the firm is now managed by the third and fourth generations of the family. Its current president identified this curtain as one of their designs made prior to the 1930s.[2]

This Torah curtain came from Congregation Emanu-El, established in Jersey City in 1930. In place of its original rings, the valance has dress labels from Fashionbilt Clothes in Jersey City, which may have been added during a repair done in that factory.

The inscriptions read: "Crown of Torah" (*Ethics of the Fathers* 4:17) and the Ten Commandments (abbreviated).

Notes: 1. See, for example, The Jewish Museum, *Danzig 1939: Treasures of a Destroyed Community,* exhibition catalogue (New York, 1980): no. 54. 2. Interview with Mr. Seymour Levine, 12 April 1984.

References: Fine, Jo Renée, and Gerard R. Wolfe. *The Synagogues of the Lower East Side.* New York: Washington Mews Book, New York University Press, 1978: 56, 73, 107, 129, and 156. Israelowitz, Oscar. *Synagogues of New York City.* New York: Dover, 1982.

103
Torah Curtain and Valance
New York, 1924/5
Rayon satin appliquéd and embroidered; cord couched
Curtain: 91 x 63" (incl. fringe); 231.1 x 160 cm.
Valance: 19⅞ x 65¼" (incl. fringe); 50.5 x 165.7 cm.
Collection of Sylvia Zenia Wiener

White Torah curtains are traditionally hung on New Year's Day and the Day of Atonement, symbolizing the spiritual purification associated with these days.

The inscriptions read: (on the valance) "Holy to the Lord" (Ex. 39:30); (on the curtain) The Ten Commandments (abbreviated) and "Elhanan s[on of] Bezalel with his mate [wife] Miriam Golde d[aughter] of R[abbi] Levi Isaac, [5]685 [1924/5]."

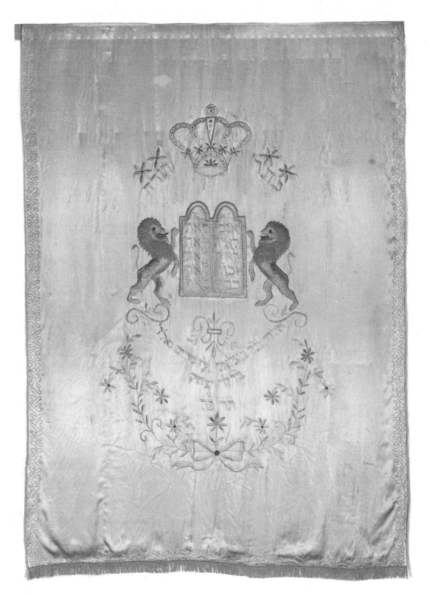

The inscription date was confirmed by newspapers employed as padding for the tablets and lions, which were discovered at the time of the curtain's conservation in late 1983. Wads of newspaper (*The Evening Journal* of 18 January 1924 and *The New York Times* of 12 September, 1924) were cut to the shape of the tablets, and hand-torn shreds were used to fill the lions. The crown, which still bore remnants of its original cardboard template, was stuffed with fabric strips, and must have been refilled during an earlier repair. According to a manufacturer of such curtains, newspapers were generally employed as stuffing during this period.[1]

This curtain belonged to a synagogue in Hackensack, New Jersey.

Note: 1. Interview with Mr. Seymour Levine, 12 April, 1984.

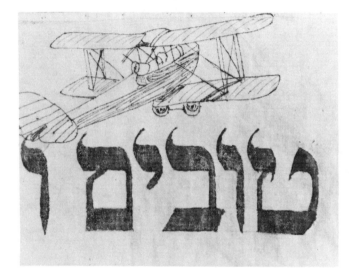

104
Torah Binder (detail)
1927
Painted linen
7 x 135"; 18 x 343 cm.
The Jewish Museum

On this relatively restrained binder, the sketched biplane is a topical element indicative of the great fascination with aviation in the year of Lindbergh's flight. Other images include references to the family firm, Frank and Co. Elektro, which appear on the drawing of a truck and on a sign held by a snowman standing beside an open refrigerator. Under a wedding canopy formed by bridging two letters, a fringed lamp is suspended over two interlocking rings and two confronting fish.

A pail placed beneath the date of birth is an allusion to the child's zodiacal sign, Aquarius. Such signs are a common feature of Torah binders.

The artist has applied a stork's head to the ascender of the Hebrew letter lamed in the word *nolad* ("born"), combining the myth of birth with a traditional East European method of teaching the Hebrew alphabet using mnemonic devices: by this method the letter lamed is represented by a stork.[1]

Each word has its own color scheme, with serifs giving the letters a scribal character.

The inscriptions read: "The little one Zeev, son of Nisan, known as Werner Willie Wolf Frank, born for a good sign on Monday, the 19th of Adar I, [5]687 [21 February 1927]. May the Lord raise him to the Torah and to the marriage canopy and to good deeds. And thus may it be His will Amen Selah."

On the Torah scroll: "The name of the righteous is invoked in blessing, but the name of the wicked rots" (Pr. 10:7).

Under the marriage canopy: "The sound of mirth and gladness, the voice of the bridegroom and bride" (Jer. 33:11).

Note: 1. For a discussion of this teaching method, see Diane Roskies, "Alphabet Instruction in the East European Heder: Some Comparative and Historical Notes," *YIVO Annual of Social Science* 17:21–53; cited in Barbara Kirshenblatt-Gimblett, "The Cut that Binds: The Western Ashkenazic Torah Binder as Nexus Between Circumcision and Torah," in Victor Turner, ed., *Celebration: Studies in Festivity and Ritual* (Washington, D.C.: Smithsonian Institution Press, 1982).

105
Eagle and Crown from a Torah Ark
Rochester, New York, c. 1930
Carved and painted wood
13 x 16⅛ x 1⅜"; 33 x 40.9 x 8.2 cm.
Karp Family Collection

Eagles or other birds occasionally appear as the topmost decoration of Torah arks in both Europe and America.[1] Cast in the role of guardian, they hover protectively over the Crown of Torah or the Tablets of the Law.

This vigilant eagle, talons planted firmly, rests on a crown carved with the letters "C[rown of] T[orah]" (*Ethics of the Fathers* 4:17). It came from the Field Street premises used from around 1930 to the mid-1950s by Beth Sholem, an Orthodox congregation in Rochester, New York.

Note: 1. See, for example, Maria and Kazimierz Piechotka, *Wooden Synagogues,* English ed. (Warsaw: Arkady, 1959): pl. 231. The recently salvaged ark from Congregation Shaarei Eli in Philadelphia has an eagle with a twenty-foot wingspread. For the lions from that ark, see cat. 97.

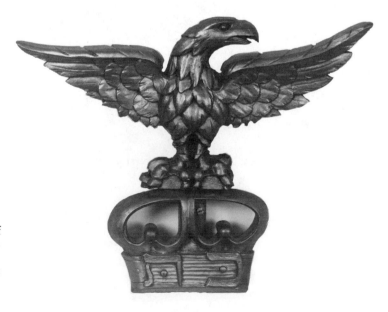

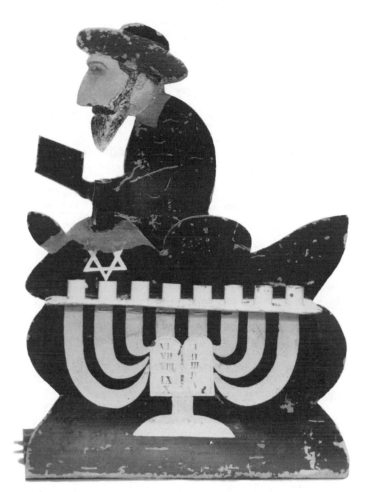

106
Hanukkah Lamp
Possibly Ohio, c. 1930
Cut and painted tin
9¾ x 7¼ x 3½"; 24.8 x 18.4 x 8.9 cm.
Collection of Mary Bert and Alvin P. Gutman

An unusual feature of this tin Hanukkah lamp is the movable painted profile figure of a bearded man dressed in a black caftan and wearing a broad-brimmed, fur-trimmed hat (*streimel*). Originating in Eastern Europe, the *streimel* is still worn in some Hasidic circles on the Sabbath and on festivals.[1] The figure holds a book bearing the first words of the affirmation known as the *Shema* (Hear): "Hear O Israel! The Lord is our God, the Lord alone" (Deut. 6:4).

Constructed so that it can rock back and forth, the figure simulates the movement made by some observant Jews during prayer; it also resembles certain secular balancing toys of the 19th century. Similar depictions that appear in popular prints, such as those of Alphonse Levy, may have suggested the use of this figure on a Hanukkah lamp.[2]

Notes: 1. Alfred Rubens, *A History of Jewish Costume*, 2d ed. (New York: Crown, 1973): 105, 122, 160, and fig. 151. 2. Edward Fuchs, *Die Juden in der Karikatur* (Munich: Langen, 1921); fig: 267.

107
Wedding Greeting (not shown)
Mordecai Cohen
Montreal, Quebec, c. 1930
Ink on paper
19¼ x 20⅞"; 49 x 53 cm.
Karp Family Collection

108
New Year's Greeting
Mordecai Cohen
Montreal, Quebec, 1932
Ink on paper
20⅛ x 20⅞"; 51 x 53.2 cm.
Karp Family Collection

In the early 1930s, Mordecai Cohen of Montreal prepared a series of large greetings to his daughter, Shirley, who was newly married to Abraham Nusbaum in Rochester, New York. Incorporating Hebrew, Yiddish, and English inscriptions, these works were prepared almost entirely through the use of small rubber-stamp cuts in red and blue ink. Despite the limitations of his medium, Cohen achieves an exuberant sense of design and color.

The New Year's greeting for the year 5693 of the Hebrew calendar, which Cohen highlights with dots of gold paint and a red notary's seal, includes original poems in English and Yiddish. The Yiddish poem expresses the hope "for a year like sugar, sweet" and looks forward to the celebration of a *brit*, the ritual circumcision that will follow the anticipated birth of a grandson. Cohen's deep affection for his daughter is expressed in the wedding greeting. Stamped seven times on the work is the Yiddish expression, "*Oy, ich benk noch dir*" ("Oh, I long for you"), and the hope expressed in English, "This will convince you how much I miss you yet I feel happy in your happiness."

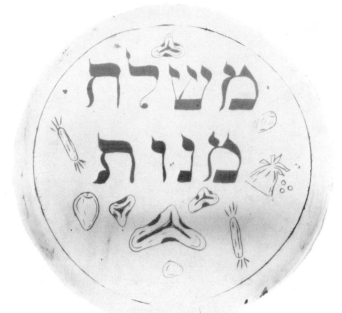

109
Purim Plate
Celia Sylvia Silverberg (1893–1979)
Alice Ellen Silverberg (1896–1976)
Buffalo, New York, c. 1935
Redware covered with white slip
Signed on back; Alice E. Silverberg and Celia Silverberg;
 stamped with seal
Diameter: 9½"; 24 cm.
The Congregation of Beth Israel Judaica Museum,
 West Hartford, Connecticut

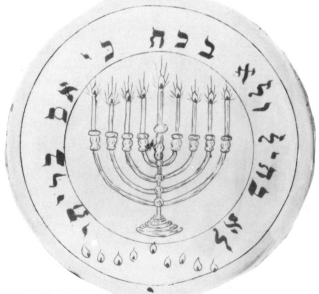

110
Hanukkah Plate
Celia Sylvia Silverberg (1893–1979)
Alice Ellen Silverberg (1896–1976)
Buffalo, New York, c. 1935

Redware covered with white slip
Signed on back; Alice E. Silverberg and Celia Silverberg;
 stamped with seal
Diameter: 9½"; 24 cm.
Collection of Judith Tuller

Two joyous holidays, Purim and Hanukkah, are honored
on these ceramic pieces.[1] Featured on the Hanukkah plate is
a nine-branched candelabrum symbolizing the Festival of
Lights (commemorating the rededication of the Temple in
Jerusalem in c. 165 B.C.E.). Circling the candelabrum is an
inscription in Hebrew from Zechariah 4:6: "Not by might,
nor by power, but by my Spirit . . ." that aptly alludes to the
triumph of Judah Maccabee and his small band of followers
against the powerful Syrian king.

Purim (Feast of Lots) celebrates the story of the
deliverance of the Jews of Persia from Haman's plot to
destroy them. The inscribed Hebrew words, "sending
portions" and the decorative candy, apples, and nuts on this
plate illustrate the injunction to the Jews to "observe them as
days of feasting and merrymaking, and as an occasion for
sending gifts to one another, and presents to the poor"
(Esther 9:22). Prominently displayed is the traditional Purim
pastry, the tricornered *hamantaschen* ("Haman's pockets"),
named after the vanquished villain.

These unique plates were jointly crafted by two sisters,
Celia and Alice Silverberg, of Buffalo, New York.[2] Holders of
doctorates in psychology and home economics, respectively,
these highly educated women, who never married, devoted
themselves to their careers as teacher and psychologist in the
Buffalo school system. Reclusive to the point of being
considered eccentric, they belonged to no congregation,
although they were deeply religious, learned in Hebrew, and
observant of the dietary laws. Engaged in pottery-making for
many years, the Silverberg sisters installed a kiln in a
bedroom in their house.

Additional known examples of their ceramics include a
wine decanter, a kiddush cup, a Christmas tree (made for
Catholic friends), a horse's head (from one of their molds),
and the Rosh Hashanah plate shown in cat. 111.

Notes: 1. The Purim plate appeared in Yeshiva University Museum's *Purim:
The Face and the Mask,* exhibition catalogue (New York, 1979): 78 (no.
212). 2. Thanks to Miriam R. Miller of Temple Beth Israel in West
Hartford, Connecticut, for her paper, "In Search of the Silverbergs."

111
Rosh Ha-Shanah Plate
Celia Sylvia Silverberg (1893–1979)
Alice Ellen Silverberg (1896–1976)
Buffalo, New York, c. 1935
Redware covered with white slip
Signed on back; Alice E. Silverberg and Celia Silverberg;
 stamped with seal
Diameter: 9½"; 24 cm.
The Jewish Museum
Museum purchase through the gift of Michael and Luz Zak
 and the Judaica Acquisition Fund

Rosh Ha-Shanah, the Jewish New Year, is commemorated
on this ceramic plate made by the Silverberg sisters. Accom-
panied by a ring of apples and a beehive, from which issues
a swarm of bees, the traditional wishes for a new sweet
year — ritualized by serving apples dipped in honey — are
charmingly expressed. The Hebrew inscription reads: "For a
good and sweet year."

112
Synagogue Model (not shown)
Abraham Isaac Miller (1864–1951)
New Jersey, 1935
Wood, glass, cellophane, sponge, masking tape, wire, various
 textiles and trimmings.
Signed and dated in right cornerstone on façade; A. Miller
33 x 30 x 61"; 84 x 76 x 155 cm.
Collection of Eleanor Sosnow Levitt, granddaughter of
 the artist

After successfully constructing a small-scale Torah ark,
built at the request of his daughter, Abraham Miller was
encouraged to embark on the ambitious project of creating a
miniature synagogue, complete with landscaping, lighting,
interior furnishings, and members of the congregation.

On the model's façade is proclaimed: "[For] my house shall
be called a house of prayer for all peoples" (Is. 56:7).
Constructed with meticulous attention to detail, the model
boasts real glass windows, the crinkled gold cellophane
backing of which creates the illusion of stained glass. In the
interior, carved steps and banisters are fashioned for the
centrally placed *bimah* (reader's platform), while the
women's balcony is reached by its own stairway. The extra-
ordinary chandelier (which has its design origins in the
lighting fixtures of the Radio City Music Hall) is composed of
over eighty parts. On the Torah ark playful lions (inspired by
the design on a can of Lion-brand milk) prance around the
Tablets of the Law. Seated in the pews are male worshipers,
whose carved detailing includes skullcaps, shoes, and articu-
lated fingers; separated, in the balcony above, are the
women, whose faces are markedly framed by their dark
hair. Visible on the podium are two officers of the
congregation wearing traditional prayer shawls, and the
cantor, robed in white satin, stands at the pulpit.

Originally run by batteries, the lighting system was
converted to electric power by Mr. Miller three years after
starting the project. In 1959, well after his death, his
daughter, with the help of friends, fashioned dresses and
gold wedding rings for the female congregants, and painted
the clothes, hats, pupils of eyes, and lips on the men.

Abraham Isaac Miller, who was born Abraham Midlarski,
left his home in Eastern Europe at the age of twenty-four,
and spent six years in England before arriving in the United
States in 1894. He settled in Kansas City, Missouri; bringing
his wife and two sons from his native country, and earned a
living as a grocer. A pious Jew, he joined the Orthodox
congregation. In 1934, at the age of seventy, he drove cross
country to join his daughter in Bergen County, New Jersey.
Besides woodcarving, Miller enjoyed growing grapes and
making his own wine for religious occasions.

After Abraham Miller's death, his daughter customarily lit
this legacy from her father in his memory on the anni-
versary of his death.

113
Torah Binder (not shown)
Leopold Halberstadt
New York, 1938
Painted cotton with ink drawing
Signed at left end in combined English and Hebrew;
 Leopold Halberstadt, 600 W. 142 Str. N. York
8 x 136½"; 20.5 x 347 cm.
The Jewish Museum

Leopold Halberstadt's lettering pattern employs nine different motifs, thus giving each word or phrase a unified scheme.[1] Red, white, and blue stripes form the letters of the words "Holy Sabbath," while the designs forming other letters resemble stained glass or mosaic tesserae.

The lamed ascender in the final word, *Selah,* is an American flag; others are grotesque heads and loose flower arrangements, contrasting sharply with the formal arrangements decorating other letters. The stork on the lamed ascender in the word *nolad* ("born") is provided with a nest.

Halberstadt has replaced the customary alms box associated with the phrase "to good deeds" with a cornucopia showering gold coins. Below the marriage canopy, a table is set with candles, two wine goblets, and an open book in preparation for the ceremony; a contemporary rug and potted plants complete the roomlike tableau.

Additional images include a Torah scroll superimposed on a rayed sun disk representing the light of Torah, flaming hearts, and the zodiacal sign of Virgo set within an oval frame surmounted by a Star of David. Above the words "Holy Sabbath" Halberstadt has drawn a loaf of hallah, a kiddush cup, and a prayer book flanked by two Sabbath candles.

The other inscriptions read: (in English written in Hebrew characters) "Donald Seligman, born Sept. 17, 1938, Forest Hills, N.Y."

"David, son of Kalman the son of Leib and his wife Yittel the daughter of Asher, born under a good sign on the holy Sabbath day, the 21st of Elul [5]698 [17 September 1938]. May he grow up in the Torah and to the canopy and to good deeds Amen Selah."

On the kiddush cup: "D.S." (in English letters).

In the prayer book: Parts of the blessings over wine and bread with zodiacal sign: "The sign of the Virgin" (Virgo).

In the Torah scroll: "She is a tree of life to those who grasp her" (Pr. 3:18).

On marriage canopy: "The sound of mirth and gladness, the voice of the bridegroom and bride" (Jer. 33:11), and "Good fortune."

With its incorporation of the American flag into the design, the bright coloring, and floral motifs, this binder resembles cat. 48 which may have been known to Halberstadt. That binder from 1869 entered the collection of The Jewish Theological Seminary two months after the birth of Donald Seligman.

Note: 1. For a similar scheme and designs, see David Altshuler, ed., *The Precious Legacy: Judaic Treasures from the Czechoslovak State Collections,* exhibition catalogue (New York: Summit Books, 1983): fig. 118.

114
Lulav, Etrog, and Box
Nehemiah Mark
c. 1940
Carved wood
Lulav: 15½ x 1½ x ¾"; 39.5 x 3.5 x 1.9 cm.
Etrog: 3¾ x 6" circ.; 9.5 x 15.2 cm. circ.
Box: 5¼ x 3 x 2"; 13.3 x 7.5 x 5 cm.
Collection of Philip and Hanna Goodman

The *lulav* and *etrog* are necessary elements in the observance of Sukkot (Feast of Tabernacles), the festival celebrating the late harvest and commemorating the Israelites' wanderings in the desert after the Exodus. Fulfilling the injunctions of Leviticus 23:40, the *lulav*—a cluster of palm shoots bound with three twigs of myrtle and two willow branches—and the *etrog,* or citron, represent the four plants carried and waved in the Sukkot ritual.[1] Extant containers fashioned for the preservation of the *etrog* date from the 18th century.[2]

Nehemiah Mark's unusual carved representations of the *lulav* and *etrog* may have been intended for instructional use, as it is known that the artist was a Hebrew school teacher. He carved the *lulav* quite realistically, but refined the *etrog* by giving it a smooth surface instead of rendering its thick, textured rind. The sides of the *etrog* box are adorned with a basketweave decoration.

Notes: 1. The *etrog* bears the sobriquet "Adam's apple" or "paradise apple," as it has been proposed, among others, that this was the forbidden fruit eaten by Adam and Eve in the Garden of Eden. See *The Jewish Encyclopedia,* 5:262. 2. Cf. the *etrog* box of G. Friedman from The Israel Museum in this exhibition, cat. 96. For other examples of containers, see Abram Kanof, *Jewish Ceremonial Art and Religious Observance* (New York: Abrams, 1969): 152–53, figs. 141–45.

Reference: For a discussion on the origin and customs of Sukkot, see Gaster, Theodor H., *Festivals of the Jewish Year.* New York: Sloane, 1953: 80–98.

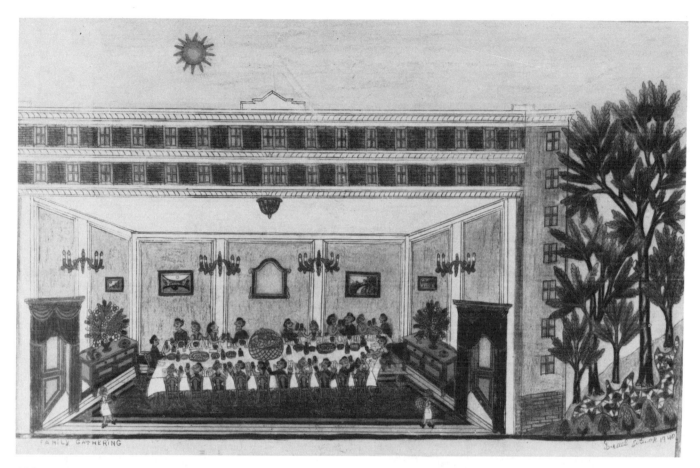

115
Family Gathering
Israel Litwak (1868–1952)
Brooklyn, New York, 1940
Crayon and pencil on board
Signed and dated in lower right
19¾ x 29¾"; 50.2 x 75.5 cm.
The Jewish Museum
Gift of Dr. Joseph Tucker

Israel Litwak was born in Odessa, and in 1903 emigrated to the United States, where he worked as a cabinetmaker. An ardent museum visitor, his early love for art was experienced solely as a spectator, but retirement at the age of sixty-eight thrust him into the active role of a creator.

In *Family Gathering,* a festive meal is observed as though through a proscenium, its arch formed by the top two stories of a typical brick apartment house in Brooklyn. The symmetry of the scene dominates, as Litwak's interplay of horizontals and diagonals creates a serene atmosphere.

The interior is divided into two equal parts—appearing as reflecting images—which, upon closer inspection, reveal slight deviations. There are four wall sconces, each holding four candles; two identical buffets, each bearing a vase of flowers; four paintings, two large and two small, placed in similar positions on the walls; two open doors, draped with vibrant blue portières, through which two maids in white uniforms have entered carrying food-laden plates. Centered on the back wall of this meticulously ordered room is a large mirror that bridges its two complementary halves.

The diners, ten identically dressed and coiffed wine-toasting couples, plus a mother and son presiding at the head of the table, are all depicted in profile; their black-outlined eyes and pointed noses giving them a caricaturelike resemblance to figures in ancient Egyptian wall paintings.

Above the rooftop, a hot orange sun shines down upon the house, and stylized trees stand out against a yellow background representing, in the artist's words, "the light of the world."[1]

Another urban folk artist—born in Manhattan—to whom the architecture of the city plays a vital role, is Ralph Fasanella. He frequently shares Litwak's proscenium device in his paintings such as *Family Supper* of 1972, which treats a similar theme.[2]

Notes: 1. Sidney Janis, *They Taught Themselves: American Painters of the 20th Century* (New York: Dial, 1942): 141. 2. Herbert W. Hemphill, Jr. and Julia Weissman, *Twentieth-Century American Folk Art and Artists,* (New York: Dutton, 1974): 180, 181.

116
The Star-Spangled Banner (not shown)
Abraham Stollerman
1943
Ink on paper
Collection of the artist

An accomplished penman, Stollerman here presents the National Anthem in Yiddish, inscribed on a scroll decorated with a flower and a quill pen, and with the Statue of Liberty at the upper left.

117 *(Plate 12)*
Moses and Aaron
Morris Hirshfield (1872–1946)
1944
Oil on canvas
28 x 40"; 70.1 x 101.6 cm.
Sidney Janis Gallery, New York

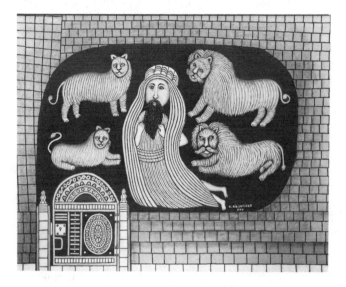

118
Daniel in the Lion's Den
Morris Hirshfield (1872–1946)
1944
Oil on canvas
33 x 42"; 80.4 x 106.7 cm.
Sidney Janis Gallery, New York

In 1939, when Sidney Janis was collecting paintings for an exhibition entitled *Contemporary Unknown American Painters* at the Museum of Modern Art, he chanced to come across several paintings by Morris Hirshfield. Janis was so enthusiastic about his discovery that he not only included two of Hirshfield's primitive paintings in the exhibition but also organized a one-man show of the artist's work at the museum four years later.

Morris Hirshfield emigrated to the United States from Russian Poland at the age of eighteen, but he did not produce his first painting until he was sixty-five years old and had retired from a successful business career in the women's apparel industry. Janis has suggested that Hirshfield's use of "textures, which remind one of various fabrics and his sense of design, which comes from pattern making" can be traced to his occupational background.[1] In the artist's essay, "My Life Biography," it becomes clear that another important influence on his artistic development began years earlier in the small town in Eastern Europe where he was born in 1872, and where he appears to have had a firm grounding in the Jewish folk arts:

It seems that even in my young days I exhibited artistic tendencies—not in painting—but in wood-carving, for at the tender age of 12 I aroused our little town by producing for myself a unique noise-maker to be used in the Jewish Purim festivals at the synagogue. On this noise-maker I managed to depict the main event of the Purim day by modeling in wood actual miniature figures of the well-known Jewish Biblical characters Mordecai, his adopted cousin Esther, Haman and King Xerxes....I painted the features to make the appearance more lifelike and actually clothed them in garments I felt befitted their day.

The fury it created was so great that the Rabbi of that congregation was compelled to go to my father pleading that he hide my work of art in order that prayers could be rendered.

Seeing my work so well received and admired, I took courage to go on to even greater efforts. At the age of fourteen I undertook the sculpturing in wood of a piece of work almost six feet high for our local synagogue. It formed the prayer stand in front of the scroll on which the Cantor's prayer-books rested. It consisted of two huge lions holding between them the ten commandments. Below the animals were two prayer books lying flat, and on top of the holy volumes were two birds, one holding in his beak a pear, the other a leaf. Everything was carved in full life-like figures and embossed with a good many more ornamental designs which I do not remember in detail and the whole gilded with gold and other colors of paint.[2]

Although Hirshfield's artistic journey led him from traditional Jewish themes to a wider universe, the two paintings illustrated here—both depicting major biblical figures—are witness to his continued awareness of his cultural heritage.

Daniel in the Lion's Den is a striking example of the artist's characteristic use of curvilinear forms, and reveals his tendency to create two-dimensional figures that seem to float in space independently from each other. The lions, in particular, are evidence of Hirshfield's debt to Jewish folk-art prototypes. As the artist El Lissitzky observed after a visit early in the century to the great wooden synagogue in Mohilev, "Behind the masks of four-legged animals and winged birds there are the eyes of human beings. This is the most characteristic aspect of Jewish folk art. And is that face of the lion in the drawings of the zodiac in the synagogue of Mohilev, not the face of a rabbi?"[3]

The respective offices of the brothers, Moses and Aaron, one as lawgiver and the other as priest, are reflected in Hirshfield's *Moses and Aaron*. Moses holds the Tablets of the Law inscribed with the Ten Commandments in Hebrew, while Aaron dispenses the "sweet incense" (Num. 4:16). Aaron's vestments are as described in Ex. 28:2–8: "a breast-plate and an ephod of gold, of blue, and of purple, of scarlet and fine twined linen, with cunning work." The dotted background—here white on blue—is a device used by Hirshfield in several paintings, but in *Moses and Aaron* it has a starlike quality suggestive of the cosmic role played by the subjects of the painting.

Notes: 1. Sidney Janis, *They Taught Themselves: American Primitive Painters of the Twentieth Century* (New York: Dial, 1942): 18. 2. *Ibid.*, 17.
3. Avram Kampf, "In Quest of the Jewish Style in the Era of the Russian Revolution." *Journal of Jewish Art* 5 (1978): 53.

119
Purim Klopfer (not shown)
Paul O. Kremer (1884–1962)
Brooklyn, New York, c. 1945
Burl maple, brass
7 x 4¼ x 6¼"; 17.5 x 10.5 x 15.9 cm.
Collection of Abraham and Bernice Kremer, son and
 daughter-in-law of the artist

While the *Megillah* (Book of Esther) is being read in the
synagogue during Purim, noisemakers are traditionally
sounded by children to drown out the name of the villain
Haman. This *klopfer* – of German and Russian antecedents –
possesses two flexible wooden joints that beat against the
sounding board when shaken.[1] It is decorated with two blue
medallions bearing Stars of David.

Born in Tomaszow, Poland, Paul O. Kremer attended a
gymnasium in Warsaw before emigrating to the United
States in 1900. A sign painter, specializing in gold-leaf
lettering on glass, Kremer enjoyed painting, woodwork, and
metalwork as avocations.

Note: 1. For similar examples, see Abram Kanof, *Jewish Ceremonial Art and
Religious Observance, (New York: Abrams, 1969): 182; ill. 191; and "Purim" in
Jewish Encyclopedia, 10:276, fig. "Haman Klopfers."

120
Walkovisk Synagogue
Samuel Rothbort (1882–1971)
New York, 1945
Oil on canvas; carved wooden frame
47 x 42" (65 x 57" frame); 119.3 x 106.7 cm.
 (165 x 144.8 cm. frame)
Collection of Ida Rothbort, daughter of the artist

The prolific painter and sculptor Samuel Rothbort pro-
duced thousands of works, of which about seven hundred
reflected life in his native town of Walkovisk, Russia.[1]
Emigrating to the United States at the age of twenty-two, he
worked as a house painter, as a ceiling decorator, and ran
dairy and chicken farms before settling down in Brooklyn in
the 1930s to devote himself to his art. For twenty years,

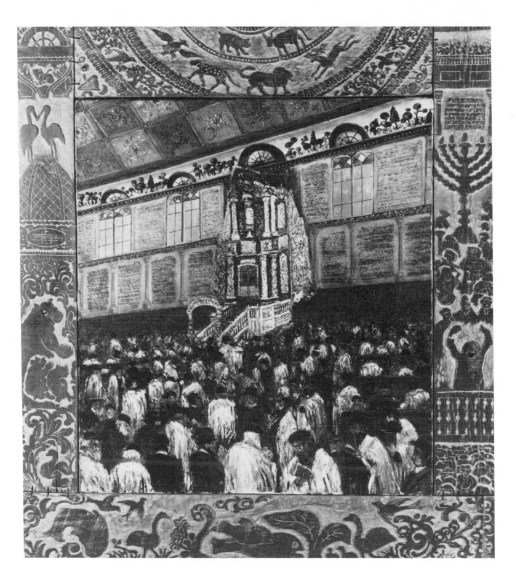

Rothbort painted self-portraits, costuming himself as famous historical figures of both genders in order "to show that we are all a part of one humanity, one responsibility, one God."[2] For his sculptures, Rothbort used only found materials, such as driftwood, tree trunks, old barn doors and fence posts. His paintings encompassed the mediums of oil, watercolor, and pen and ink.

In *Walkovisk Synagogue* the artist depicts from memory the wooden synagogue of his youth, which was destroyed by fire in the early 1900s. A grandiose interior, with a rectangular-patterned ceiling, provides the setting for a surging mass of men—bearded, hatted, and draped in prayer shawls—joined in prayer, among them a few conspicuously dressed in blue uniforms. While most of the worshipers face the eastern wall, several look out toward the viewer. Attention is focused on the elaborate two-tiered Torah ark, reached by carved stairs and protected by a balustrade, which is typical of those found in the old wooden synagogues in Eastern Europe.[3] The painting's somber palette is relieved by the whites of the Torah ark and prayer shawls and the intense red of the Torah curtain. This devotional scene, seemingly impressionistic in technique, contrasts with the earthy, naïve character of its carved wooden frame.

The asymmetrically decorated frame presents a series of inventive figural vignettes, as well as rows of vigorously executed animals, birds, and fish. Included are a bull, deer, lion, leopard, eagle, swan, and whale. A pair of affectionate storks nest on top of a domed building that bears the Hebrew inscription, "The chair of Elijah." Traditionally a symbol of filial and maternal piety, the stork was believed to bring good luck and, of course, babies.[4] It is apt that the prophet Elijah, who symbolically attends every circumcision ceremony, should have his seat in such an auspicious place. On the right panel, under the great Hanukkah lamp, a group of musicians rejoice in the sounds of their strings, woodwinds, and brass.

Samuel Rothbort's *Walkovisk Synagogue* honors a lost world, a world in which for him "there was spirit and joy."[5]

Notes: 1. Two hundred and fifteen of Rothbort's paintings of the town of Walkovisk were used to make a film entitled "The Ghetto Pillow." *National Jewish Monthly,* September 1966: 18. 2. Francis Sugrue, "Portrait of an Artist," *New York Herald-Tribune,* November 7, 1965. 3. Maria and Kazimierz Piechotka, *Wooden Synagogues,* English ed. (Warsaw: Arkady, 1959): ills. 15 and 63. 4. Beryl Rowland, *Birds with Human Souls: A Guide to Bird Symbolism* (Knoxville: University of Tennessee Press, 1978): 161-63. See also cat. 96. 5. Sugrue, *op. cit.*

121
Torah Binder (detail)
New York, 1946
Painted cotton with ink drawing
8¼ x 136¾"; 21 x 347.5 cm.
The Jewish Museum

This unsigned binder was made for Morton Seligman, the brother of Donald Seligman for whom Leopold Halberstadt had created a binder in 1938 (cat. 113). Morton's binder lacks the playfulness and creativity of Donald's; several of the images appear to have been traced from commercial sources, such as greeting cards. It is problematical to add it to Halberstadt's *oeuvre.*

The anonymous artist has, however, constructed an imaginative series of letters, shaded and ornamented so they appear to be carved and painted wood. Each word has its own color and design scheme in a somber palette. Several of the lameds (the Hebrew letter "l") terminate in grotesque heads. To mark abbreviations in the Hebrew text, the artist employed a small crown, Stars of David, leaves, and clusters of colored dots.

The five pictorial elements consist of an orchid corsage with an accompanying card, an ornately bound prayer book, a Torah scroll in a purple cover with a silver shield, a marriage canopy surmounted by a Star of David and supported by four vine-entwined poles, and an alms box.[1] The latter three elements are depicted at appropriate points in the text.

Below the main inscription—in English and printed in gothicized letters that harmonized with the Hebrew—appears: "Morton Seligman, Jan. 1, 1946."

On the card accompanying the orchid corsage: (in Hebrew) "Good Fortune"; (in English) "Morton."

The cover of the prayer book includes an abbreviated text of the Ten Commandments in Hebrew, with the Hebrew initial letters of "C[rown] of T[orah]" appearing on the Torah mantle.

The text on the alms box reads: "But righteousness saves from death" (Pr. 10:2; 11:4).

The main inscription reads: "Mordechai, son of Kalman Seligman, born for a good sign in New York, the 28th of Tevet [5]706 [1 January 1946]. May the Name raise him to the Torah and to the canopy and to good deeds Amen Selah."

Note: 1. For a similar alms box, see cat. 91.

122
Torah Binder (not shown)
Reuben M. Eschwege (1890–1977)
New York, 1947
Painted linen with ink drawings
8¾ x 94"; 22 x 238.8 cm.
Collection of Mr. and Mrs. Sidney G. Adler

Reuben M. Eschwege concurrently pursued the occupations of cantor, teacher, circumciser (*mohel*), and artist. He expressed in his Torah binders his knowledge and sense of humor. He was born in Germany, where he attended the Jewish school taught by his father. Graduating from the Jewish Teachers Seminary in Würzburg in 1911, he served for twenty-five years as chief cantor of a Würzburg congregation. He resumed his cantorial career upon his arrival in New York in 1940.

Among his Torah binders are four made for the sons of Sidney Adler, a relative. Following the Western Ashkenazic tradition, he utilized the cloths on which the infants had been placed during the circumcision ceremony. Three were donated to synagogues in New York and Baltimore, while this example remains with the family.

Highly colored and boldly lettered, this binder contains, in addition to the traditional inscription, forty-seven drawings, each with an inscription consisting of a biblical quotation or the name of the festival, bird, animal, or object depicted. While the choice of some quotations or objects remains obscure, the matching of text to drawing usually reveals the artist's love for puns. For example, Cantor Eschwege accompanies the Hebrew word for "wrapped" with a cigar ("wrapped" refers to the function of the cloth itself in a double context: first for wrapping the child and later for wrapping the Torah).[1] Along with a vignette of a nursemaid bathing a baby in its nursery is the inscription: "And this is what you shall do to them to cleanse them" (Num. 8:7), which in the Bible refers to the consecration of the Levites.

He continues in this vein with a portrayal of a photographer half-hidden under the black cloth draping the viewfinder of his camera. The text reads: "And I will take away my hand and you will see my back, but my face must not be seen" (Ex 33:23), God's words to Moses in the tent of meeting in response to Moses's request that God reveal His glory.

The main inscription reads: "Abraham, son of Pinhas [Sidney], commonly known as David A. Adler, may his light shine, was born for a good sign on the 21st day of Nisan, [11 April], *eruv Shabbat Kodesh* which is the 7th day of Passover, 1947 to the counting. May God cause him to grow up to Torah, and to the marriage canopy, and to good deeds. Amen, so be His will forever."

Within the Torah scroll: "Crown of Torah [*Ethics of the Fathers* 4:17], belongs to Chaim Joseph [his maternal grandfather], son of Solomon. May his soul be bound up in the bond of everlasting life."[2]

A couple, dressed for an informal postwar wedding, approach a marriage canopy on which is inscribed: "The voice of the bridegroom and bride" (Jer. 33:11).

David A. Adler, for whom this binder was made, is the author of over forty children's books including, coincidentally, a series of game, riddle, and puzzle books on the Bible and on Jewish festivals.

Notes: 1. For a discussion of this concept, see Barbara Kirshenblatt-Gimblett, "The Cut that Binds: The Western Ashkenazic Torah Binder as Nexus Between Circumcision and Torah," in Victor Turner, ed., *Celebration: Studies in Festivity and Ritual* (Washington, D.C.: Smithsonian Institution Press, 1982). 2. This quotation is from the memorial service for the dead.

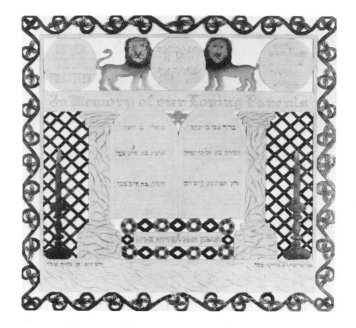

123
Memorial Plaque
Kate Ring Rosenthal (1899–1975)
Boston, Massachusetts, after 1949
Watercolor and pencil on cut paper
17¾ x 18⅝"; 45.2 x 47.5 cm.
Collection of T'Mahry Axelrod, niece of the artist

It is believed that this plaque was created by Baruch Zvi Ring's daughter Kate, who, inspired by her father's papercuts, determined to carry on in his tradition. (See cats. 53, 77, 80, and 95.) She, however, lacked her father's superior skill and imagination. Inscribed in English and Hebrew, this plaque bears the names of her parents, Baruch Zvi and Tamara, two of her brothers, Hyman (Hayyim) and Ely (Elijah), and other close relatives.

In the central medallion, flanked by docile lions, appears the word *yahrzeit* (anniversary of a death) in Yiddish, while medallions to the left and right contain the phrases "Never to be forgotten" and "May their souls be bound up in the bond of everlasting life" in English and Hebrew respectively. Supporting this section is a horizontal band inscribed, in English, "In Memory of our Loving Parents." The pillars flank two tablets listing six of the deceased:

On the left: "Meir son of Joseph" [brother of Tamara]
 "Ita daughter of Hayyim Tzvi"
 "Hasha daughter of Hayyim Tzvi"
On the right: "Baruch Tzvi son of Jacob"
 "Tamara daughter of Elijah Isaac"
 "Hayya Tamara daughter of Hayyim Dov"
 [Kate's niece]

Under these, enclosed within a rectangular design, appears the Hebrew inscription, "and you are faithful to revive the dead."[1] Below the candlesticks the artist has memorialized the names of her brothers, "Hayyim Dov, Son of Baruch Tzvi" (died 1949), and "Elijah Isaac, Son of Baruch Tzvi" (died 1933).

Note: 1. From the Amidah (Eighteen benedictions).

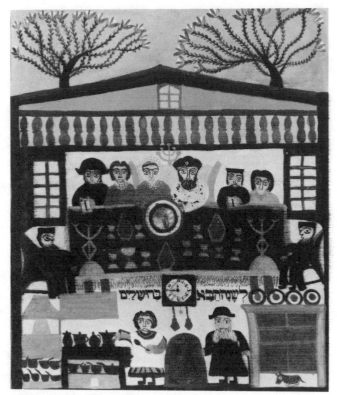

124
The Seder
Meichel Pressman (1864–1953)
New York, 1950
Watercolor on paper
Signed and dated; Meihel Pressman, 1950
22¼ x 18½"; 56.5 x 47 cm.
The Jewish Museum

Mixing childhood memories of Poland with the fancies of his ageless imagination, Meichel Pressman concocts a seder as delectable as the Passover meal it represents.

Born in a village in Galicia, where he labored on a farm, Pressman came to America around the turn of the century and worked as a pants presser. At the age of eighty-four, retired and crippled, Pressman found a box of crayons in his house and started to draw, taking his themes from the Bible and from recollections of his early years.

With an unerring instinct for design, Pressman recreates the nostalgic Passover scene, as it was celebrated in the home of his youth. The lost world of East European Jewry is evoked in this highly stylized, colorful group: the hostess wears a typical Polish kerchief, while the men, with their heavy beards, side locks, and long black coats are garbed in the everyday costume of Polish Jews, their headgear resembling the three-cornered hats favored by rabbis in the late 18th and early 19th century.[1]

Echoes of Polish wooden synagogues may be found in the carved friezelike balustrade and in the narrow ten-paned vertical windows.[2]

Prominently aligned on the Passover table, stand the wine goblets required for the seder, and a huge round seder plate traditionally used for the symbolic foods. The forms of the two golden menorah-shaped candelabra are repeated by the

twin trees crowning the house. Below, flanking the clock, inscribed in large Hebrew letters, is the chant from the Haggadah: "Next year in Jerusalem."

At Pressman's seder every element has been perfectly chosen and placed, including the almost unnoticed dog hiding under the dresser, whose downturned tail provides a humorous visual counterpoint to the upturned handles of the cooking utensils.

Notes: 1. Alfred Rubens, *A History of Jewish Costume* (New York: Crown, 1973): 104 ff.; figs. 233, 234, 236, 251. 2. Maria and Kasimierz Piechotka, *Wooden Synagogues,* English ed. (Warsaw: Arkady, 1959): ills. 31–36, 114, 258, 282.

References: Werner, Alfred. "Art and Artists," *Congress Weekly* 18, no. 1 (January 1, 1951): 15. Lawton, George. "Life is Always Beginning." In *Meichel Pressman,* exhibition announcement, Carlebach Gallery, New York, March 21 to April 2, 1949.

125
Czar Nicholas II Thumbing His Nose at President
** Theodore Roosevelt over the Kishinev Pogrom**
"Grandpa" Zelig Tepper (1877–1973)
New York, 1954
Watercolor on paper
Signed and dated lower right; Z. Tepper 11/54
13¼ x 15⅝"; 33.7 x 39.6 cm.
Edythe Siegel Gallery of Jewish-American Folk Art,
 Stamford, Connecticut

In this witty painting based on a historical event, the playful treatment of the subject contradicts the seriousness of the theme. The first of two notorious pogroms against the Jews in Kishinev, Russia took place in 1903; it was sanctioned by government officials. In the United States, a committee from B'nai B'rith drafted a petition of protest, which President Theodore Roosevelt submitted for delivery to Czar Nicholas II, who refused to accept it.[1] "Grandpa" Tepper, however, chose to invent his own legendary response.

Facing each other across the ocean stand the two adversaries—Nicholas, defiantly thumbing his nose at Teddy Roosevelt, who brandishes his proverbial "big stick." The caption accompanying the American president warns "Teddy Roosevelt 1903. Hands off." A panorama of romantic buildings and onion-domed churches, in red, white, and brown, provides the characteristic Russian setting for the figure of the czar, while the president, isolated, stands firmly on a rock surrounded by water, with the splendid dome of the nation's Capitol as his sole companion. Typifying the protagonists' antithetic political views, Nicholas is aristocratically dressed in an orange tunic with gold epaulettes and flaunts a saber and gold crown in vivid contrast to Roosevelt, clad in khaki, sporting a loosely tied neckerchief, the emblem of the Rough Rider.

On the Russian side, at the upper left, the pogrom is depicted; cavalrymen set houses ablaze and pursue fleeing citizens, while the bodies of those they maimed and killed lie on the ground. (To escape such persecutions, thousands of Russian Jews fled their homeland and crossed the ocean, to seek refuge in the United States.)

Born in Ludma in the Ukraine, Zelig Tepper retained vivid memories of the Kiev pogrom of 1881, recalling the fear and chaos he experienced as a four-year-old, when his parents

took precautions to protect the family from possible anti-Semitic attack. After he left his native Ukraine in 1895, Tepper worked in New York as a milliner and later as a jeweler. He began to paint at the age of seventy-three, when he was considered legally blind, and concentrated on sentimental scenes of his childhood, as well as Jewish and secular contemporary American themes.

Note: 1. *The Universal Jewish Encyclopedia,* 9: 198–99. *Encyclopedia Judaica,* 6: cols. 1063–69.

126 (Plate 17)
Hanukkah Lamp
Mae Shafter Rockland (1937–
Princeton, New Jersey, 1974
Wood covered in fabric with molded plastic figures
11 x 24 x 7"; 27.9 x 60.9 x 17.8 cm.
Collection of the artist

This Hanukkah lamp is strongly influenced by Pop Art, particularly the flag paintings of Jasper Johns, and the assemblages of the 1950s and 60s.

The candle holders, commercially manufactured souvenirs, are iconographically reinforced by the stenciled inscription, "I lift my lamp beside the Golden Door," a line from the sonnet "The New Colossus" by Emma Lazarus. These verses were set onto a plaque affixed to the pedestal of the Statue of Liberty in 1903. The first sight for many immigrants as they entered New York harbor, the statue has ever remained a symbol of freedom; for this reason, it also serves as an appropriate image for a Hanukkah lamp, Hanukkah being in essence a festival of freedom.

Inspired by the significance of Hanukkah, Mae Shafter Rockland created a variety of objects referring to this festival, including a ceramic Hanukkah chess set. She is also known for her paper-cuts and quilts.

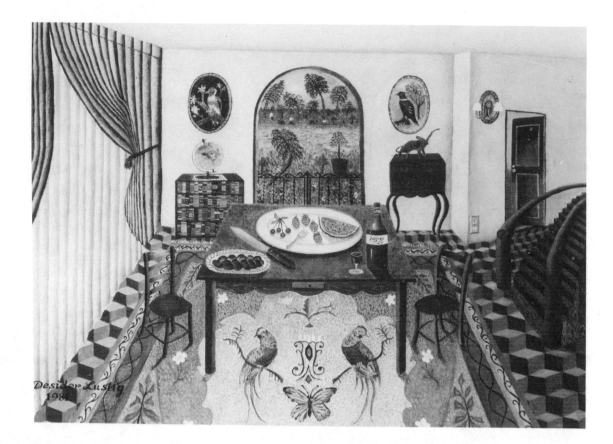

127 (Plate 16)
Esther and Ahasuerus
Malcah Zeldis (1931–　　)
New York, 1976
Oil on Masonite
20 x 24"; 51 x 61 cm.
Jay Johnson America's Folk Heritage Gallery, New York

Among contemporary folk painters, Malcah Zeldis occupies a special place because of her distinctive palette of "raw and vibrant" colors.[1] A strong sense of Jewish identity is apparent in much of her work, although she also finds themes in the problems of contemporary life and inter-personal relationships.

Malcah Zeldis was born in New York in 1931, and grew up in Detroit. At the age of eighteen she moved to Israel, where she worked on *kibbutzim,* married, and raised two children. It was not until she returned to New York in the late 1960s that she began to paint. She has depicted many of the major events in the Jewish life cycle, as well as in the religious calendar. She also looks to the Bible for inspiration, as evidenced in this colorful depiction of Queen Esther at the court of her husband, King Ahasuerus. Esther's successful intercession on behalf of the Jews is celebrated each year at Purim.

Note:　1. Jay Johnson and William C. Ketchum, Jr., *American Folk Art of the Twentieth Century* (New York: Rizzoli, 1983): 329.

128
The Sabbath Table
Desider Lustig (1900–　　)
New York, 1981
Oil on canvas board

Signed and dated lower left corner
18 x 24"; 45.7 x 61 cm.
Collection of Dr. Barbara Kirshenblatt-Gimblett

The Sabbath Table presents a fascinating potpourri of disparate elements, woven into unusual visual passages. The lush, tropical landscape seen through the arched window, the exuberantly patterned rug, the mysterious opened door, and the sharply foreshortened staircase leading to the unknown, contribute to the work's dramatic power. Central to the design and theme, the table acts as an anchor upon which the braided loaf of hallah and the wine and cup for the prayer of sanctification (*kiddush*) are conspicuously displayed.

Composed of myriad personal images, the painting attains its unity through an overall control of color and design, by which Lustig establishes a mood of domestic order. In a burst of lyricism, cherries, strawberries, and watermelon are lovingly arranged, rendered in the artist's favored red, balancing the two red chairs and the parrots' scarlet breasts. In a humorous vein, the figure of an elephant, trunk raised, echoes the curved legs of the dresser on which it is placed.

Desider Lustig was born in Hungary in 1900, and came to the United States at the age of twenty-one. Trained as an electro-technician, he was soon hired by the New York Central Railroad as an electrical inspector. Lustig was an accomplished violinist, and appeared as soloist at numerous musical events sponsored by Hungarian organizations. He suffered a hearing loss in 1972, and was forced to give up the violin; consequently he embraced painting as an alternate means of self-expression.

Reference:　*Images of Experience: Untutored Older Artists.* Exhibition catalogue. Pratt Manhattan Center Gallery, New York, 1982. Entry on Desider Lustig.

Selected References

Altshuler, David, ed. *The Precious Legacy: Judaic Treasures from the Czechoslovak State Collections.* Exhibition catalogue. New York: Summit Books; and Washington, D.C.: Smithsonian Institution Traveling Exhibition Service, 1983.

Ameisenowa, Zofja. "The Tree of Life in Jewish Iconography." *Journal of the Warburg Institute* 2 (1939): 326–45.

Avigad, Nahman. *Beth She'arim,* Volume 3. Jerusalem: Massada Press, 1976.

Avrin, Leila. *Micrography as Art.* Paris: Centre national de la recherche scientifique; and Jerusalem: The Israel Museum, 1981.

Barnett, R. D., ed. *Catalogue of the Permanent and Loan Collections of the Jewish Museum.* London: Harvey Miller, 1974.

Brener, David. *The Jews of Lancaster, Pennsylvania: A Story with Two Beginnings.* Lancaster: Congregation Shaarai Shomayim in association with the Lancaster County Historical Society, 1979.

Carrick, Alice Van Leer. *A History of American Silhouettes: A Collector's Guide: 1790–1840.* Rutland, Vt.: Tuttle, 1968 (reprint of 1928 edition of *Shades of Our Ancestors*).

Charles Peale Polk, 1767–1822: A Limner and His Likenesses. Exhibition catalogue. Washington, D.C.: Corcoran Gallery of Art, 1981.

Christensen, Erwin O. *The Index of American Design.* New York: Macmillan, 1950.

Corn, Wanda. "The Development of the Appreciation of American Folk Art." Master's thesis. New York: New York University Institute of Fine Art, 1965.

Cortelyou, Irwin. "Micah Williams: New Jersey Primitive Portrait Artist." *The Monmouth Historian: Journal of the Monmouth County Historical Association* 2 (Spring 1974).

Danzig 1939: Treasures of a Destroyed Community. Exhibition cagalogue. New York: The Jewish Museum, 1980.

Davis, Eli and Elise. *Jewish Folk Art over the Ages: A Collector's Choice.,* 2d rev. ed. Jerusalem: Rubin Mass, 1983.

Encyclopedia Judaica. Jerusalem: Keter, 1972.

Epstein, Shifra. *Purim: The Face and the Mask.* Exhibition catalogue. New York: Yeshiva University Museum, 1980.

Evans, Sondra. "Marcus Charles Illions." *Carrousel Art,* issue 18 (July/August 1982): 2–5.

Fabric of Jewish Life. Exhibition catalogue. New York: The Jewish Museum, 1977.

Fendelman, Helaine W. *Tramp Art: An Itinerant's Folk Art.* New York: Dutton, 1975.

Fine, Jo Renée, and Gerard R. Wolfe. *The Synagogues of New York's Lower East Side.* New York: Washington Mews Books, New York University Press, 1978.

Frankel, Giza. "Jewish Paper-Cuts." *Polska Sztuka Ludowa* 3 (1965): 135–46, 178 (English summary).

———. "Little Known Handicrafts of Polish Jews in the Nineteenth and Twentieth Centuries." *Journal of Jewish Art* 2 (1975): 42–49.

Fried, Frederick. *A Pictorial History of the Carousel.* New York: Barnes, 1964.

Garvan, Beatrice B. and Charles F. Hummel. *The Pennsylvania Germans: A Celebration of Their Arts, 1683–1850.* Exhibition catalogue. Philadelphia: Philadelphia Museum of Art, 1982.

Greenwald, Alice M. "The Masonic Mizrah and Lamp: Jewish Ritual Art as a Reflection of Cultural Assimilation." *Journal of Jewish Art* 10 (forthcoming).

Grinstein, Hyman B. *The Rise of the Jewish Community of New York 1654–1860.* Philadelphia: Jewish Publication Society of America, 1945.

Gutmann, Joseph. "Jewish Participation in the Visual Arts of Eighteenth and Nineteenth-Century America." *American Jewish Archives* 15 (April 1963): 21–57.

Gutstein, Morris A. *The Story of the Jews of Newport: Two and a Half Centuries of Judaism, 1658–1908.* New York: Bloch, 1936.

Hershkowitz, Leo, and Isidore S. Meyer (eds.). *The Lee Max Friedman Collection of American Jewish Colonial Correspondence: Letters of the Franks Family (1733–1748).* Waltham, Mass.: American Jewish Historical Society, 1968.

Ingathering: Ceremony and Tradition in New York Public Collections. Exhibition catalogue. New York: The Jewish Museum, 1968.

Israelowitz, Oscar. *Synagogues of New York City.* New York: Dover, 1982.

Jackson, E. Nevill. *Silhouettes: A History and Dictionary of Artists.* New York: Dover, 1981 (reprint of 1938 edition of *Silhouette: Notes and Dictionary*).

Janis, Sidney. *They Taught Themselves: American Primitive Painters of the Twentieth Century.* New York: Dial Press, 1942.

The Jewish Community in Early America, 1654–1830. Exhibition catalogue. Washington, D.C.: Daughters of the American Revolution Museum, 1980.

The Jewish Encyclopedia. New York: Funk and Wagnalls, 1901–6.

Johnson, Jay, and William C. Ketchum. *American Folk Art of the Twentieth Century.* New York: Rizzoli, 1983.

Johnston, Sona K. *American Paintings, 1750–1900, from the Collection of The Baltimore Museum of Art.* Baltimore: The Baltimore Museum of Art, 1983.

Johnston, William R. "Charles Peale Polk: A Baltimore Portraitist." *Annual III, Part I.* Baltimore: The Baltimore Museum of Art (1968): 32–37, 77.

Kampf, Avram. "In Quest of the Jewish Style in the Era of the Russian Revolution." *Journal of Jewish Art* 5 (1978): 48–75.

Kanof, Abram. *Jewish Ceremonial Art and Religious Observance.* New York: Abrams, 1969.

Kayser, Stephen, and Guido Schoenberger. *Jewish Ceremonial Art.* 2d ed. Philadelphia: Jewish Publication Society of America, 1969.

Kedourie, Elie (ed.). *The Jewish World: Revelation, Prophecy, and History.* London: Thames and Hudson, 1979.

Kelly, Susan H., and Anne C. Williams. *A Grave Business: New England Gravestone Rubbings: A Selection.* New Haven, Conn.: Art Resources of Connecticut, 1979.

Kirshenblatt-Gimblett, Barbara. "The Cut That Binds: The Western Ashkenazic Torah Binder as Nexus Between Circumcision and Torah." In Turner, Victor (ed.). *Celebration: Studies in Festivity and Ritual.* Washington, D.C.: Smithsonian Institution Press, 1982: 136–46.

Krueger, Glee. *New England Samplers to 1840.* Sturbridge, Mass.: Old Sturbridge Village, 1978.

Landsberger, Franz. "The Jewish Artist before the Time of Emancipation." *Hebrew Union College Annual* 16 (1941): 321–413.

Lebeson, Anita Libman. *Pilgrim People.* New York: Minerva Press, 1975.

Lewis, Rabbi Dr. Theodore. "History of Touro Synagogue." *Newport History: Bulletin of the Newport Historical Society* 48, part 3, no. 159 (Summer 1975): 281–320.

Lipman, Jean, and Tom Armstrong (eds.). *American Folk Painters of Three Centuries.* New York: Hudson Hills Press in association with the Whitney Museum of American Art, 1980.

Lipman, Jean, and Alice Winchester. *The Flowering of American Folk Art, 1776–1876.* New York: Viking Press in cooperation with the Whitney Museum of American Art, 1974.

Little, Nina Fletcher. *The Abby Aldrich Rockefeller Folk Art Collection.* Boston and Toronto: Little, Brown, 1957.

London, Hannah R. *Miniatures of Early American Jews.* Reprinted in *Miniatures and Silhouettes of Early American Jews.* Rutland, Vt.: Tuttle, 1970.

_____. *Portraits of Jews by Gilbert Stuart and Other Early American Artists.* Reprinted. Rutland, Vt.: Tuttle, 1969.

_____. *Shades of My Forefathers.* Reprinted in *Miniatures and Silhouettes of Early American Jews.* Rutland, Vt.: Tuttle, 1970.

Ludwig, Allan I. *Graven Images: New England Stonecarving and Its Symbols, 1650–1815.* Middletown, Conn.: Wesleyan University Press, 1966.

Masonic Symbols in American Decorative Arts. Lexington, Mass.: Scottish Rite Masonic Museum of Our National Heritage, 1976.

Mendes, Rev. A. P. "The Jewish Cemetery at Newport, Rhode Island: A Paper Read before the Newport Historical Society, June 23, 1885." *The Rhode Island Historical Magazine* 6, no. 2 (October 1885): 81–105.

Narkiss, Bezalel. *Hebrew Illuminated Manuscripts*. Jerusalem: Keter, 1969.

Narkiss, Mordecai. *The Hanukkah Lamp*. Jerusalem: Bney Bezalel, 1939 (Hebrew with English summary).

The Paper-cut: Past and Present. Exhibition catalogue. Haifa: Haifa Municipality Ethnological Museum and Folklore Archives, 1976.

Piechotka, Maria, and Kazimierz Piechotka. *Wooden Synagogues*. English ed. Warsaw: Arkady, 1959.

Pool, David de Sola. *Portraits Etched in Stone: Early Jewish Settlers, 1682–1831*. New York: Columbia University Press, 1952.

Quimby, Ian. M. G., and Scott T. Swank (eds.). *Perspectives on American Folk Art*. New York: Norton; and Toronto: McLeon, 1980.

Ray, Dorothy Jean. *Artists of the Tundra and the Sea*. Seattle: University of Washington Press, 1961.

———. *Eskimo Art: Tradition and Innovation in North Alaska*. Seattle: Henry Art Gallery, University of Washington, 1977.

Rosenbloom, Joseph R. *A Biographical Dictionary of Early American Jews: Colonial Times Through 1800*. Lexington: University of Kentucky Press, 1960.

Roskies, David G., and Diane K. Roskies. *The Shtetl Book: An Introduction to East European Jewish Life and Lore*. 2d rev. ed. New York: Ktav, 1979.

Rubens, Alfred. *A History of Jewish Costume*. 2d ed. New York: Crown, 1973.

Rumford, Beatrix T. (ed.). *American Folk Portraits: Paintings and Drawings from the Abby Aldrich Rockefeller Folk Art Center*. Boston: New York Graphic Society in association with the Colonial Williamsburg Foundation, 1981.

Schoener, Allon. *American Jewish Album: 1654 to the Present*. New York: Rizzoli, 1983.

Shelley, Donald A. *The Fraktur-Writings or Illuminated Manuscripts of the Pennsylvania Germans*. Allentown, Pa.: Pennsylvania German Folklore Society, 1961.

Sherman, Philip. "The Engaging Mrs. E." Catalogue. *3rd Annual Maryland Antiques Show and Sale*. Baltimore, 1981.

Silber, Julie. "The Reiter Quilt: A Family Story in Cloth." *The Quilt Digest*, 1983: 50 55.

Stern, Malcolm H. *First American Jewish Families: 600 Genealogies, 1654–1978*. Cincinnati: American Jewish Archives; and Waltham, Mass.: American Jewish Historical Society, 1978.

Tora-Wimpel. Exhibition catalogue. Brunswick: Braunschweigisches Landesmuseum, 1978.

Trachtenberg, Joshua. *Consider the Years: The Story of the Jewish Community of Easton, 1752–1942*. Easton, Pa.: Centennial Committee of Temple Beth Shalom, 1944.

Weinreich, Uriel. "Paper Cutouts from Eastern Galicia." *Yidishe Folklor*, January 1954: 12.

Wheeler, Robert G., and Janet R. MacFarlane. *Hudson Valley Paintings 1700–1750 in the Albany Institute of History and Art*. Albany, 1959.

Wischnitzer, Rachel. *The Architecture of the European Synagogue*. Philadelphia: Jewish Publication Society of America, 1964.

Wolf, Edwin 2nd, and Maxwell Whiteman. *The History of the Jews of Philadelphia from Colonial Times to the Age of Jackson*. Philadelphia: Jewish Publication Society of America, 1957.

Zborowski, Mark, and Elizabeth Herzog. *Life Is with People: The Culture of the Shtetl*. New York: Schocken, 1952.

Glossary

Ashkenazi – in Hebrew lit. "German"; conventional term used to designate Jews of West or East European origin.

bar mitzvah – a boy's acceptance at age 13 of adult responsibilities and obligations in religious observance.

bimah – a raised platform at the front or center of the synagogue, from which the Torah is read.

Crown of Torah – one of four crowns mentioned in *Ethics of the Fathers* 4:17 which are iconographic motifs found in Jewish art.

etrog – a citron, a fruit resembling a lemon, that is one of the four species of plants used during the liturgy of the Sukkot holiday.

halakhah – generic term for Jewish law based on the Torah, the Talmud, and rabbinic exposition.

hallah – in Hebrew lit. the portion of dough removed from each baking and given to the priest in ancient Israel or burned after the destruction of the Temple; by synecdoche the name given to the special bread used *par excellence* on Sabbaths and festivals.

Hanukkah – a Jewish holiday commemorating the victory of the Hasmoneans over their Greco-Syrian overlords in 165 B.C.E. and the establishment of religious freedom in ancient Israel.

ketubbah – in Hebrew lit. "that which is written"; a Jewish marriage contract.

kiddush – prayer of sanctification over wine recited on Sabbaths and festivals.

lulav – three branches, one of myrtle, one of palm and one of willow, used with the *etrog* during Sukkot rituals.

matzah (sing.), **matzot** (pl.) – unleavened bread eaten during Passover.

megillah – a scroll; e.g., *Megillat Esther*, the Book of Esther, written on a scroll.

menorah – a seven-branched candelabrum used in the biblical sanctuary and Jerusalem Temple; a seven-branched candelabrum found in a synagogue; an eight-branched candelabrum used during the Hanukkah festival.

mezuzah – a parchment scroll inscribed with biblical passages (Deut. 6:4–9, 11:13–21) that is affixed to the doorpost of a Jewish home usually encased in a protective cover.

Mishnah – body of Jewish oral law, edited by Rabbi Judah ha-Nasi around the beginning of the third century C.E.

mizrah – in Hebrew lit. "east"; a plaque or wall-hanging placed on the eastern wall of a Jewish home or communal building west of Jerusalem to indicate the direction of prayer.

omer – in Hebrew lit. "sheaf"; an offering brought to the Temple on the 16th of the Hebrew month of Nisan; the name of the period between Passover and Shavuot.

pinkas (sing.), **pinkasim** (pl.) – Hebrew from the Greek *pinaxes*, "register" or "list"; a book of minutes or records of a society within the Jewish community.

seder – in Hebrew lit. "order"; a term given to the fourteen-part order of liturgical home service for the first two nights of Passover, which includes recitation of the story of the Exodus from Egypt accompanied by ritual eating and drinking.

Sephardi – in Hebrew lit. "Spanish" or "of Spain"; conventional term used to designate Jews of Spanish and Portuguese ancestry.

shammash – in Hebrew lit. "servant" or "one who ministers"; used to designate both a synagogue functionary (sexton) and, specifically, the candle or light on the Hanukkah lamp that kindles (serves) the eight other lamps.

Shavuot – Feast of Weeks, a two-day festival commemorating the giving of the Torah at Sinai and the bringing of offerings to the Temple in Jerusalem, occurring seven weeks after the second day of Passover.

shiviti – a plaque hung in a synagogue inscribed with the verse *shiviti Adonai le-negdi*, i.e., "I am ever mindful of the Lord's presence" (Ps. 16:8).

shofar – a ram's horn sounded during the services on Rosh Hashanah and Yom Kippur as a call to repentance.

Simhat Torah – a one-day celebration occurring at the end of Sukkot, when the yearly cycle of reading the Torah scroll is completed and begun again.

Sukkot – In Hebrew lit. "booths"; Feast of Tabernacles, which begins four days after Yom Kippur, at the time of the autumnal harvest.

tallit – a prayer shawl.

tefillin – two leather boxes enclosing passages from the Torah that are worn during morning prayer, except on Sabbaths and festivals.

Torah – a parchment or leather scroll inscribed with the first five books of the Hebrew Bible.

Torah ark – a cabinet set in or against one wall of a synagogue. It holds the Torah scrolls and is the focus of prayer.

Torah binder – a band that holds the two staves of a Torah scroll together when the Torah is not being read.

Torah curtain – a curtain hung in front of the Torah ark in synagogues.

yahrzeit – in Yiddish lit. "time of year"; the anniversary of the death of an individual which in Jewish practice is commemorated by members of the immediate family.

Yom Kippur – in Hebrew lit. "Day of Atonement"; a day of fasting and prayer that falls on the tenth day of the Hebrew month of Tishri.

Photographic Credits

Numbers refer to catalogue entries

American Jewish Historical Society, Waltham,
Massachusetts 3, 7, 11, 24, 28, 86

The Baltimore Museum of Art, Maryland 12

Bill Buckner 127

Coxe & Goldberg 18, 19, 20, 25, 27, 33, 34, 36, 39, 40, 44, 48,
50, 52, 53, 55, 56, 59, 60, 61, 62, 64, 66, 67, 69, 72, 75, 76, 78,
79, 80, 82, 87, 88, 89, 90, 93 A & B, 95, 101, 102, 103, 104, 106,
109, 110, 113, 114, 115, 120, 121, 122, 123, 124, 125, 126, 128

Michael Ehrenthal 85

Lynton Gardiner 42, 43, 65

Don Gray 37

Hebrew Union College, Skirball Museum, Los Angeles,
California 38, 46, 57

Ken Hicks 83

The Hudson River Museum, Yonkers, New York 54

The Israel Museum, Jerusalem, Israel 96, 98, 99

Sidney Janis Gallery, New York City 117, 118

Courtesy of Lender 8, 13, 14, 22

The Library of The Jewish Theological Seminary of America,
New York City 23, 47, 90

The Maryland Historical Society, Baltimore 10

Museum of the City of New York 1, 2

National Museum of American Jewish History, Philadelphia,
Pennsylvania 6, 10, 17, 21, 97

Carleton Palmer 31, 32, 45, 100

Courtesy *The Quilt Digest*, San Francisco, California 58

Nicholas Sapieha & Nicholas Vreeland 84

Smithsonian Institution, National Museum of American
History, Washington D.C. 35

Sotheby's, New York City 51, 70, 81, 94, 111

Spertus Museum, Chicago, Illinois 71

Grant Taylor 4, 5, 26, 49, 63, 73, 77, 105, 108

Jane Voorhees Zimmerli Art Museum, Rutgers, The State
University, New Brunswick, New Jersey 30

Graydon Wood 30 (color)